Ellis Island

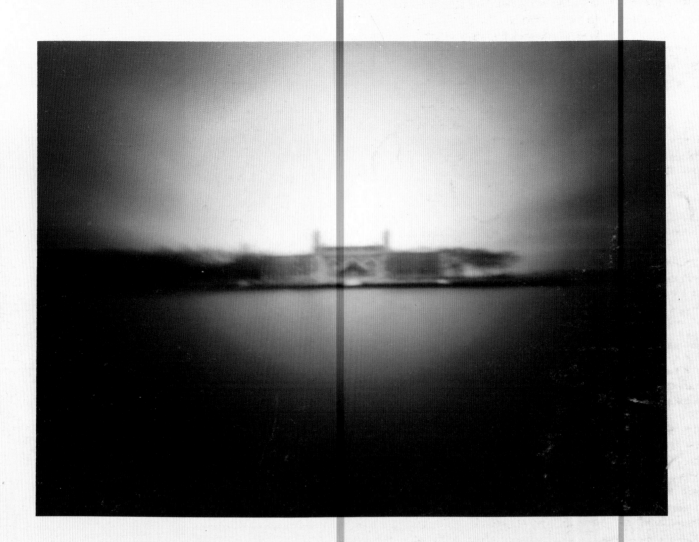

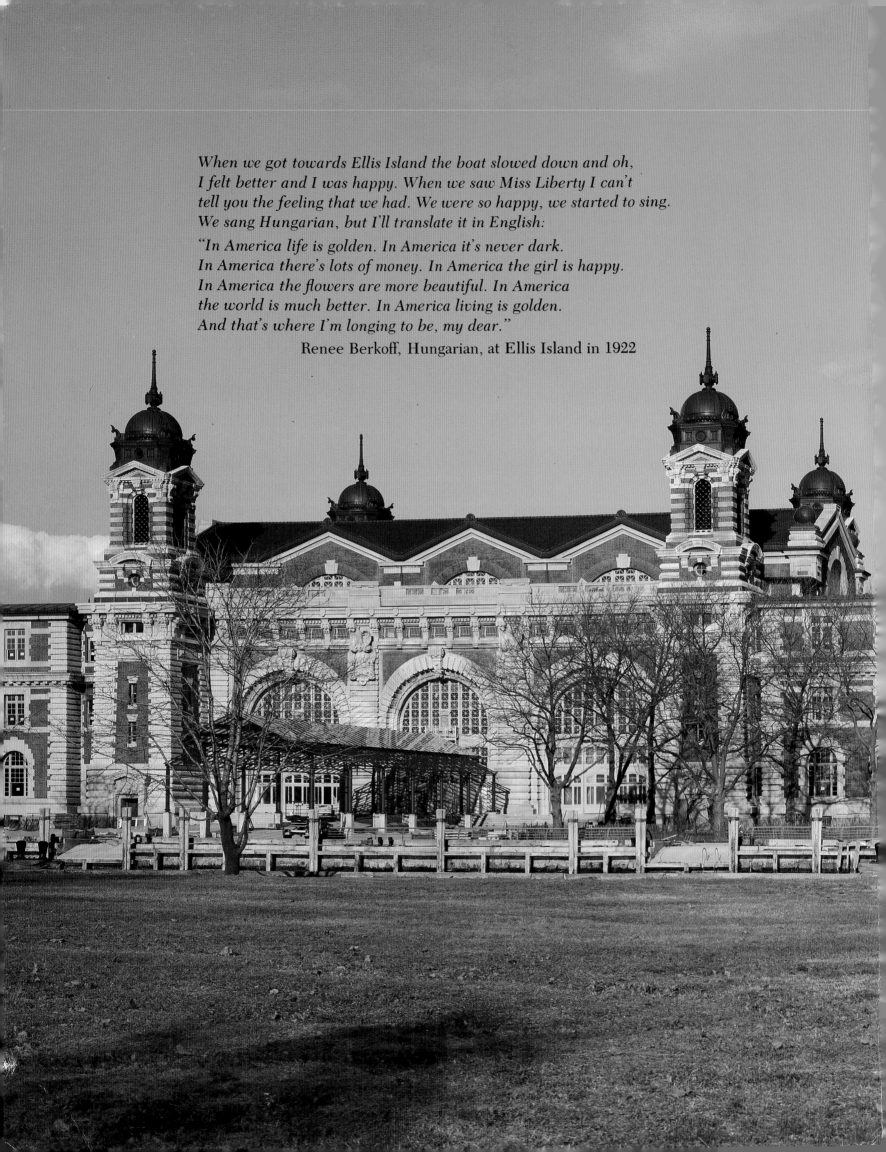

*When we got towards Ellis Island the boat slowed down and oh,
I felt better and I was happy. When we saw Miss Liberty I can't
tell you the feeling that we had. We were so happy, we started to sing.
We sang Hungarian, but I'll translate it in English:*

*"In America life is golden. In America it's never dark.
In America there's lots of money. In America the girl is happy.
In America the flowers are more beautiful. In America
the world is much better. In America living is golden.
And that's where I'm longing to be, my dear."*

Renee Berkoff, Hungarian, at Ellis Island in 1922

Ellis Island
ECHOES FROM A NATION'S PAST

ESSAYS BY

Norman Kotker, Shirley C. Burden,
Charles Hagen and Robert Twombly

EDITED BY

Susan Jonas

CONTRIBUTING EDITORS:

Klaus Schnitzer, Montclair State and
Brian Feeney, The National Park Service, U.S. Department of the Interior

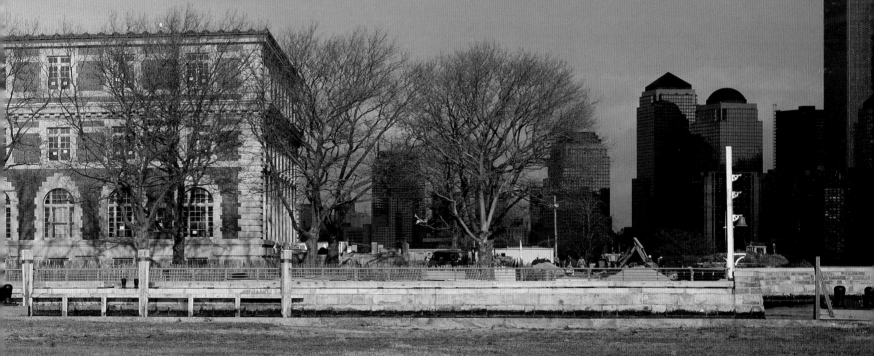

AN APERTURE BOOK

IN ASSOCIATION WITH THE NATIONAL PARK SERVICE, U.S. DEPARTMENT OF THE INTERIOR
AND MONTCLAIR STATE COLLEGE

CONTENTS

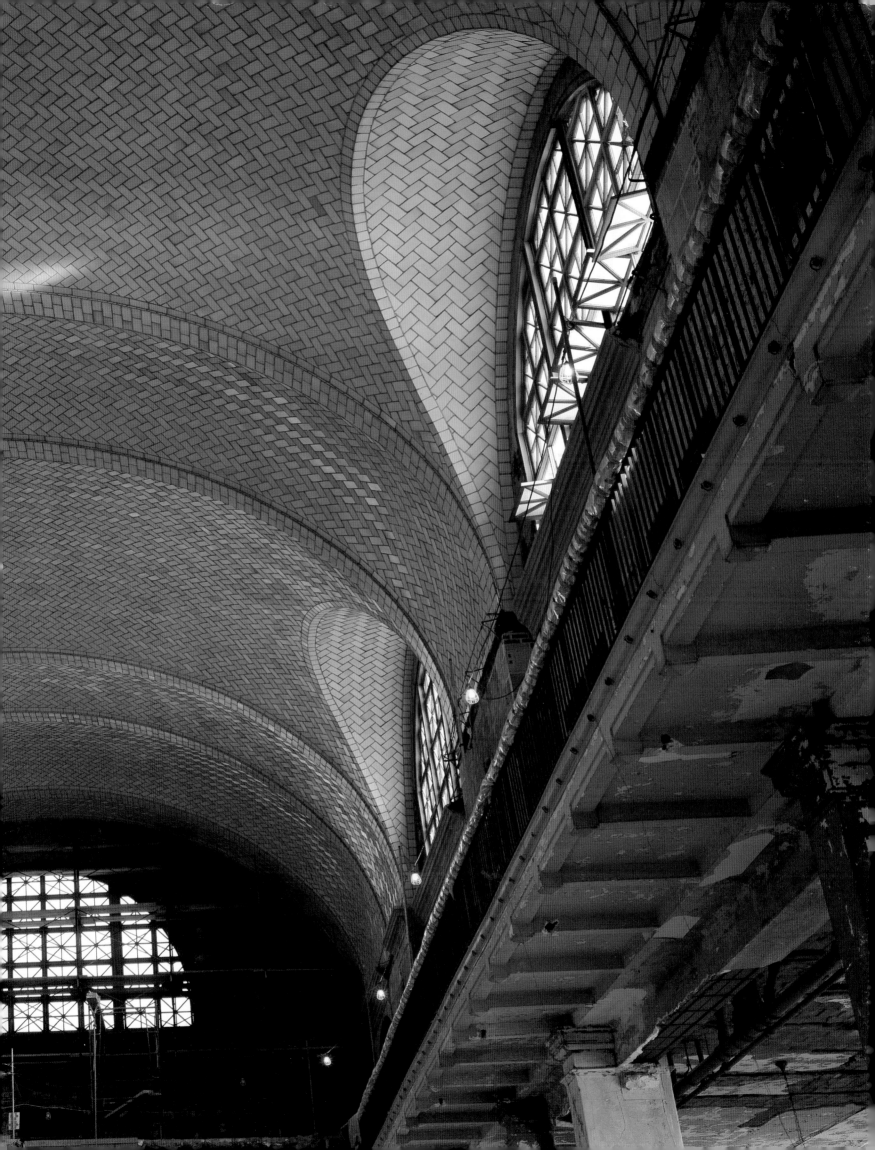

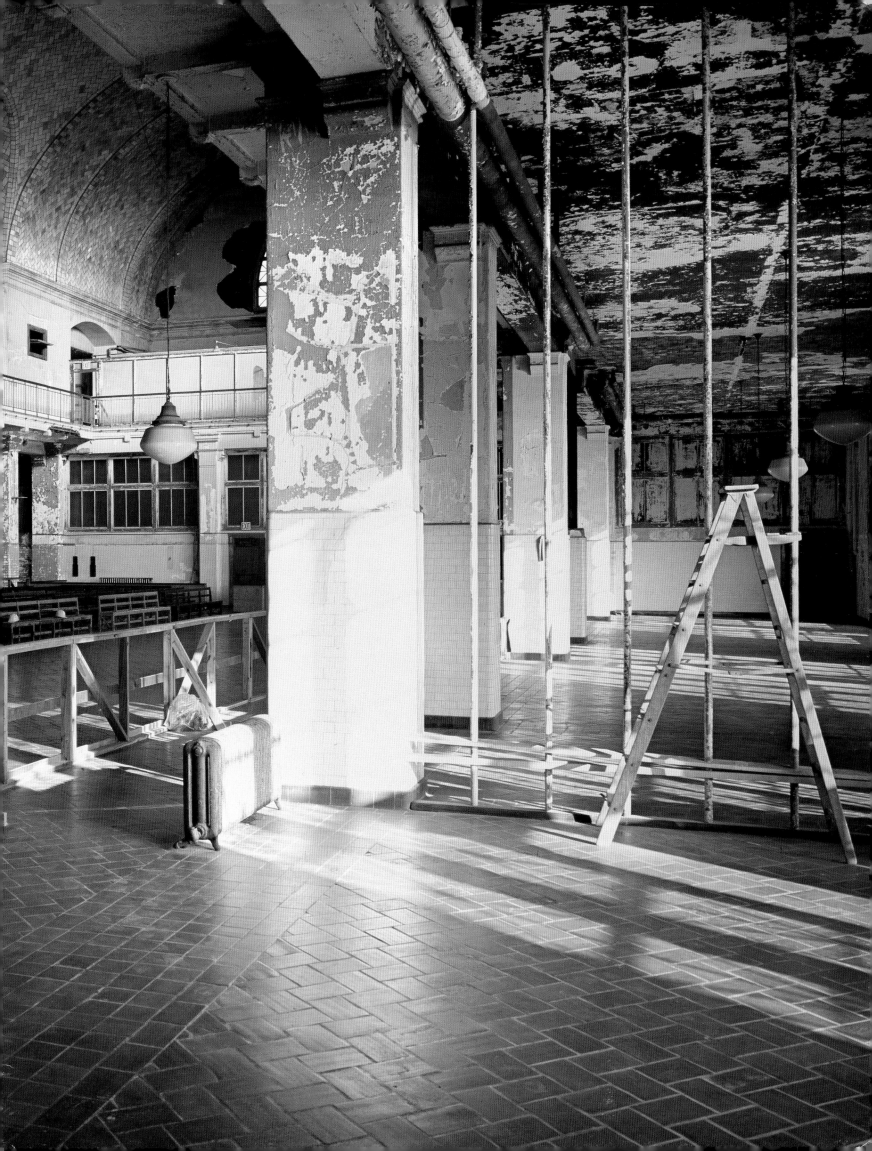

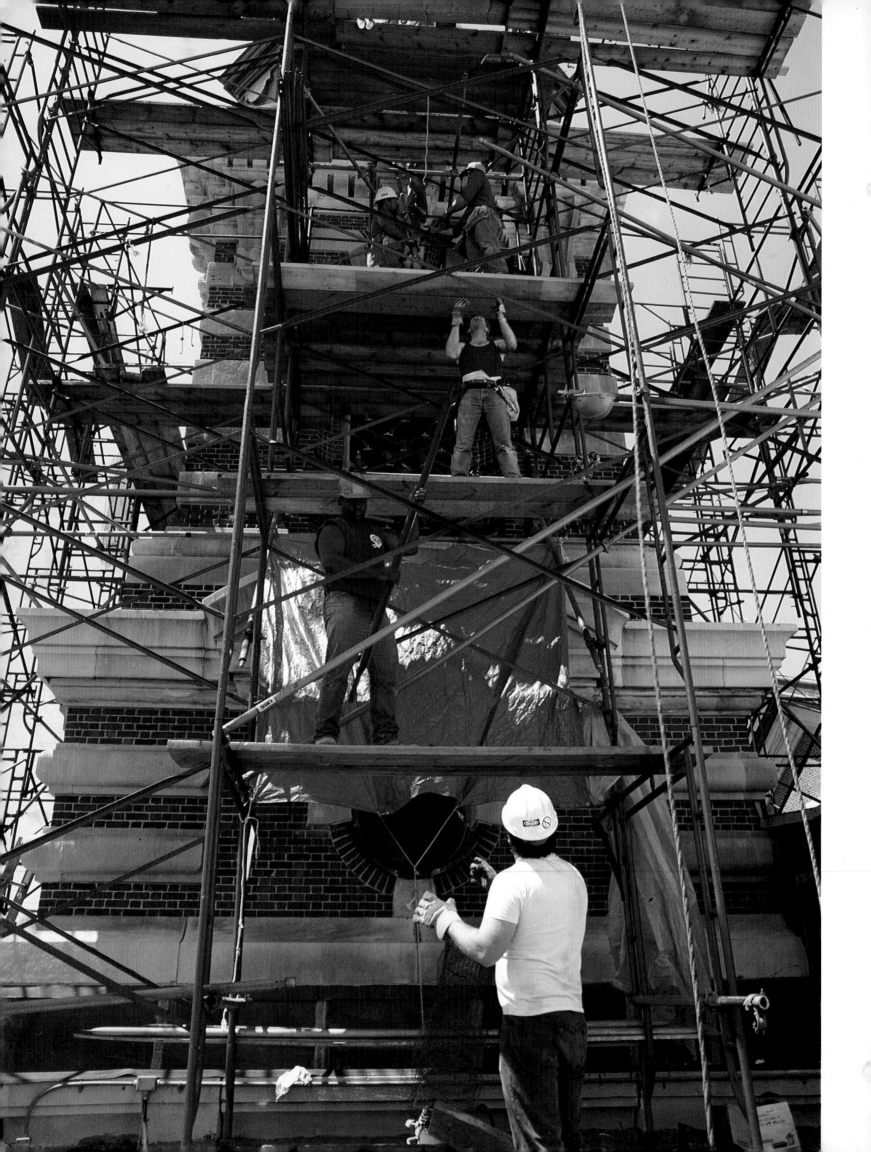

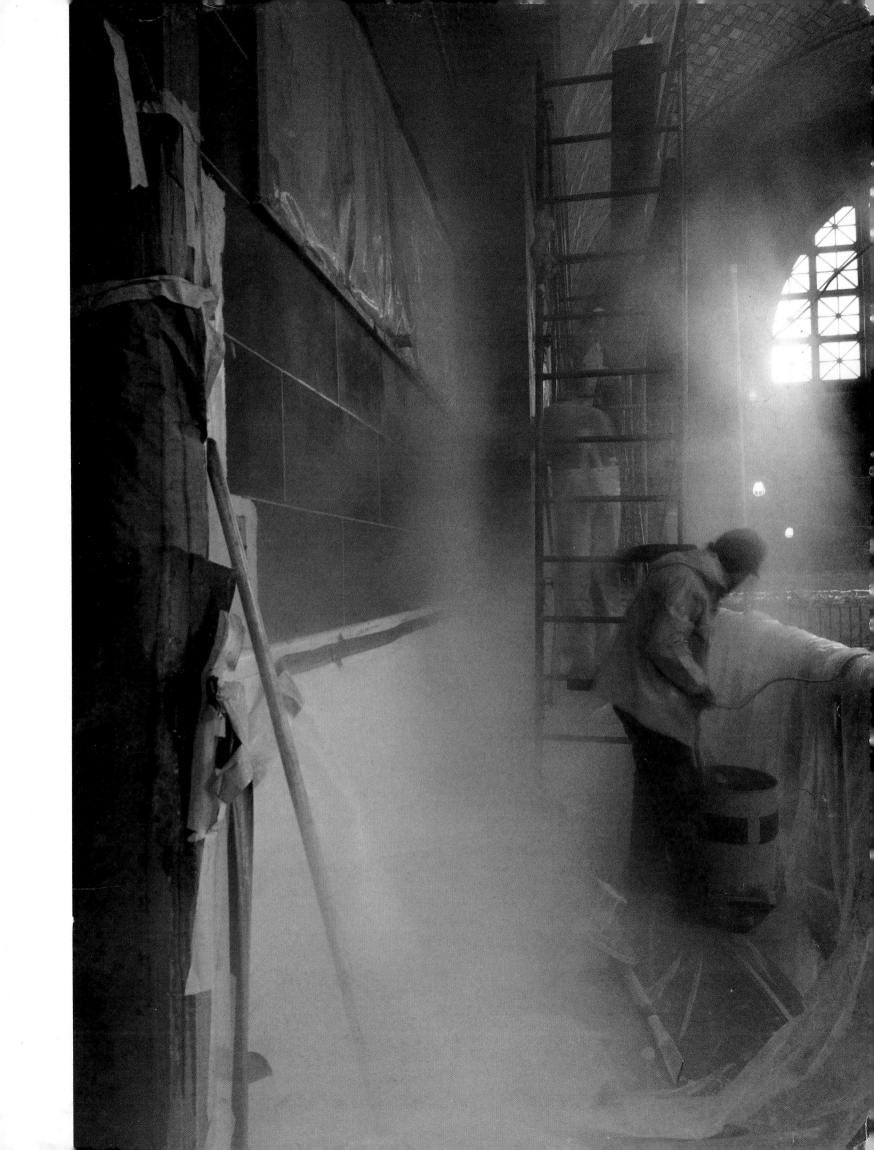

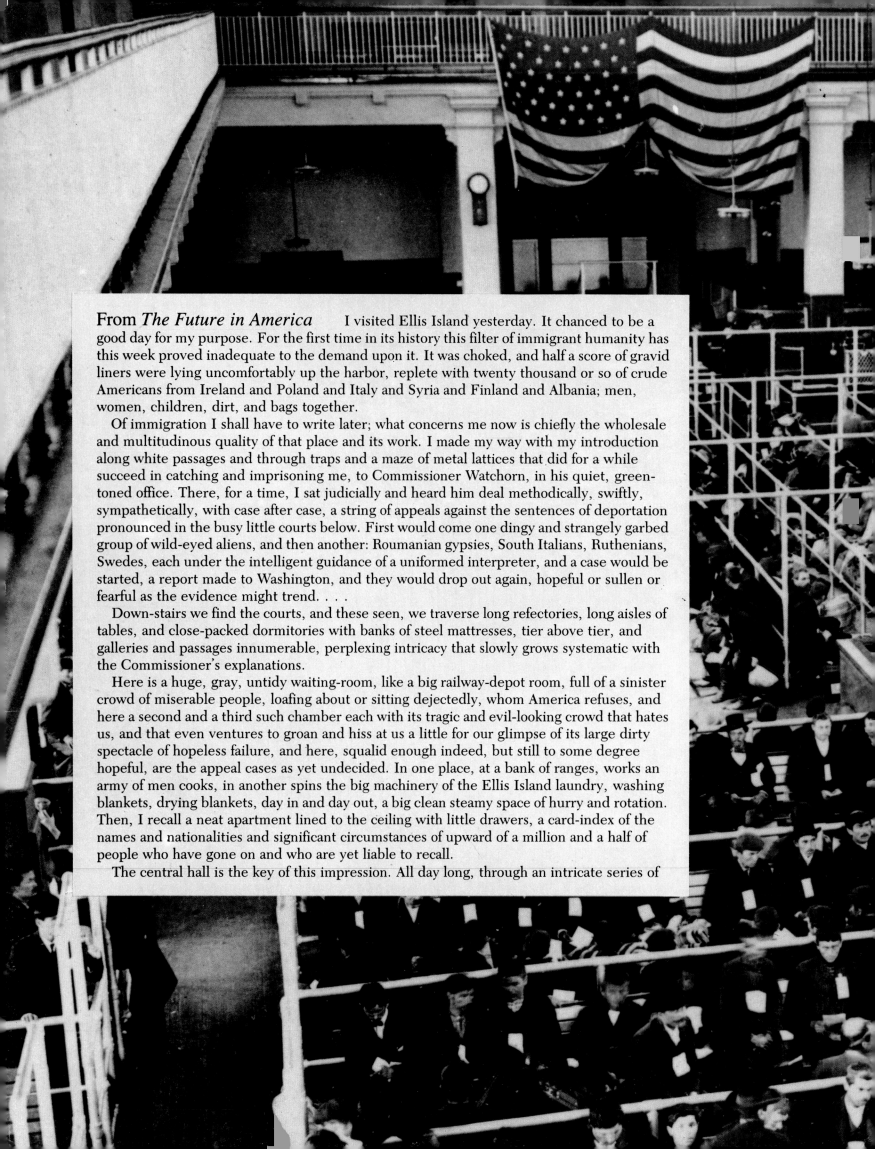

From *The Future in America* I visited Ellis Island yesterday. It chanced to be a good day for my purpose. For the first time in its history this filter of immigrant humanity has this week proved inadequate to the demand upon it. It was choked, and half a score of gravid liners were lying uncomfortably up the harbor, replete with twenty thousand or so of crude Americans from Ireland and Poland and Italy and Syria and Finland and Albania; men, women, children, dirt, and bags together.

Of immigration I shall have to write later; what concerns me now is chiefly the wholesale and multitudinous quality of that place and its work. I made my way with my introduction along white passages and through traps and a maze of metal lattices that did for a while succeed in catching and imprisoning me, to Commissioner Watchorn, in his quiet, green-toned office. There, for a time, I sat judicially and heard him deal methodically, swiftly, sympathetically, with case after case, a string of appeals against the sentences of deportation pronounced in the busy little courts below. First would come one dingy and strangely garbed group of wild-eyed aliens, and then another: Roumanian gypsies, South Italians, Ruthenians, Swedes, each under the intelligent guidance of a uniformed interpreter, and a case would be started, a report made to Washington, and they would drop out again, hopeful or sullen or fearful as the evidence might trend. . . .

Down-stairs we find the courts, and these seen, we traverse long refectories, long aisles of tables, and close-packed dormitories with banks of steel mattresses, tier above tier, and galleries and passages innumerable, perplexing intricacy that slowly grows systematic with the Commissioner's explanations.

Here is a huge, gray, untidy waiting-room, like a big railway-depot room, full of a sinister crowd of miserable people, loafing about or sitting dejectedly, whom America refuses, and here a second and a third such chamber each with its tragic and evil-looking crowd that hates us, and that even ventures to groan and hiss at us a little for our glimpse of its large dirty spectacle of hopeless failure, and here, squalid enough indeed, but still to some degree hopeful, are the appeal cases as yet undecided. In one place, at a bank of ranges, works an army of men cooks, in another spins the big machinery of the Ellis Island laundry, washing blankets, drying blankets, day in and day out, a big clean steamy space of hurry and rotation. Then, I recall a neat apartment lined to the ceiling with little drawers, a card-index of the names and nationalities and significant circumstances of upward of a million and a half of people who have gone on and who are yet liable to recall.

The central hall is the key of this impression. All day long, through an intricate series of

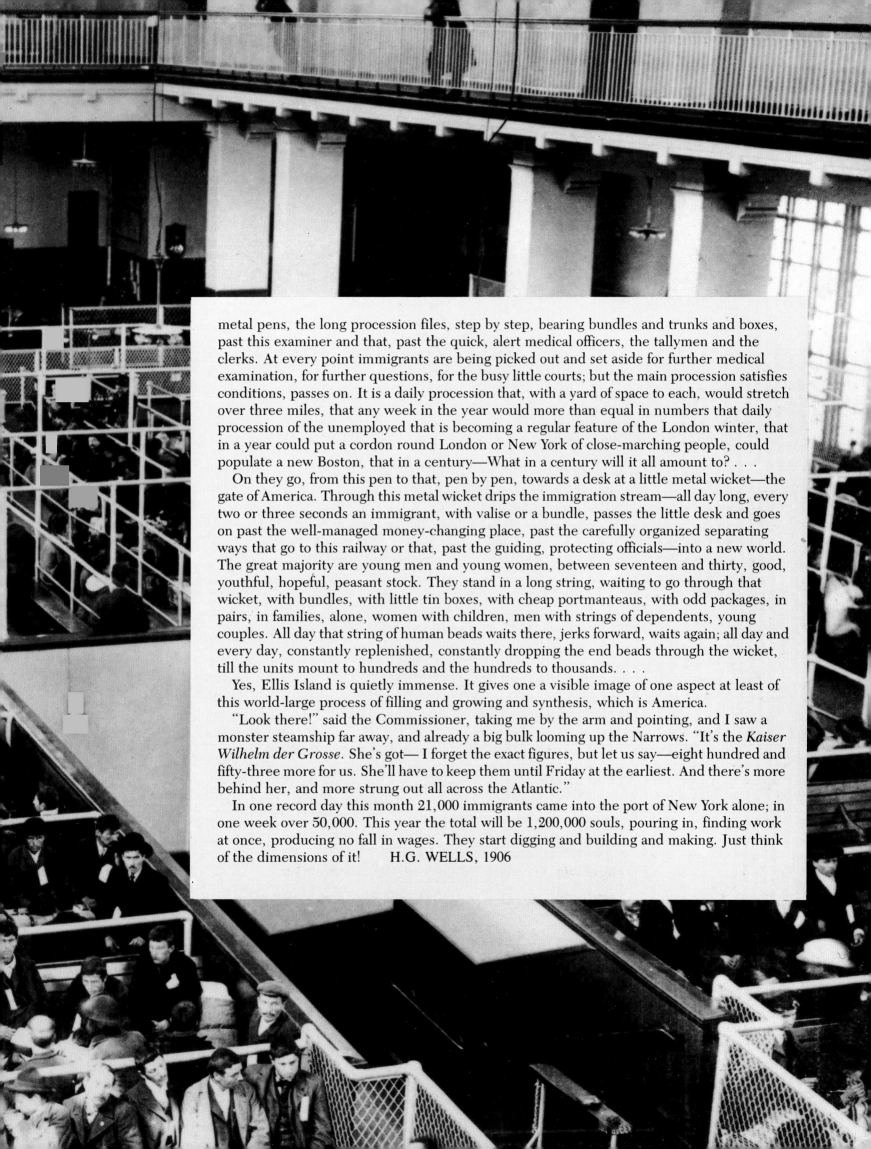

metal pens, the long procession files, step by step, bearing bundles and trunks and boxes, past this examiner and that, past the quick, alert medical officers, the tallymen and the clerks. At every point immigrants are being picked out and set aside for further medical examination, for further questions, for the busy little courts; but the main procession satisfies conditions, passes on. It is a daily procession that, with a yard of space to each, would stretch over three miles, that any week in the year would more than equal in numbers that daily procession of the unemployed that is becoming a regular feature of the London winter, that in a year could put a cordon round London or New York of close-marching people, could populate a new Boston, that in a century—What in a century will it all amount to? . . .

On they go, from this pen to that, pen by pen, towards a desk at a little metal wicket—the gate of America. Through this metal wicket drips the immigration stream—all day long, every two or three seconds an immigrant, with valise or a bundle, passes the little desk and goes on past the well-managed money-changing place, past the carefully organized separating ways that go to this railway or that, past the guiding, protecting officials—into a new world. The great majority are young men and young women, between seventeen and thirty, good, youthful, hopeful, peasant stock. They stand in a long string, waiting to go through that wicket, with bundles, with little tin boxes, with cheap portmanteaus, with odd packages, in pairs, in families, alone, women with children, men with strings of dependents, young couples. All day that string of human beads waits there, jerks forward, waits again; all day and every day, constantly replenished, constantly dropping the end beads through the wicket, till the units mount to hundreds and the hundreds to thousands. . . .

Yes, Ellis Island is quietly immense. It gives one a visible image of one aspect at least of this world-large process of filling and growing and synthesis, which is America.

"Look there!" said the Commissioner, taking me by the arm and pointing, and I saw a monster steamship far away, and already a big bulk looming up the Narrows. "It's the *Kaiser Wilhelm der Grosse.* She's got— I forget the exact figures, but let us say—eight hundred and fifty-three more for us. She'll have to keep them until Friday at the earliest. And there's more behind her, and more strung out all across the Atlantic."

In one record day this month 21,000 immigrants came into the port of New York alone; in one week over 50,000. This year the total will be 1,200,000 souls, pouring in, finding work at once, producing no fall in wages. They start digging and building and making. Just think of the dimensions of it! H.G. WELLS, 1906

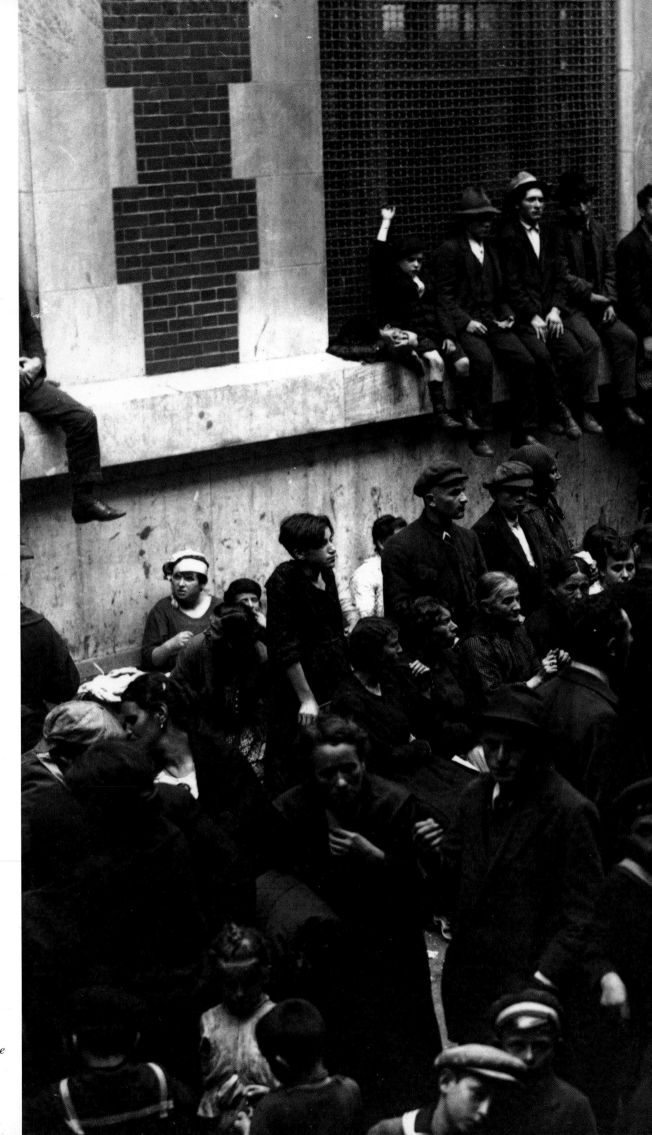

*Newly arrived immigrants
congregate outside the main
building at Ellis Island in the
fall of 1920.*

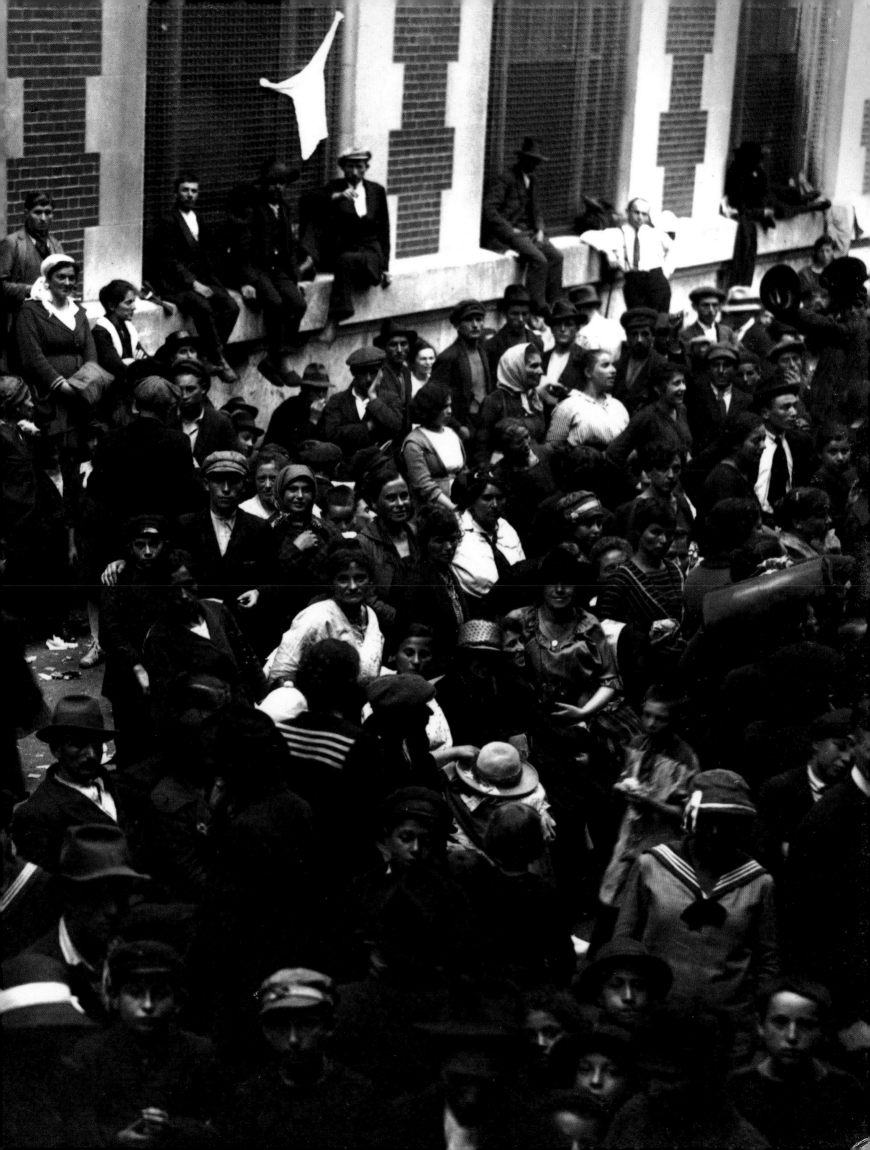

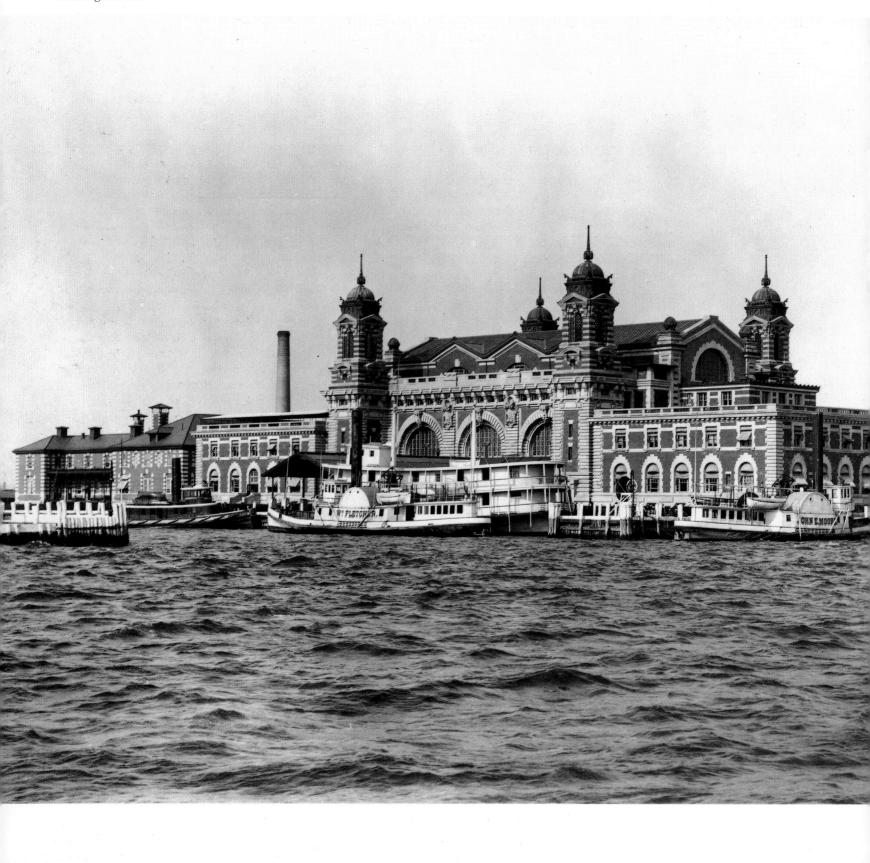

*Ferryboats which picked up
and discharged immigrants
line up at the slip in front of
Ellis Island's main processing
building in 1905.*

Welcome: The Immigrants Arrive

By NORMAN KOTKER

They were tired. They were poor. After sailing across the ocean for ten or fifteen or twenty-two days, huddled below deck in cramped and fetid steerage quarters, they were yearning to breathe free. They—or their relatives who had already emigrated to America—had hoarded enough money to purchase a steerage-class ticket on a ship sailing across the Atlantic. Plus enough money to pay for the long journey to the port of embarkation. Plus more money to pay the bribes and official charges required for crossing borders. Plus money to show the inspectors at Ellis Island. Stories circulated that the land of the free required a small fortune to enter; in some years it was twenty-five dollars. And now, having been off-loaded from the ship on which they had journeyed to America, they were standing, still huddled, on the deck of a barge or ferry which was going to take them to Ellis Island.

Between 1820 and 1920, some thirty million European immigrants arrived in the United States. Most of them came through the port of New York, and after 1892 most of these were funneled through Ellis Island. In the early years, most of the immigrants came from Ireland, Germany, and Scandinavia but in the years when Ellis Island was at its height, southern and eastern European immigrants predominated. Although they encountered some restrictions, they were generally welcomed until 1921 when quotas on immigration began. By 1927 only 335,000 immigrants, mostly from northern and western Europe, were allowed into the country and that figure was never exceeded in subsequent years.

But in the year 1906 when activity at Ellis Island was at its height, 1,100,735 immigrants arrived in America. One of them was my maternal grandmother who traveled from the province of Kovno in Russian Lithuania with two small children in tow. Her husband, my grandfather, had come over a few years earlier, fleeing Russia to escape being drafted into the Czar's army where the enlistment period was thirty years and Jews like him were forced to abandon their religion. To comfort him in the strange new land, he had carried along a photograph of his wife and children. It showed a pretty, slender young matron in a long gown, with a plump little girl standing at her knee and a

baby boy beside her, perched on a column, the photographer's studio prop. Now they were coming to America too. Somehow they got to Rotterdam from Lithuania, and from Rotterdam they booked steerage passage to America.

For immigrants headed for Ellis Island, the trip across the ocean in steerage was always terrible. Shipping-line advertisements promised a six-day trip on a fine ship, "including a plentiful supply of cooked provisions." But often a week passed before the ship managed to labor halfway across the Atlantic and the cooked provisions were scarcely edible: soggy rye bread and a barrel of herring for the Slavs, Swedes, Germans, and Jews traveling on the northern routes; sardines and soggy wheat bread for the Italians, Greeks, and Armenians who came via the Mediterranean. Wise immigrants packed sausages and loaves of brown bread for themselves or, as one Hungarian immigrant later recalled, "a wicker basket with roast chicken and cookies and apple strudel." The cost of the ticket was around thirty-five dollars. Children paid half price and infants traveled free.

Steerage quarters below deck were horribly crowded with hundreds, sometimes even thousands of immigrants in a room only six or eight feet high, divided down the middle by a blanket hung on a rope to separate the men from the women and children. With no portholes, little ventilation, and skimpy and carelessly maintained toilet facilities, the smell was appalling. Most passengers didn't wash; the few who did had to brave the cold ocean water that ran from faucets in the steerage washroom. Many passengers believed that eating garlic on bread warded off seasickness. That made steerage even smellier. Even on easy passages—and most journeys took place during the calm spring or summer months—many were seasick. "I couldn't lift my head for four days," a Czech immigrant later recalled. "I thought I would never see the United States." In good weather children could play on deck, running among the young people who sat there singing and flirting with each other. But when, as so often happened, the weather turned bad and the immigrants were indeed tempest-tost, they were unable to get up onto the deck to vomit overboard. In stormy weather the steerage hatchway door was locked

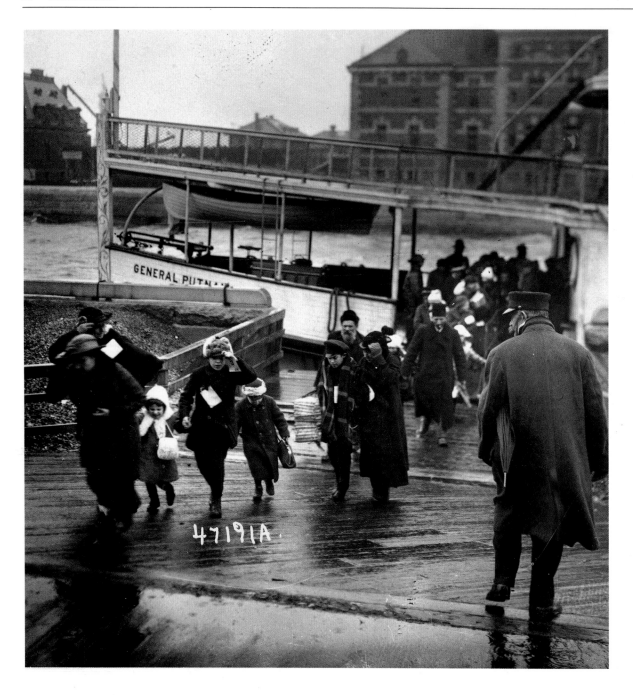

At a quarter to ten we steamed for Ellis Island. We were then marched to another ferry-boat, a floating waiting-room. We were crushed and almost suffocated. We could not move an inch from the places where we were awkwardly standing; babies kept crying sadly, and irritated immigrants swore at the sound of them. All were thinking—"Shall I get through?" "Have I enough money?" "Shall I pass the doctor?" At a quarter past eleven we were released in detachments. Every twenty minutes each and every passenger picked up his luggage and tried to stampede through with the party, a lucky few would bolt past the officer in charge, and the rest would flood back with heart-broken desperate looks on their faces. Every time they failed to get included in the outgoing party the emigrants seemed to feel that they had lost their chance of a job, or that America was a failure, or their coming a great mistake. At last, at a quarter past twelve, it was my turn to rush out and find what Fate and America had in store for me.

Stephen Graham, 1914

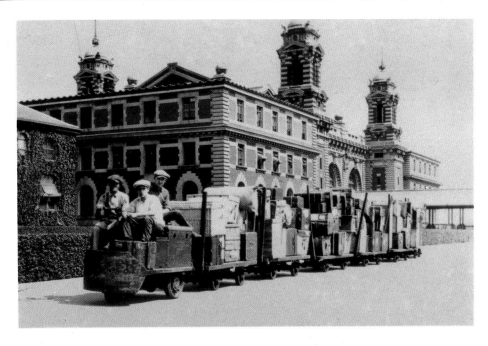

A group of Belgian refugees (left) disembark at Ellis Island in 1917.

Immigrants' baggage, stowed upon arrival on the ground floor of the main building, is transported by baggage handlers between 1915 and 1933.

and then tied shut as well, to make sure that no passenger reached the deck and got swept overboard. Since the only drinking water available was on deck, stormy weather brought thirst as well as seasickness.

Inside the steerage cabin there were bunks, two or three tiers high, equipped with meager mattresses populated by lice. Featherbedding brought from home made the bunks a little more comfortable. Women traveling with babies, as my grandmother did, made sure they got a lower bunk. They had to sleep with their arms around their children who might easily roll out of bed while the boat was rocking. They slept that way if they could, indeed, sleep at all. Beneath them the noisy engine was constantly pounding.

Eventually, however, the water calmed as the ship steamed into New York harbor. To prepare for landing, steerage passengers got dressed in their finest clothes. If they had two coats, they wore them both. That made less to carry. Women wore embroidered peasant costumes with three or four petticoats underneath and men put on the new derbies they had purchased especially for the journey. My grandmother probably wore the fine dress that she had been photographed in.

Eager to catch sight of the new land, steerage passengers hurried up on deck. In Europe they had heard of the Statue of Liberty, although many weren't exactly sure what it was. Some Italians believed that it was Columbus's tomb. Still, to all of them, the first sight of it was unforgettable. "You're looking at it and you're saying, 'Thank God, I'm free. I'm coming to a place where I can be free,'" one Armenian immigrant later recalled. "You really have to live through this to be able to realize what goes through your mind." What he had lived through

before coming to America was the murder of his parents, the kidnapping of his sister, and his own kidnapping and circumcision by Turks who intended to raise him as one of their own. Many other immigrants had stories equally horrifying.

From the harbor, the steamship sailed up the Hudson to a pier where first- and second-class passengers, native or immigrant, debarked. Their passage through immigration was quick and courteous (unless a keen-eyed observer from the Women's Christian Temperance League decided that one of them was a prostitute). While these passengers were being cleared, the steerage passengers were kept waiting. And waiting. Working a twelve-hour day, the Ellis Island staff could process five thousand immigrants. But some days, two or three times that number arrived and had to wait on board the ships they'd traveled in.

When the immigrants finally did debark, they were harshly commanded to hurry. Bulky in their layers of clothing, carrying infants, bedding, pots and pans, even cuttings from a home vineyard to transplant in America, they scrambled from the ship—Good riddance! Glad to leave it!—onto the barge or ferry that would transport them to Ellis Island. But then, before the barge moved, they were required to wait again, an enormous crowd of them, waiting one hour, two hours, or even much longer, standing without food or water—sometimes in the rain (when layers of clothing came in handy), sometimes in the sun during one of New York's terrible heat waves (when layers of clothing were a curse). And during all the hours they were waiting, there was plenty of time to worry: Will I get in? Will all of us get in, even the child who keeps rubbing her eyes? Were her eyes still red from the rubbing? What should they do if the child had to be returned? She couldn't be sent back alone. Impossible! But then they would all have to return to Europe, losing all the money that had been hoarded for the passage with little hope of ever amassing it again.

There was plenty of time to think these thoughts while the barge waited to cross Ellis Island and the child rubbed her eyes. "Stop rubbing the eyes!" Shouting would make the child stop for a minute but it would also make her cry which made her eyes even redder. While not obsessed with such worries, immigrants had

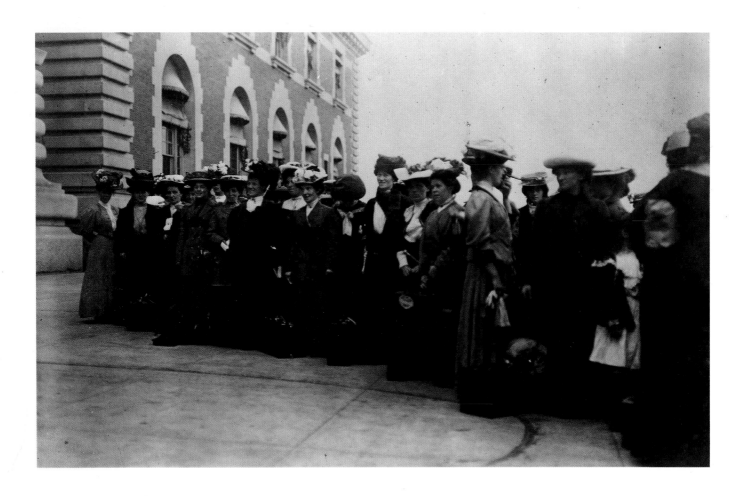

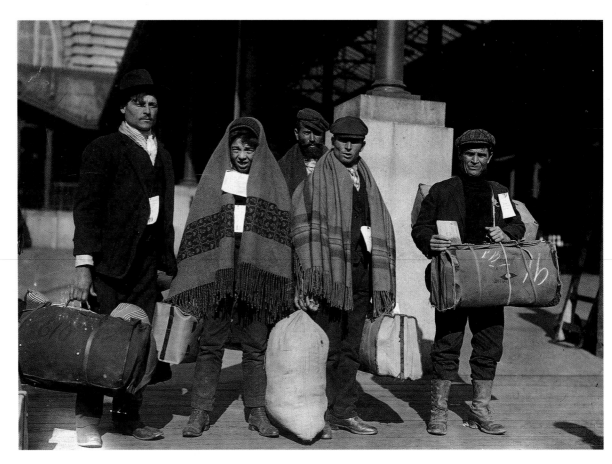

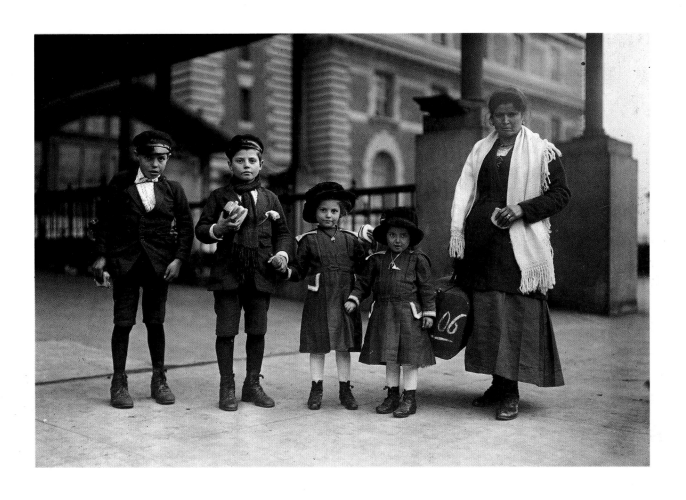

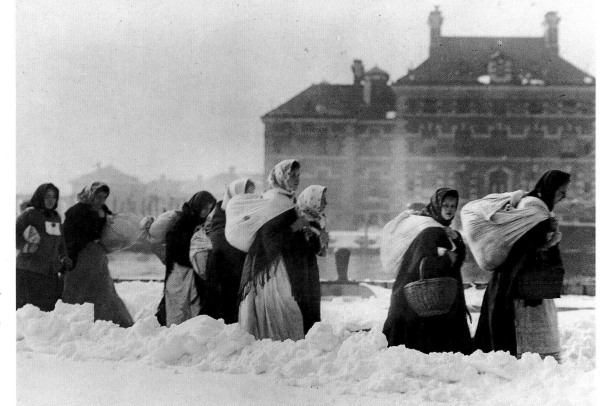

An Italian mother (above) and her children.

Slavic women (right), their belongings on their backs, arrive at Ellis Island in the winter of 1910.

Some of the "one-thousand marriageable women" (top left) who came to America on the Baltic in 1907.

Southern Italians (bottom left) wear their identification cards, which every immigrant needed in order to be processed.

plenty of time to rehearse their answers to the questions they knew would soon be asked of them. I am a tailor. I am a carpenter. My husband will meet me. No, I do not have a job waiting for me. I have twenty-three rubles with me. No, I did not buy my ticket myself, my uncle sent it to me. My uncle lives in Chicago.

Finally landing on the island, immigrants were lined up in front of the main door, to stand under an enormous metal canopy that was about fifty feet wide. It was oppressively large, like the immigration building itself, but on busy days immigrants filled all the space beneath it. Before sailing, the ship's crew had prepared lists detailing information about each of the passengers. Now these lists—called manifests— came into use. Immigrants waiting to enter the building were formed into groups by manifest number, thirty at a time since each manifest contained thirty names, and tagged with labels bearing their manifest numbers. If more than one immigrant ship had landed, the immigrants had a foretaste of America: Hungarians, Russians, and Swedes might have encountered each other on ships leaving Hamburg or Rotterdam; now they encountered Greeks and Italians as well.

Directly inside the entrance there was a stairway. Immigrants could leave heavy baggage on the ground floor while they went upstairs for processing. They deposited their baggage with a prayer for its safety; robberies had been known to occur. My grandmother left her bulky featherbedding there but she made sure that she herself carried her precious silver Sabbath candlesticks. Holding on to her daughter and carrying her son who was barely old enough to walk, she began climbing the stairway that led up to the immense Registry Room.

A great many prayers were recited on that stairway. God, the Virgin Mary, and various saints were implored to watch over the safety of the left luggage, to blind officials to the immigrants' flaws and open their eyes to the immigrants' virtues, to bring the immigrants to their final destinations. At the top of the stairway they could see a cluster of officials. The

A doctor uses a special instrument to turn back a young man's eyelid. He is looking for trachoma, a contagious, incurable, blinding eye disease that was the leading medical cause for deportation.

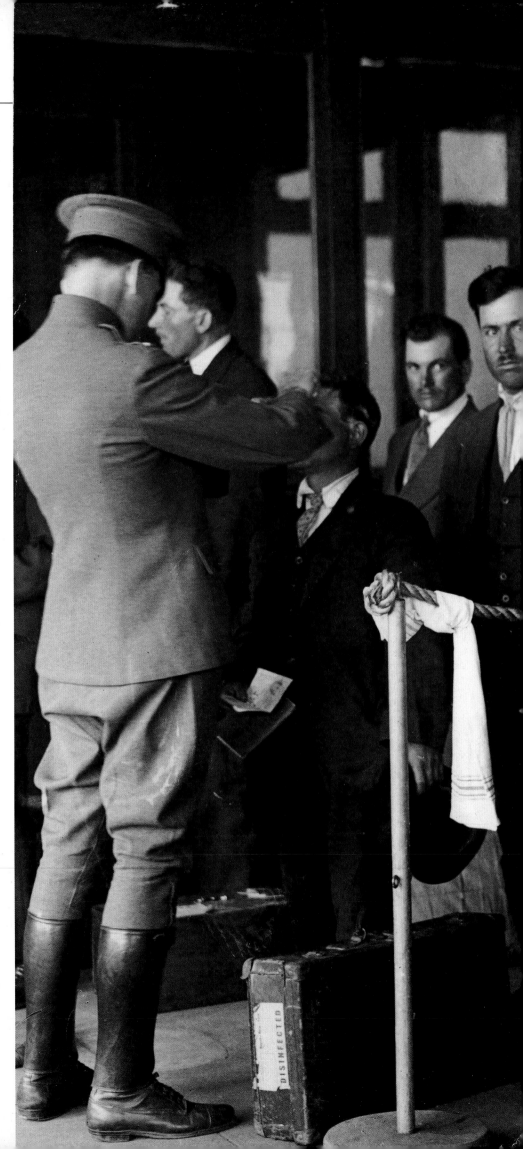

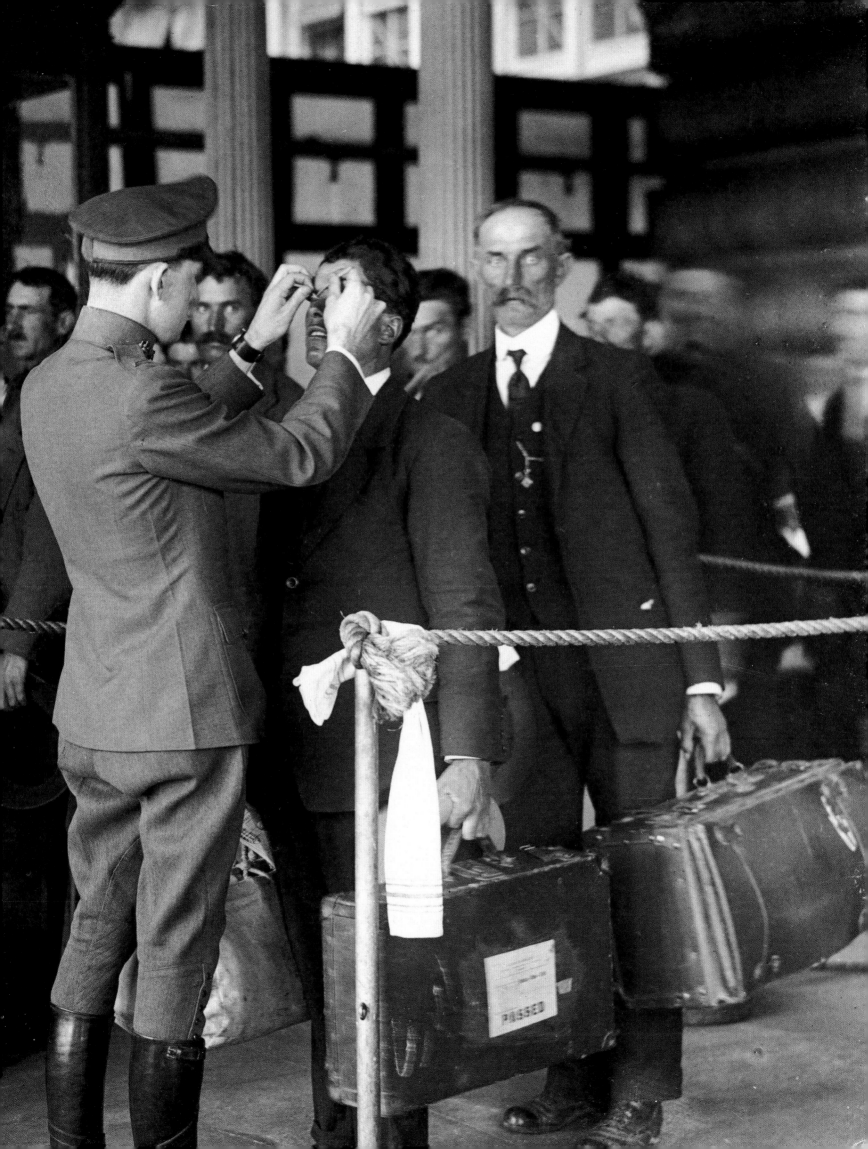

immigrants weren't aware of it but among them was a doctor who carefully watched the way they were climbing the stairs, keeping an eye out for any signs of weakness or illness which would later require a more thorough medical examination.

After a slow and laborious climb, the immigrants finally reached the Great Hall of judgment. It was a room more than fifty feet high and it was thronged with people moving slowly ahead along aisles separated from each other by iron railings. At the top of the stairs one of the officials, a man wearing a neat uniform and well shined shoes, stamped their identification cards and steered or sometimes shoved them into one of the iron-railed aisles. Here too there was a good deal of waiting while the immigrants ahead were being examined. In 1911 the iron railings dividing the room into aisles were replaced by benches on which the weary could sit; but when my grandmother went through, such comfort was unknown. Immigrants were told to walk ahead slowly toward the doctors who were examining them, keeping about ten feet apart from each other. Babies could be carried, but if a child had reached the age of two, he had to walk by himself to prove that he could. Bored with waiting, children chinned themselves on the iron bars. The three-year-old girl who was to become my aunt must have entertained herself by ducking in and out under the iron railings, despite orders not to. Three-year-olds are not easy to manage, and more than one child must have escaped control and gotten lost in the vast hall, disappearing as in later years many would disappear in America itself.

As my grandmother walked slowly toward the doctor, she was carefully inspected to make sure that her gait was steady and that her demeanor seemed normal. The United States had no desire to admit, and later support, foreign cripples or lunatics. At the end of the aisle the railing turned right, which allowed the doctor to observe her in profile. But before she was allowed to proceed further, her two children had to undergo a scalp inspection. Their hats were taken off and their hair was rumpled to reveal their scalps. Of course they disapproved of this procedure; they must have responded to it by crying or squirming, thus informing the doctors that they were healthy, normal children.

Occasionally the line slowed to allow one of the doctors to take a closer look at what might turn out to be a problem case. Doctors thumped chests, inspected skin and fingernails (bluish nails might indicate heart trouble), and listened for hoarseness or labored breathing. As the immigrants moved forward, they saw standing directly in front of them the American they feared most, the eye doctor. When they reached his post, their eyes widened with anxiety. The doctor quickly reached over and everted their eyelids with his fingers or with a small instrument to check for trachoma. If he saw any indications of the disease—granulations under the eyelid which would eventually scar the cornea and cause blindness—he marked an *E* on the immigrant's clothing with a piece of chalk. *E* for eyes. That meant certain rejection.

As the immigrants slowly walked past the doctors, other chalk marks appeared on them from time to time. Cryptic letters: *H, K, X, Sc.* An ominous sight, particularly for those immigrants—Jews, Russians, Armenians, and Greeks—who were unfamiliar with the letters of the English alphabet. Nobody but the doctors knew what these letters meant, although the guilty parties wearing them could usually guess. *K* meant hernia; *Sc* meant scalp disease; *H*, heart disease; *X*, mental abnormality.

Transporting immigrants was a very profitable business, with human freight being shipped westward across the Atlantic and cotton, wheat, or timber being carried eastward. But the shipping lines were required to take back any immigrant who wasn't admitted to the United States. Chalk marks cost them money. As the years went by, they began to keep a sharp eye out for possible rejects. This almost kept my father off the boat when, at the age of seven, he emigrated to the port of Boston in 1914. He had ridden by train halfway across Russia to reach a port of embarkation, and while riding had kept his cheek pressed against the train window so that he could watch the scenery passing by. As a result, he developed a rash on his cheek. His immigrant ship was the last one out of Russia before the outbreak of World War I and on boarding it his mother had to do some fast talking to convince the ship's officers that her boy wasn't infected with a serious disease.

Most immigrants got through the medical ordeal unmarked and moved on to the back of the

Detained at Ellis Island in 1950, an Italian father, with children in tow and a heavy briefcase filled with entry papers, strides through the dining hall. (Photograph by Alfred Eisenstaedt)

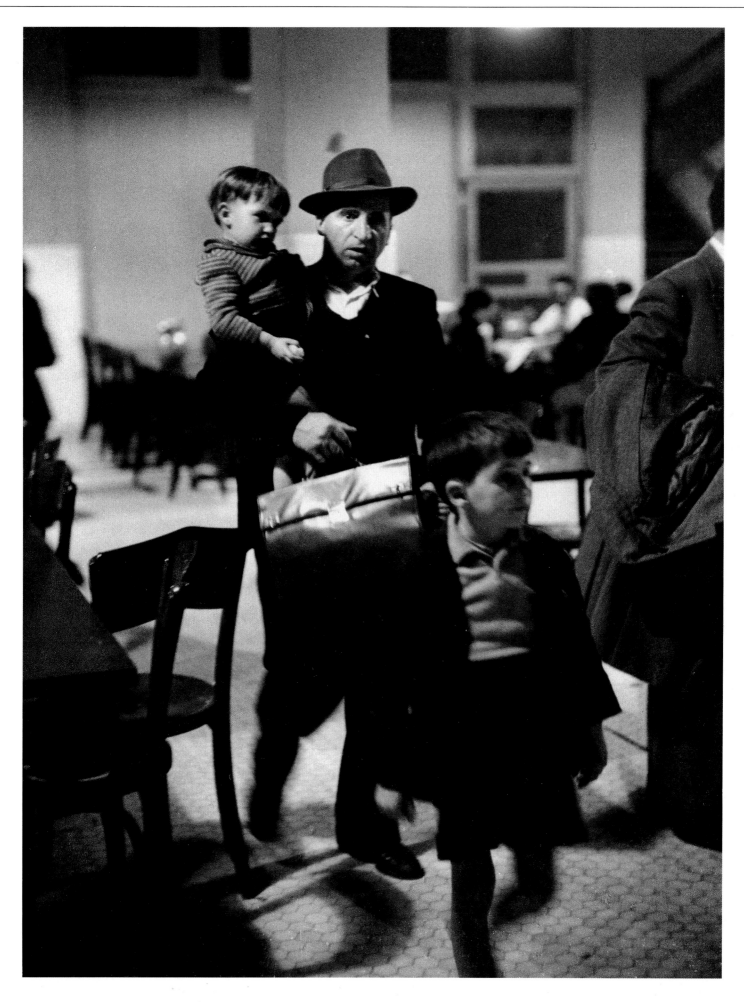

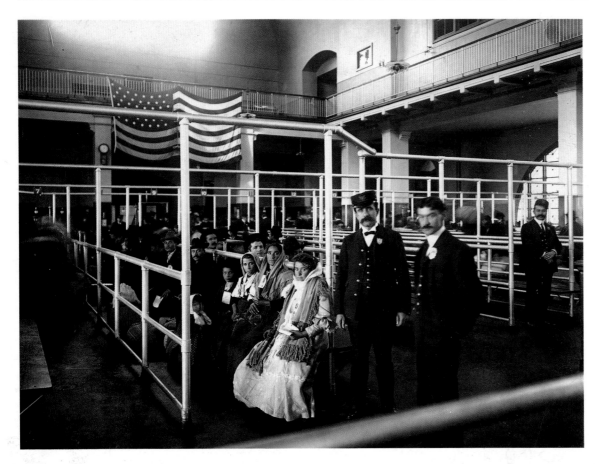

Immigrants, around 1905, wait their turn to be examined in the Registry Room (left).

In 1920, an inspector (below) questions a man to determine whether he is officially eligible to land.

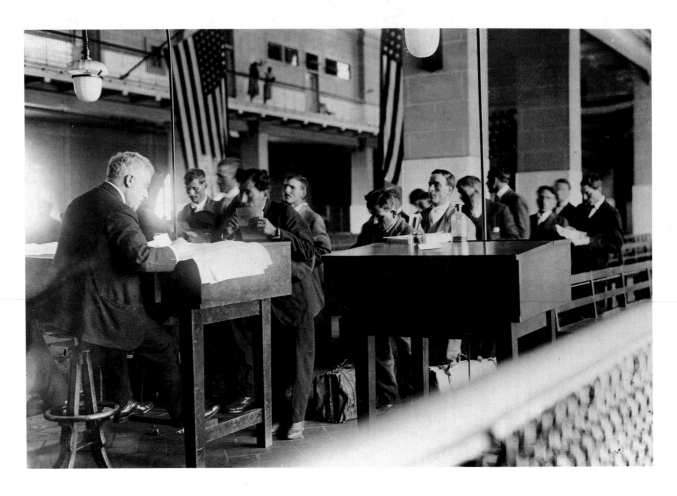

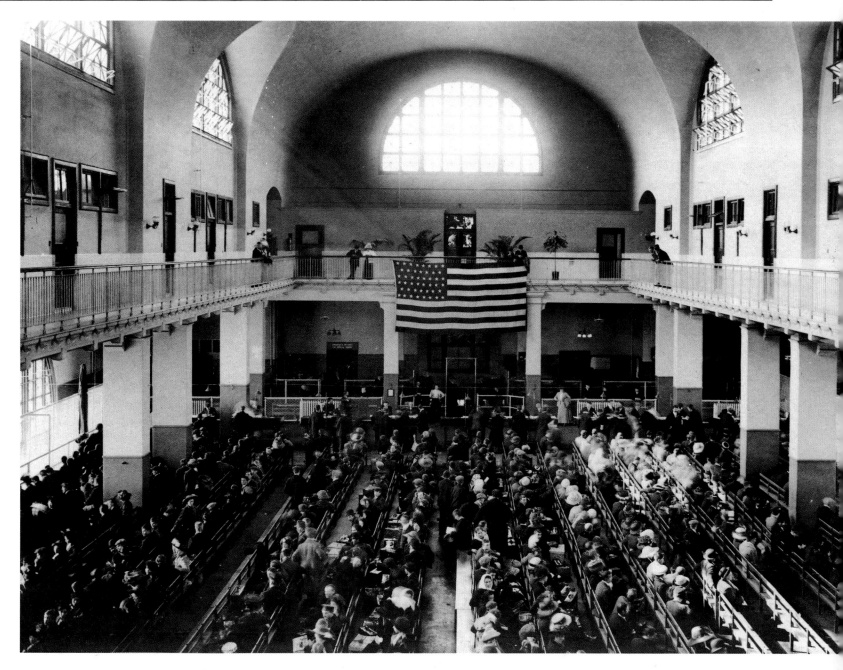

The Registry Room, around 1912, is filled with immigrants who sit on benches leading to the inspection desks. Though the actual questioning took minutes, immigrants often waited hours to be examined.

room. There, waiting for them at a desk under a great American flag, was the 'primary' inspector, the man who would finally give—or withhold—permission for them to go ashore. Here names were checked against those on the manifest. "Anna Kaplan!" My grandmother's name was called and the inspector watched her to see if she responded alertly. Anna Kaplan was a new name for her. In Europe she had been called Chana Kaplanas. Americans stubbornly hold on to the belief that immigrants' names were changed at Ellis Island; but such changes frequently took place at immigrant processing centers, located at European ports of embarkation. It was in Rotterdam and not at Ellis Island that Chana Kaplanas became Anna Kaplan. There too her three-year-old daughter, Sorekeh, probably became Sarah and her baby son, Boruch, became Benjamin, a change which would make life much

easier for him years later when he was attending Harvard.

The inspector or interpreter asked the immigrant a total of twenty-nine questions. My grandmother was asked her age and marital status and she was asked whether she could read and write. (In 1906, a simple yes or no sufficed. In later years a Yiddish text would have been held up for her to read to determine whether she was lying when she said yes.) She was asked her occupation and destination in America; and all her answers had to match the information that appeared on the manifest, information which she had already given when she boarded ship. If they didn't match, she was in trouble.

The most difficult of the twenty-nine questions was one that men often stumbled over: Have you got work waiting for you in the United States? The correct answer was *No*. The importation of

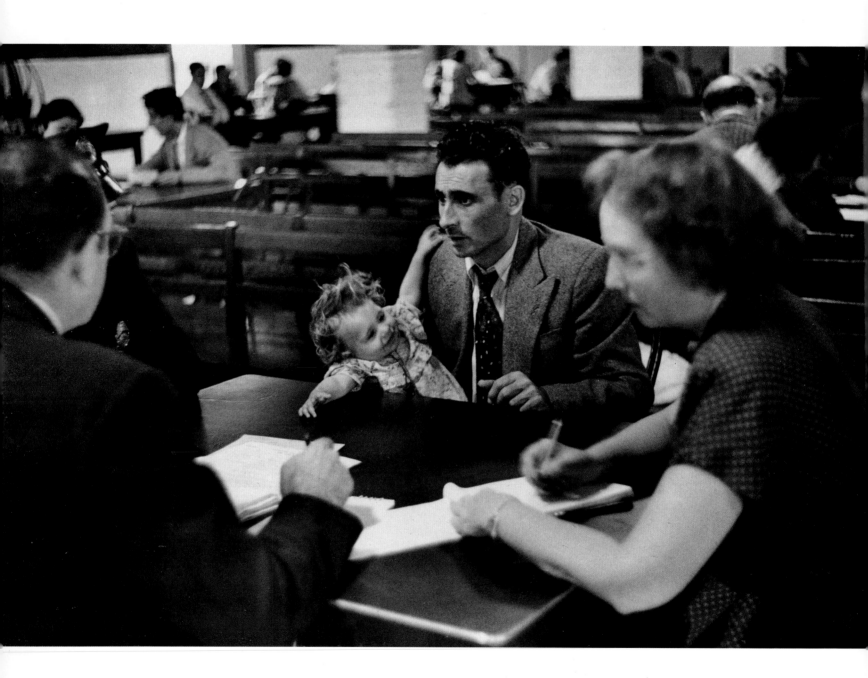

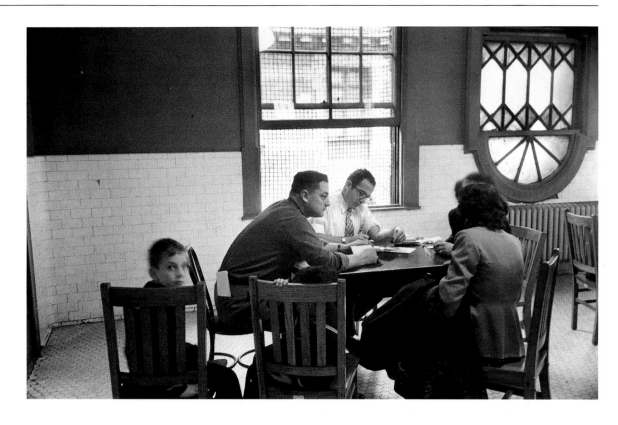

In 1950, aliens (above and left), displaced by World War II, are interrogated by an inspector-stenographer-interpreter team who ask a battery of questions about their finances and past political connections. (Alfred Eisenstaedt)

contract labor was illegal, and in April 1906 one thousand contract laborers were deported from Ellis Island. But men were always tempted to answer *Yes.* Relatives in America had assured them that jobs were available and easy to get. Many had even been promised employment. And men were eager to make it clear that they would be self-supporting and would not end up as public charges. It is no wonder that many men got flustered answering this question and were detained on the island until it became clear they hadn't been imported by a labor contractor.

After leaving the primary inspector, my grandmother went back to the baggage room to pick up her belongings. Then she proceeded to a room where a sign said MONEY EXCHANGE in English, French, Italian, German, and other languages. The money changer, securely guarded behind a diagonal grid of stout wire, stood in front of a blackboard on which current exchange rates were chalked. Before reformers and American Express took charge of this booth in 1902, the money changer had often been a shortchanger as well. But by 1906, when my grandmother went through, money changing was honest.

With their papers stamped at the primary inspector's desk, she and her children were now free to enter the United States. At this point some immigrants went outside the building to meet relatives who had been ferried over to the island on a United States Immigration Service boat. Or they themselves took a boat over to Manhattan where they could go directly on to the

El. The Second, Third, Sixth, and Ninth Avenue Els all started at the Battery. On the El, people must have stared at them because their clothing identified them as being right off the boat. When my father arrived in Boston, the relative who met him scooped off the European-style schoolboy's cap he was wearing—only greenhorns dressed like that!—and flung it into Boston Harbor. That sort of response was common and immigrants quickly abandoned their European clothing and tried to blend in with the crowd.

It's unlikely that my grandfather had managed to save up the $3.65 it cost to travel down to New York to meet his family, plus $3.65 more to buy a ticket for the return trip. So my grandmother and her children were probably shepherded by a Yiddish-speaking representative of the Hebrew Immigrant Aid Society toward the room where train tickets to Boston were sold. Italian and Polish immigrants, similarly adrift, were cared for by The Italian Welfare League or The Polish Society. Such organizations were necessary because the immigrants, like all travelers—even Marco Polo and Chaucer's Canterbury pilgrims—were easy marks. Lurking in wait for them were ersatz clergymen acting as shills for immigrant boarding houses; pimps trying to recruit solitary girls into an exciting, high-paying new career; guides who offered weary immigrants, frightened by the enormous alien city, a carriage ride to Grand Central Station for only fifty cents and then, after collecting their money, took them there by subway at a nickel a head.

Although eighty percent of the immigrants

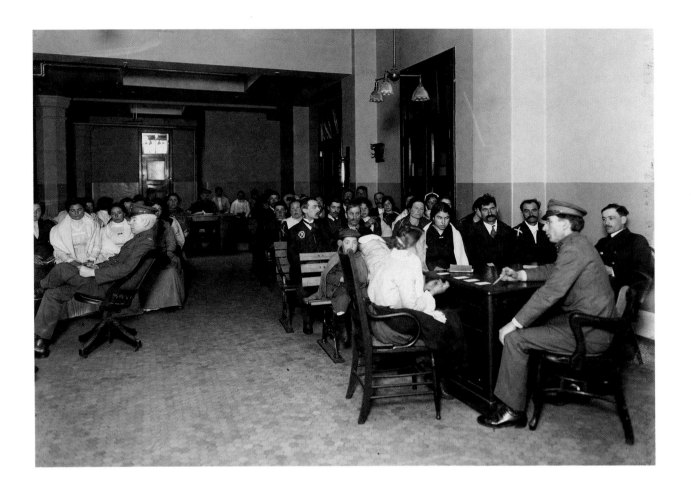

Having shown some sign of abnormal mentality during the routine medical inspection, a woman (above) is interviewed and given a psychological performance test in 1910.

In 1912, immigrant men (left) wait to have their eyes examined. Doctors have chalk-marked their shoulders with an X, the code for possible mental retardation.

The Board of Special Inquiry (right) questions a couple who have failed to satisfy the inspectors that they should be given entry to the United States. Though an immigrant could appeal the Board's decision, he faced deportation if the decision was not overturned.

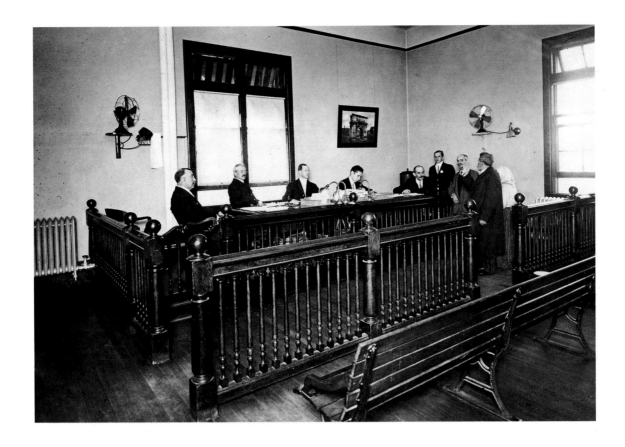

Two undersized old people stand before the commissioner. They are Hungarian Jews whose children have preceded them here, and who, being fairly comfortable, have sent for their parents so they can spend the rest of their lives together. The questions, asked through an interpreter, are pertinent and much the same as those already asked by the court which has decided upon their deportation. The commissioner rules that the children be put under a sufficient bond to guarantee that this aged couple shall not become a burden to the public, and consequently they will be admitted.

A Russian Jew and his son are called next. The father is a pitiable-looking object; his large head rests upon a small, emaciated body; the eyes speak of premature loss of power, and are listless, worn out by the study of the Talmud, the graveyard of Israel's history. Beside him stands a stalwart son, neatly attired in the uniform of a Russian college student. His face is Russian rather than Jewish, intelligent rather than shrewd, materialistic rather than spiritual. "Ask them why they came," the commissioner says rather abruptly. The answer is: "We had to." "What was his business in Russia?" "A tailor." "How much does he earn a week?" "Ten to twelve rubles." "What did the son do?" "He went to school." "Who supported him?" "The father." "What do they expect to do in America?" "Work." "Have they any relatives?" "Yes, a son and brother." "What does he do?" "He is a tailor." "How much does he earn?" "Twelve dollars a week." "Has he a family?" "Wife and four children." "Ask them whether they are willing to be separated; the father to go back and the son to remain here?" They look at each other; no emotion as yet visible, the question came too suddenly. Then something in the background of their feelings moves, and the father, used to self-denial through his life, says quietly, without pathos and yet tragically, "Of course." And the son says, after casting his eyes to the ground, ashamed to look his father in the face, "Of course." And, "This one shall be taken and the other left," for this was their judgment day.

Edward Steiner, 1906

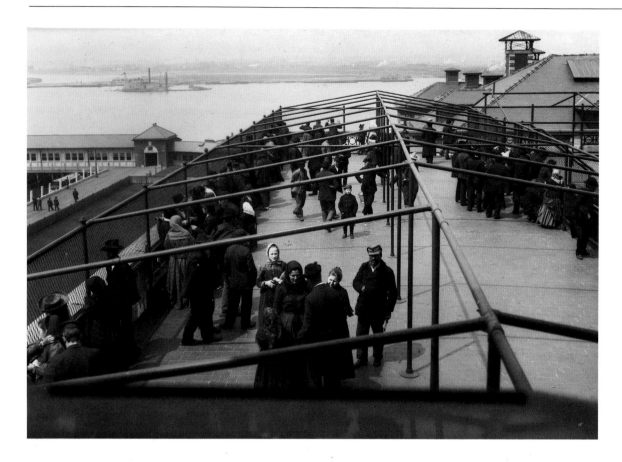

passed through Ellis Island quickly, one out of every five was sent to the detention pens to await further processing. Half of those detained weren't chalk-marked. They were merely waiting for funds to come from relatives or friends already in America. Those funds, or the responsible relatives themselves, usually arrived soon to liberate the detainees. If, however, after five days nobody had come to meet them, abandoned women and children were handed into the custody of one of the many missionary groups who watched over the island. Eventually they were permitted to make their way into America.

But the remaining ten percent were examined more closely by physicians or inspectors. Those who had been marked with an X received a not-very-rigorous intelligence test before an examining officer and an interpreter. On the examiner's desk were the tools of his trade, simple pictures and objects which would test the immigrant's mental acuity. Among them was a kindergarten-style form board, with holes of curious shapes cut into it and blocks which had to be fit into the holes. Woe to the immigrant who tried to fit a square peg into a round hole! He was either very retarded or a practicing anarchist. Either way he'd get deported. Inspectors particularly watched out for "stupid-looking" or "inattentive" immigrants. They were asked to add two and two. If they answered that correctly, they were given a more advanced mathematical

problem: Add four and four. Most X-marked immigrants were able to pass such tests and were admitted to the country.

Detainees were housed in dormitories that were almost as crowded and unpleasant as the steerage quarters they had just left. Under blankets smelling of disinfectant, they slept in three-tiered bunks that were infested with lice despite frequent delousings. A passageway only two feet wide separated the rows of bunks. In summer it was hellishly hot. A Russian who had been imprisoned in Siberia reported that conditions at Ellis Island were just as bad, although on the island he hadn't been beaten daily and the food was better. The food may have been plentiful, it may have tasted all right, but still, in the early years, it left much to be desired. The dining room was filthy and dinner bowls were used again and again without being washed. Finally, after 1901, Theodore Roosevelt reformed the island's administration and conditions were greatly improved.

"No charges for meals here" said a sign on the dining-room wall, and that comforting message was translated into numerous languages. The immigrants were fed well: They were served white bread which was a great novelty to many, tapioca pudding, and, most astonishing of all, bananas which they had to be taught to peel. Children who had been detained for a while and had become used to the place rushed into the dining hall as soon as it was open and grabbed a

Waiting and hoping: Around 1910, immigrants detained at Ellis Island try to pass the time on the roof of the main building.

In 1950, a young woman (right) sits apathetically in the Registry Room as she waits for her name to be called. (Alfred Eisenstaedt)

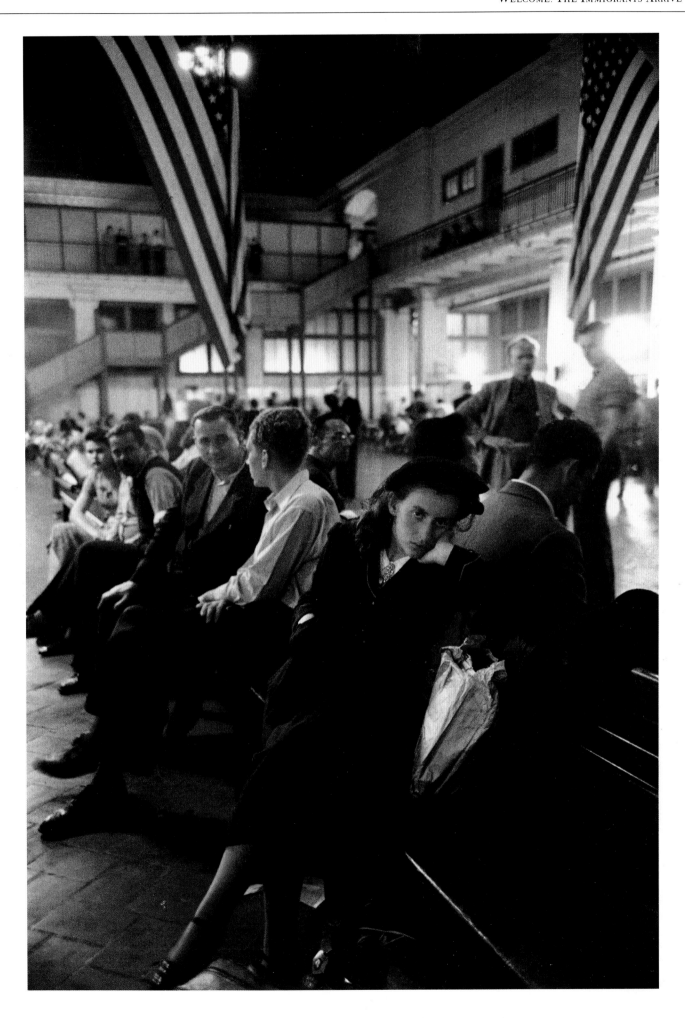

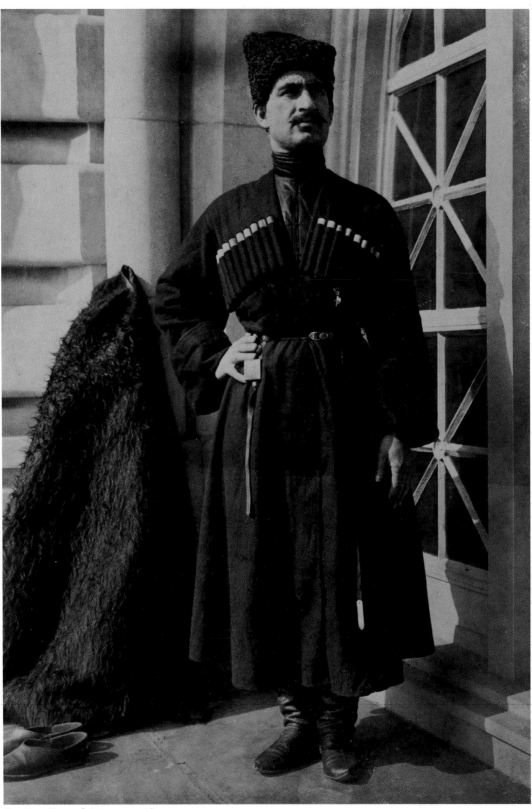

Russian Cossack (Augustus Sherman)

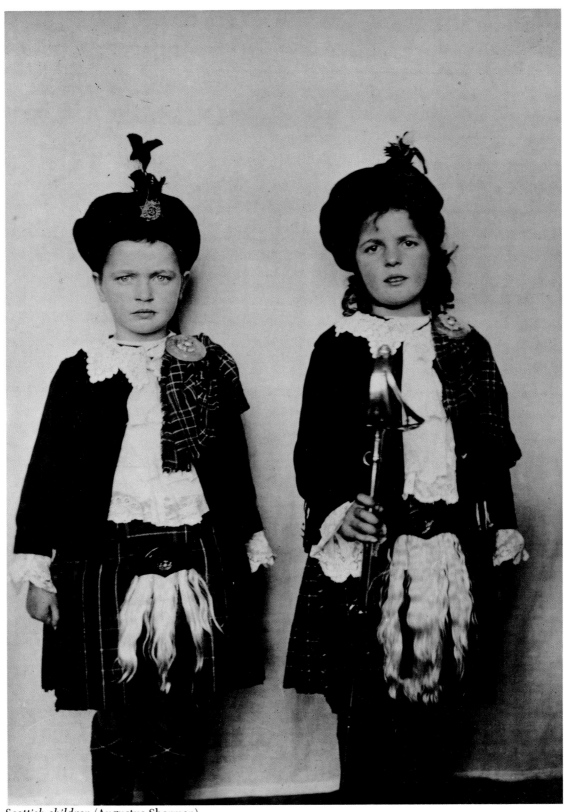

Scottish children (Augustus Sherman)

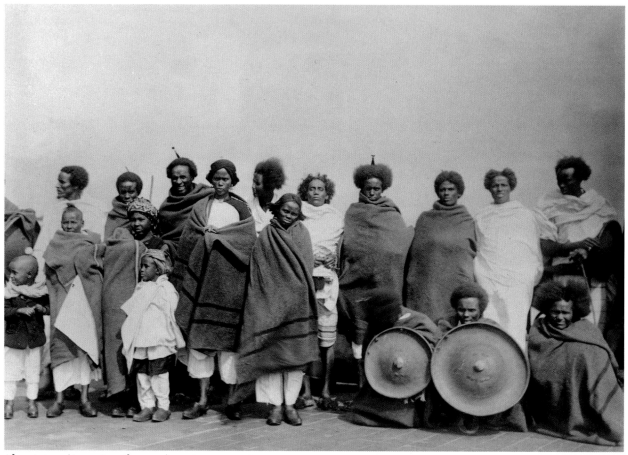

Abyssinians (Augustus Sherman)

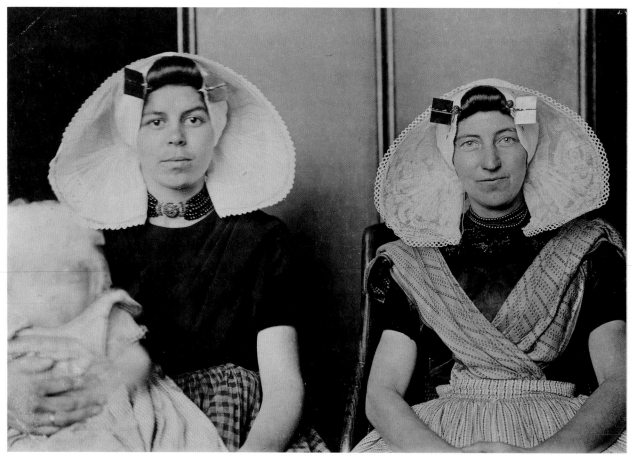

Dutch women (Augustus Sherman)

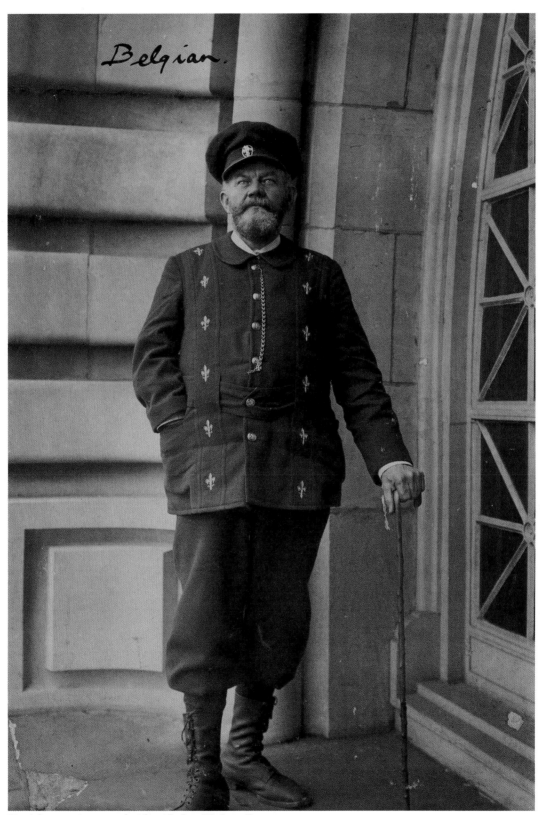

Danish man, incorrectly identified as "Belgian"
on the photograph (Augustus Sherman)

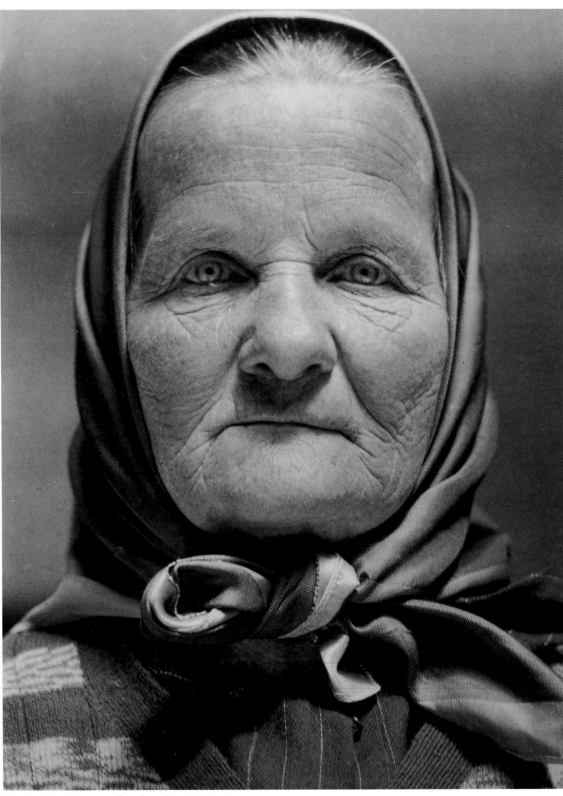

Czechoslovakian grandmother (Lewis Hine)

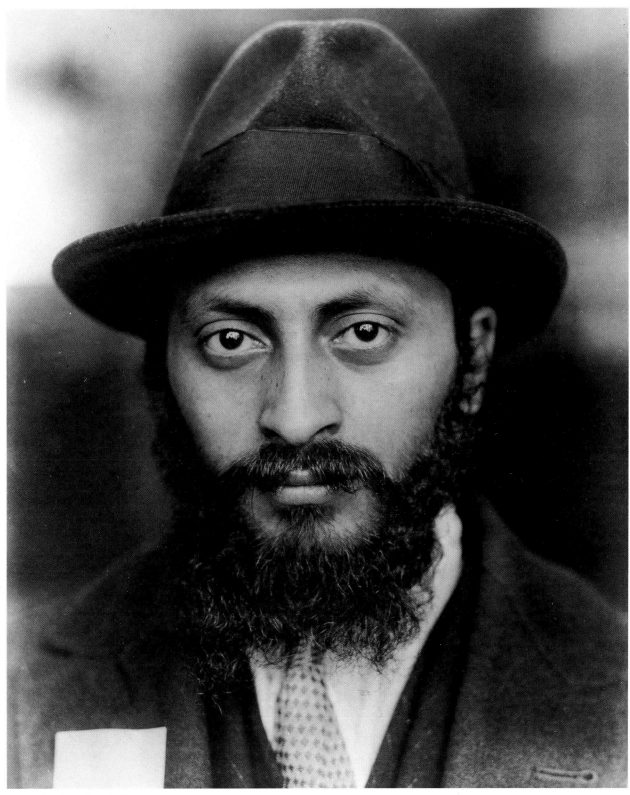

Armenian Jew (Lewis Hine)

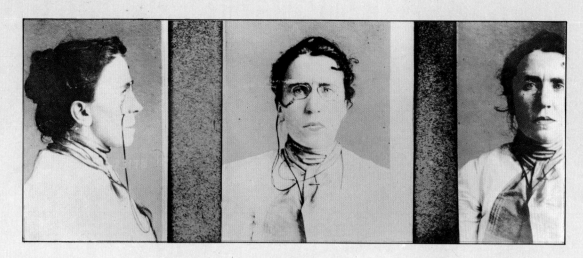

DEPORTED

At the very outset of this hearing I wish to register my protest against these star chamber proceedings, whose very spirit is nothing short of a revival of the Spanish Inquisition or the more recently defunct Third Degree system of Czarist Russia.

This star chamber hearing is furthermore a denial of the insistent claim on the part of the government that in this country we have free speech and a free press, and that every offender against the law—even the lowliest of men—is entitled to his day in open court and to be heard and judged by a jury of his peers.

If the present proceedings are for the purpose of proving some alleged offense committed by me, some evil or anti-social act, then I protest against the secrecy and third degree methods of this so-called "trial." But if I am not charged with any specific offense or act, if—as I have reason to believe—this is purely an inquiry into my social and political opinions, then I protest still more vigorously against these proceedings as utterly tyrannical and diametrically opposed to the fundamental guarantees of a true democracy.

Every human being is entitled to hold any opinion that appeals to her or him without making herself or himself liable to persecution. Ever since I have been in this country—and I have lived here practically all my life—it has been dinned into my ears that under the institutions of this democracy, one is entirely free to think and feel as he pleases. What becomes of this sacred guarantee of freedom of thought when persons are being persecuted and driven out for the very reasons for which the pioneers who built up this country laid down their lives?

And what is the object of this star chamber proceeding, that is plainly based on the so-called anti-anarchist law? Is not the only purpose of this law and the deportations en masse to suppress every symptom of popular discontent now manifesting itself throughout this country, as well as in all European lands? It requires no great prophetic gift to foresee that this new governmental policy of deportation is but the first step toward the introduction into this country of the old Russian system of exile for the high treason of entertaining new ideas of social life and industrial reconstruction. Today so-called aliens are deported, tomorrow native Americans will be banished.

Emma Goldman, Deportation hearing, 1919

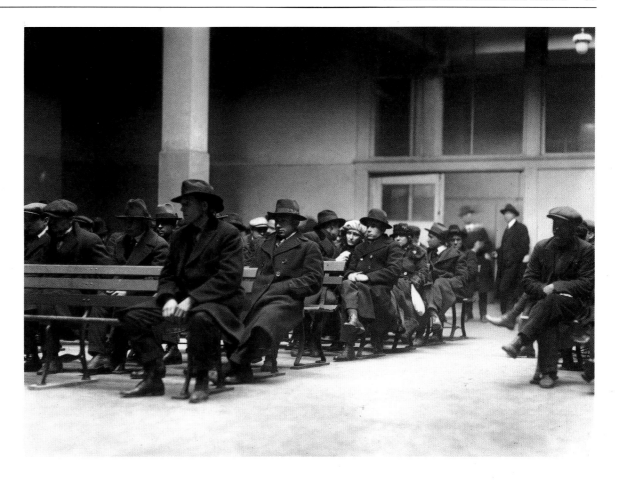

*"Reds" and radicals, detained
at Ellis Island in 1920 in
response to a growing national
hysteria about Communists
and Communist sympathizers,
wait to be deported.*

pages 40–41:
*Detainees at Ellis Island in
1949 get fresh air in the men's
exercise yard.*

cookie from each serving place at the long dining
tables. Though most of them weren't accustomed
to drinking milk, they learned that American
children had to drink it, whether they liked it or
not. Fortified with vitamin D, they were allowed
to go up to a playground on the roof of one
of the buildings and ride on a tricycle or a
rocking horse.

"Aliens have no inherent right to land on
American soil," the Ellis Island commissioner
William Williams had once declared. Detainees
were reminded of that statement when they
encountered island functionaries who were harsh
and impatient. "Cossacks!" the Jews called these
officials. "Turks!" Armenian and Greek
immigrants said of them. But most of the island's
officials were reasonably kind and most of the
detainees spent only an extra day or two at Ellis
Island before being allowed to cross the harbor
to America. Others, less fortunate, were held on
the island for days or even weeks until the
complications of their cases were unraveled.
Those with infectious diseases, those unmet by
the relatives they claimed were coming for them,
those suspected of being anarchists, criminals,
prostitutes, or contract laborers had to stay; and
sometimes they were deported back to where
they had come from. But there weren't many of
these. Of the more than one million immigrants
who arrived in 1906, only 12,432 were excluded.
For them and for the long-term detainees, Ellis

Island was a terrible place and it well merited
being called, as it sometimes was in the tabloids,
"The Island of Tears."

All detainees had the right to a hearing before
an appeals board made up of three officials. Their
major interest was not to turn away immigrants;
they wanted only to keep out people who might
end up costing the public money. When
immigrants went up before the appeals board,
they carried much anxiety along with their
papers. No friends, relatives, or lawyers were
permitted to attend the hearings and testify on
their behalf. The only support they seemed to
have came from the interpreter. Nevertheless,
the board was usually helpful rather than hostile
and most immigrants passed through.

After the outbreak of World War I in 1914,
immigrant ships stopped sailing to America.
Until the United States entered the war in 1917,
the island was almost empty, although a few
immigrants continued to be processed. The war
inspired a great campaign to round up and deport
alien prostitutes and pimps. But because the only
ships crossing the Atlantic were troopships and
war freighters, these un-American miscreants
had to stay on Ellis Island. They were joined by
two thousand German war prisoners and
numerous other aliens who had had the
misfortune to be caught committing crimes.
Between 1918 and 1920, hundreds of foreign-
born "Reds" were also interned there.

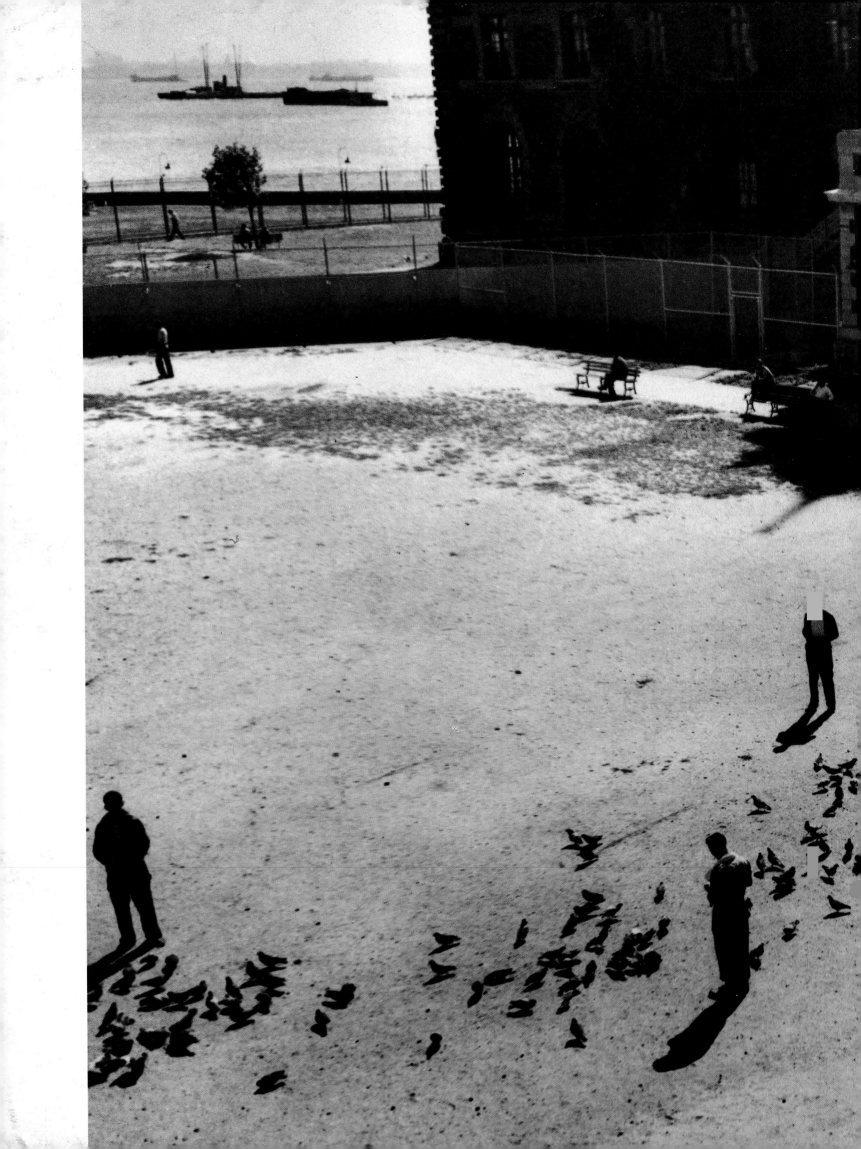

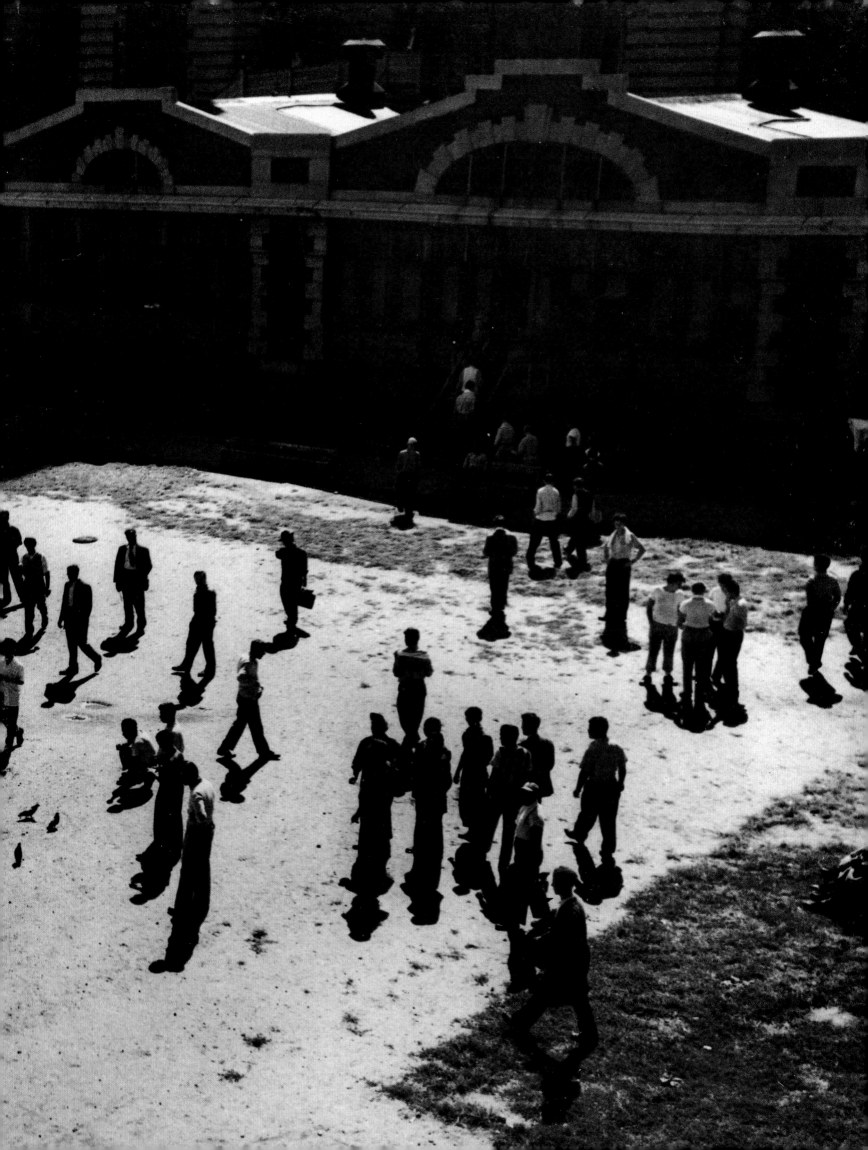

So when I came to Ellis Island, my gosh, there was something I'll never forget. The first impression—all kinds of nationalities. And the first meal we got—fish and milk, big pitchers of milk and white bread, the first time I saw white bread and butter. There was so much milk, and I drank it because we didn't have enough milk in my country. And I said, "My God, we're going to have a good time here. We're going to have plenty to eat."
Marta Forman, Czechoslovakian,
at Ellis Island in 1922

The country had become frightened of "Reds" and of foreigners in general. In 1917, immigration rules became stricter. Before being allowed in, immigrants now had to prove that they were literate. For a time, all men coming through the island had to unbutton their trousers to be examined for VD. So few cases were discovered that the practice was eventually discontinued. But delousing went on without interruption. Immigrants carried lice; lice carried typhus; typhus was endemic in some parts of Europe. Now a great many immigrants were stripped of their clothing just as they were to be stripped of their languages and nationalities. Their baggage and clothes were taken away to be disinfected. All they were left with was the papers in their hands.

By the twenties, after the golden door was slammed shut, the number of immigrants diminished greatly. By then the earlier immigrants had fanned out all across the United States, moving on to the slums, the sweatshops, the stockyards, to the coal mines, to the factories. It took America a long time to realize that the obscure steamships with forgotten names that had carried them over on their difficult journeys were as authentically historic as the Mayflower itself. By the time the country had come to recognize this, new waves of immigrants from Asia and Latin America began to arrive. The Ellis Island immigrants and their offspring had themselves moved onward, trading slums for suburbs; steerage crossings for Caribbean cruises; the halls of Ellis Island for city halls, state houses, and Congress; a European past for a new American life.

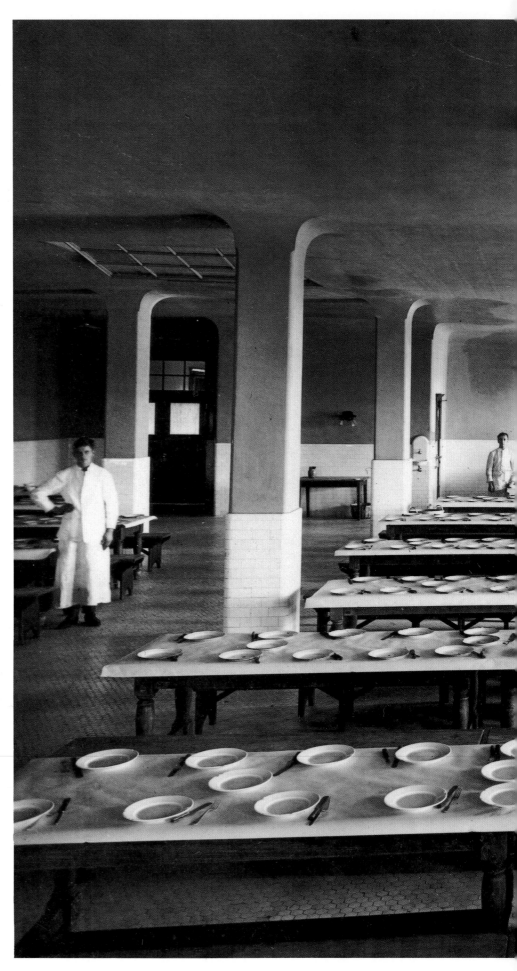

In the large dining hall, around 1910, immigrants were fed soups and meat, boiled vegetables and fruits, and bread. (Edward Levick)

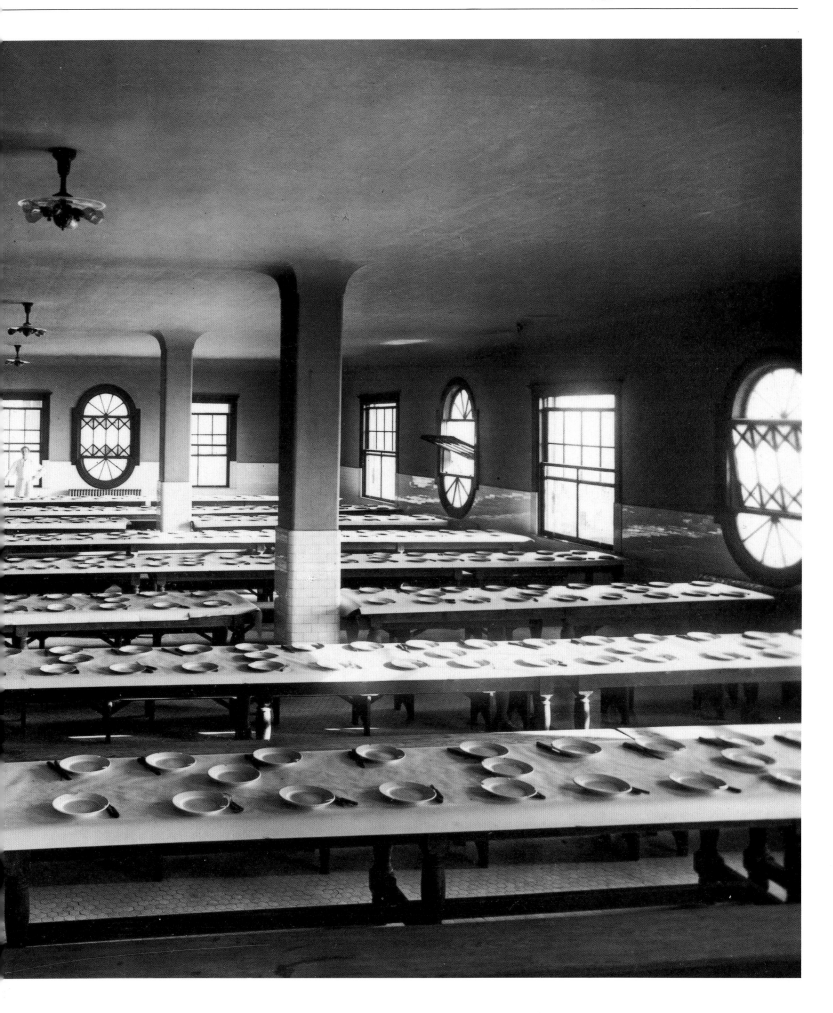

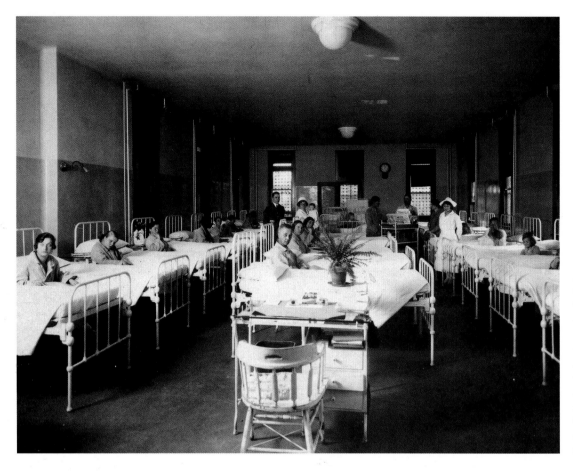

The Public Health Service Hospital (left) at Ellis Island, around 1923, provided care for immigrants suffering from disease, illness, and injuries.

Shirts (below) are dried and "pressed" in a men's dormitory room in 1932. (Erich Salomon)

Men (right) detained at Ellis Island in 1932 because of strict immigration regulations listlessly eat their noonday meal. (Erich Salomon)

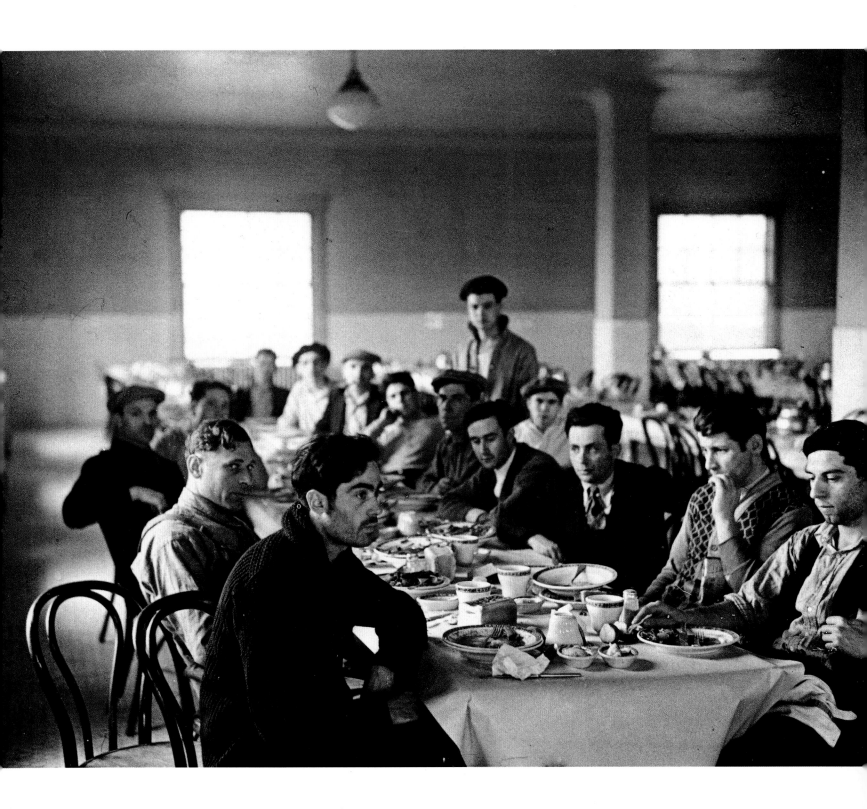

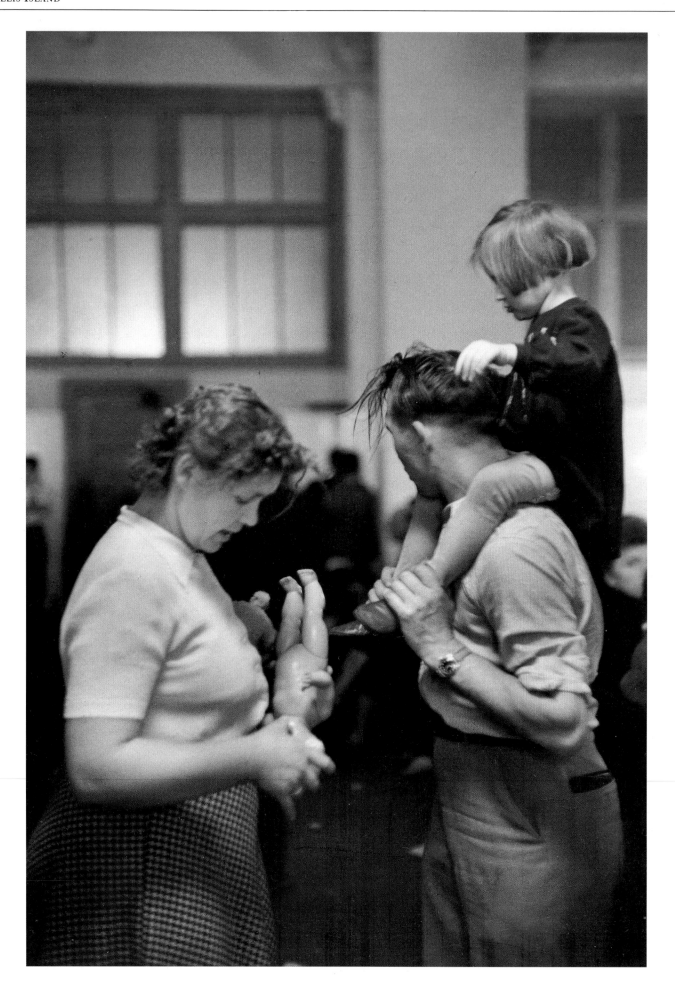

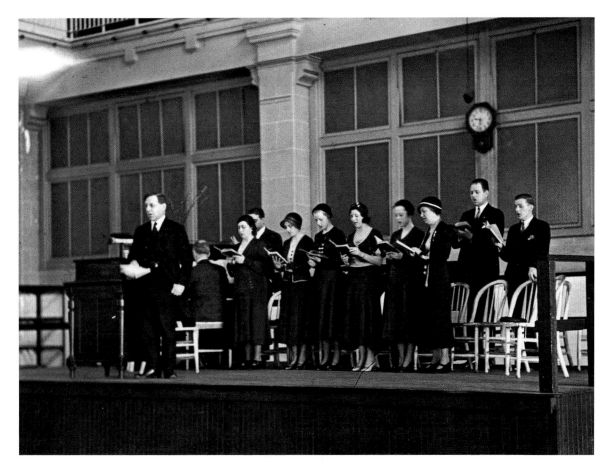

While awaiting disposition of their cases, a mother and father try to amuse their child in 1950 (left); and school-age "detainees" attend classes in 1947 (below). Volunteers (right) provide concert entertainment in 1932. (Alfred Eisenstaedt, left, and Erich Salomon, right)

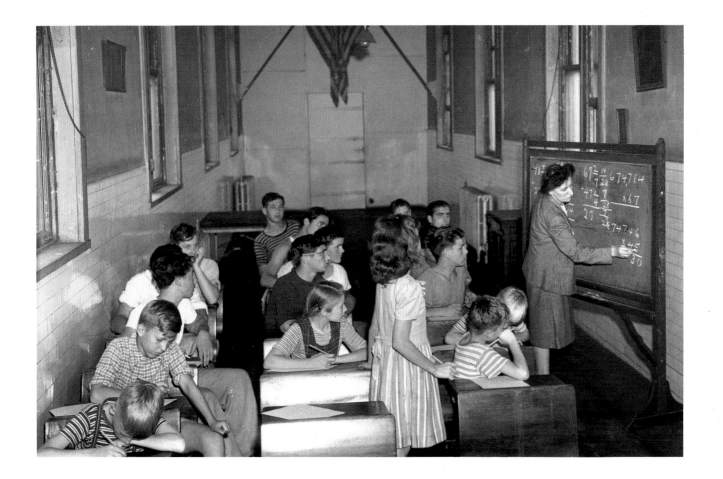

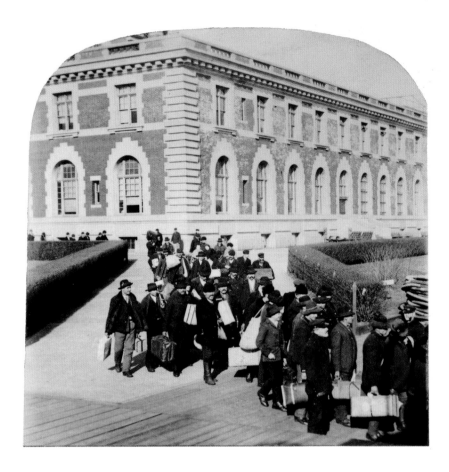

Prior to departure, an immigrant is fitted with clothes supplied by voluntary and charitable agencies (right). Those going to New York (left and below, right) head for the Ellis Island ferry which will deliver them to Manhattan's barge office. (Alfred Eisenstaedt, below, right)

The railroad ferries come and take their daily host straight from Ellis Island to the train, ticketed now with the name of the route that is to deliver them at their new homes, West and East. And the Battery boat comes every hour for its share. Then the many-hued procession—the women are hooded, one and all, in their gayest shawls for the entry—is led down on a long pathway divided in the middle by a wire screen, from behind which come shrieks of recognition from fathers, brothers, uncles, and aunts that are gathered there in the holiday togs of Mulberry or Division Street. The contrast is sharp—an artist would say all in favor of the newcomers. But they would be the last to agree with him. In another week the rainbow colors will have been laid aside, and the landscape will be the poorer for it. On the boat they meet their friends, and the long journey is over, the new life begun. Those who have no friends run the gauntlet of the boarding-house runners, and take their chances with the new freedom, unless the missionary or "the society" of their people holds out a helping hand. For at the barge-office gate Uncle Sam lets go. Through it they must walk alone.

Jacob A. Riis, 1903

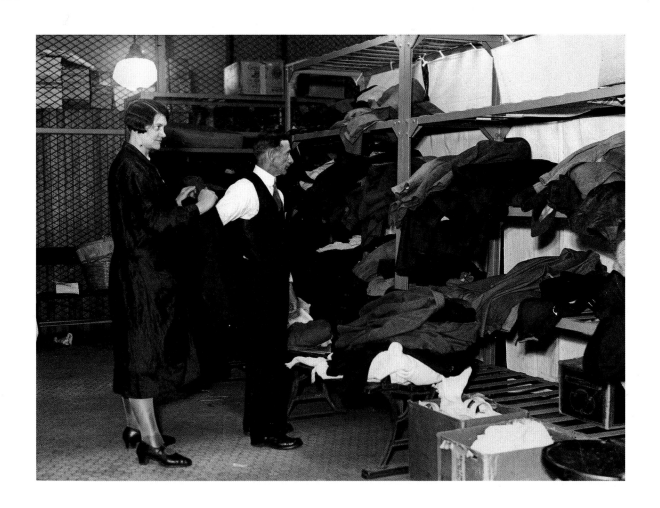

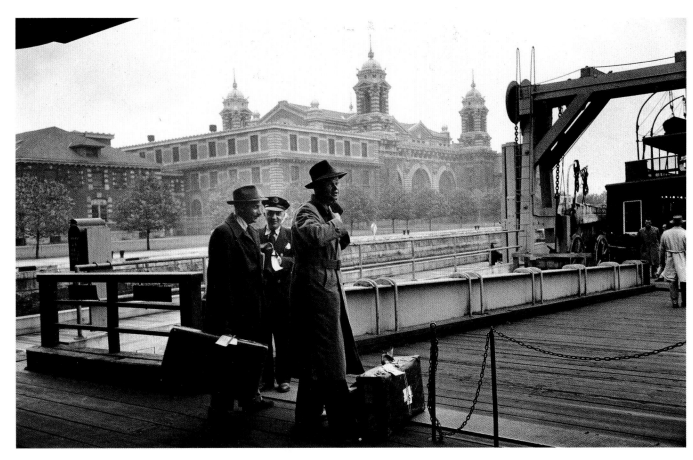

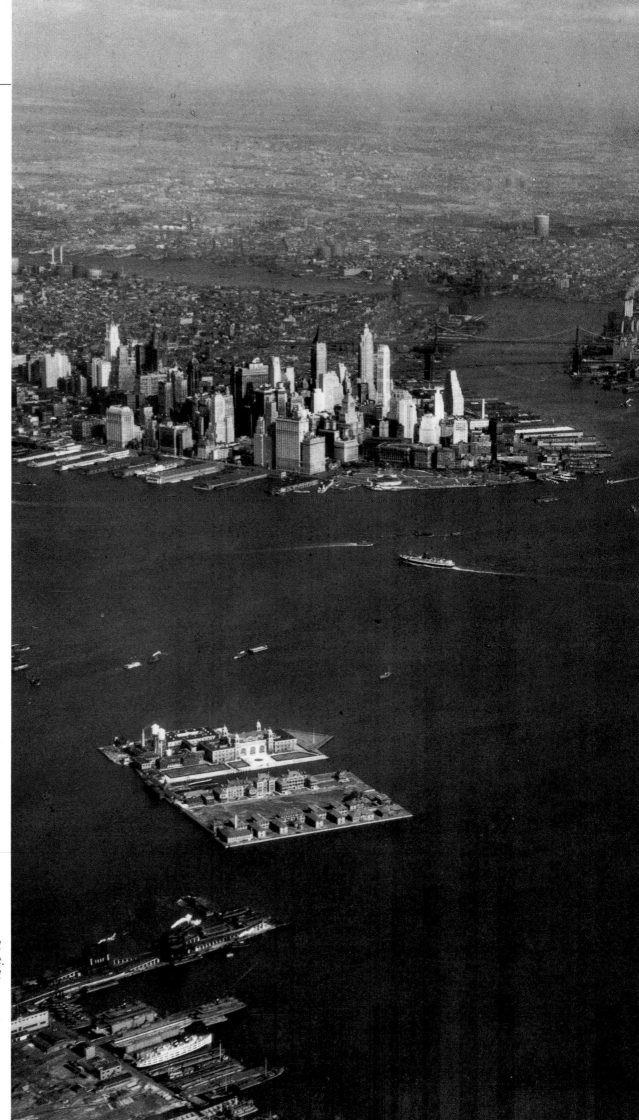

A 1932 aerial photograph shows Ellis Island at left and the Statue of Liberty at right. New York City, only one and one-quarter miles beyond Ellis Island, was the destination point for roughly one third of all the immigrants processed at the island.

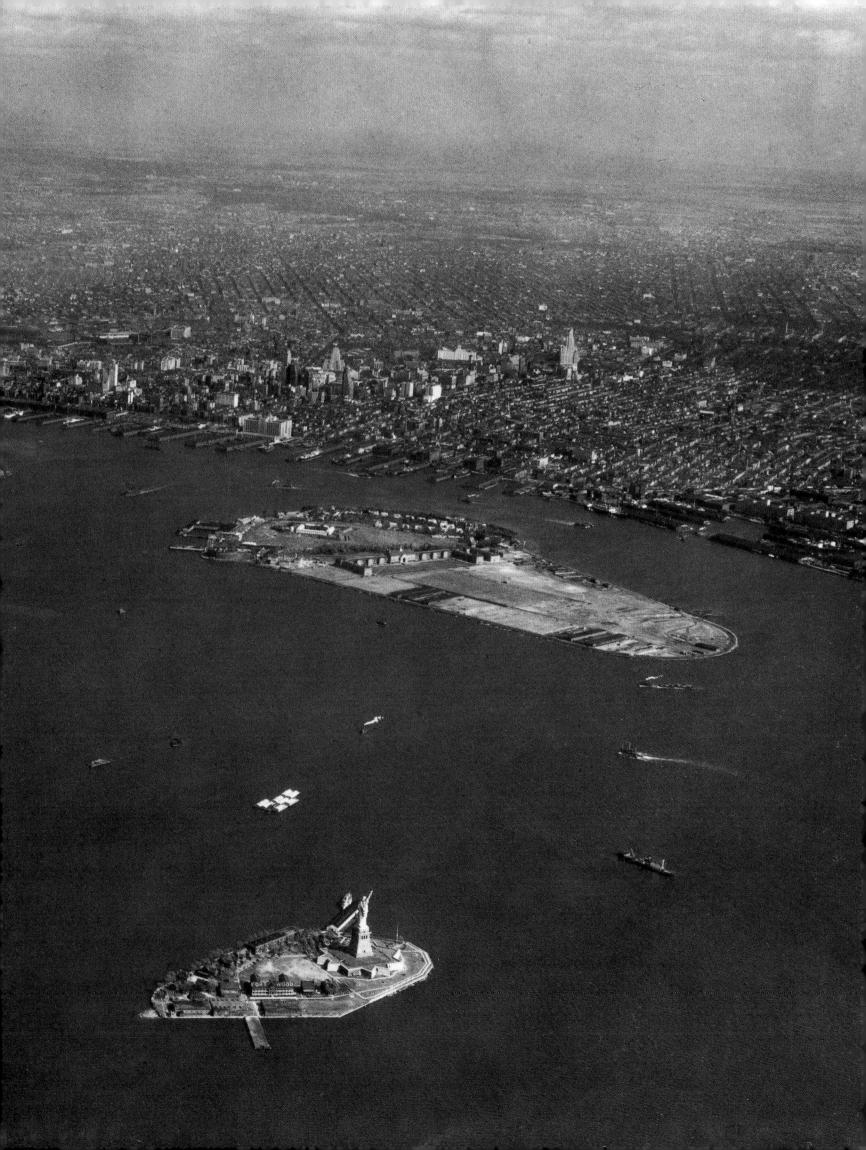

An Island Abandoned

By SHIRLEY C. BURDEN

I was born in New York City—lived there most of my life. Like many New Yorkers, I knew very little about my birthplace. I had only heard of Ellis Island, "The Gateway to America." It was an island in New York Harbor that people from other countries were obliged to visit before they were admitted to the United States.

At twenty, I went to Hollywood to seek fame and fortune in the motion-picture industry. From time to time, I would fly back to New York to visit my family. It was on one of these trips that Ellis Island entered my consciousness again. The cocktails had been exhausted, all the food eaten, the wine drunk, the movie slept through, and I was about to fascinate the lady next to me with witty conversation, when that one and only New York skyline came into view. Not far from the Statue of Liberty the setting sun outlined an island cloaked in blackness.

Several days went by before I decided to have a look at Ellis Island. I took the subway to The Battery, walked across Battery Park past the shell of the old aquarium, and stood at the water's edge. There it was, a pile of masonry, abandoned and forgotten. I was hooked. I had to have a closer look. But, how to get there?

I started walking up the West Side Highway past the docks, looking for a friendly boatman. My first encounter was with a policeman who was coiling rope on the stern of a police patrol boat. After the customary conversation about the weather and life in general, I told him I wanted to go to Ellis Island and take some pictures—would he drop me off sometime when he was patrolling the harbor? He said he couldn't, and asked whether I had permission to go there. That terminated the conversation rather abruptly.

My next stop was the immigration office at Columbus Circle. The office looked very much like a post office: lots of small windows with bored, uninterested faces looking out at long lines of frustrated people. At the last window there was a white-haired motherly type. The line was longer than the others, but I had a hunch she would be worth waiting for.

Once again, I told my story. The unexpected question confused and bothered her, but bureaucracy hadn't taken over completely. She hesitated. Official permission might be impossible, but if I could find a way of getting there, I might not have too much trouble when I arrived.

Next day I took the subway to Wall Street, walked over to the East River, and started my search. I walked and walked and walked, studying every boat as a possible means of transportation. I was about to give up when I saw a scow. Webster's dictionary has it: "A scow is a large boat with a flat bottom and square ends, chiefly used for freight and usually towed." My scow was not large, and it was not towed, although many times during our lengthy crossing I wished it had been. Somewhere, within its depths, there was a motor that propelled it, if you don't mind using "motor" and "propelled" loosely. On its deck was an object that looked like a telephone booth. Inside, a man, all 300 pounds of him, was sipping coffee.

Maneuvering myself down a very slippery ladder and across an equally slippery deck, I knocked on the booth door. The man opened it a crack—I don't think he dared open it more, or he would have flowed onto the deck—and asked what I wanted. Would he take me to Ellis Island? The look in his eye told me he would do anything for money. Before discussing it, further conversation was in order.

He offered me coffee, which was most welcome, since it was very cold and there was no room for me in the booth. I learned he earned his living by selling produce to the boats anchored in the harbor. After I had finished my coffee, I thought it was time for a business talk. How much to take me to Ellis Island? "Fifty bucks," he replied. I have never been much of a bargainer, but somehow I felt the time had come for me to have a try. We talked about hard times, how much everything cost, how bad business was, and then settled on twenty dollars for the trip. It was a decision I was later to regret.

The great day finally arrived. There wasn't any smog: they didn't have smog in those days. There wasn't any pollution either. A slightly tired head of lettuce, floating in the harbor, was a thing of beauty rather than something to have a Congressional investigation about. The sky was very blue, the sun very bright. It was crisp and cold. Even six o'clock in the morning didn't seem too early to start.

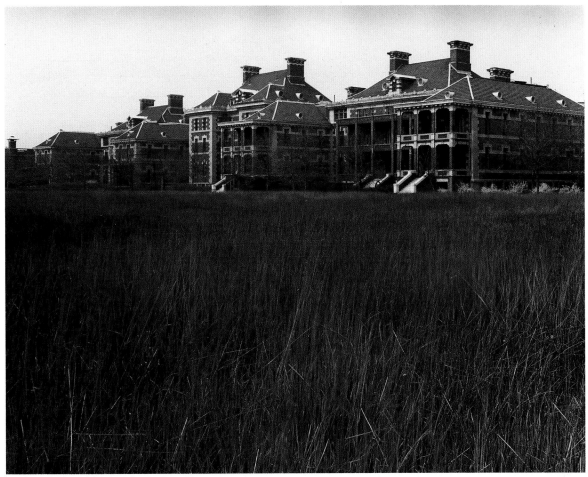

Shirley C. Burden, *Hospital buildings*, 1956

On any ordinary craft the trip to Ellis Island would take about ten minutes. We were still plowing through the waves a half hour after leaving the dock. This was the time it was worth being aboard the tortoise rather than the hare. If you haven't seen the New York skyline from a boat early in the morning, you haven't lived.

We finally arrived at the island and tied alongside the ferryboat *Ellis Island*. There was no one in sight. The lapping of the waves against the hull of the ferryboat was the only sound. The buildings stood there looking down at me as if to ask why I was disturbing their solitude.

It was some minutes before I turned to see what had happened to my boat. The deckhand had cast off. The boat was clear of the slip and about to take off for parts unknown. The captain opened the door of his "phone booth" and yelled at me. "I can't pick you up. I'm too busy." True, I had saved thirty dollars on the deal, but was it worth it? My friend at the immigration office had said she thought there was a caretaker on the island. I prayed she was right.

I started walking, where to I didn't know. At first, the pictures I saw were beautiful, then they grew sad. There was no guard, no baby's cry, no whispers of hope, no longing for liberty, just a

mute skeleton of the past. Those tall skyscrapers just across the bay must be an illusion. I was on another planet.

In the distance I could hear a humming sound. Was it a flying saucer warming up or dynamos in a powerhouse? The latter proved to be correct. I met Mr. Jones there. He was neither a ghost nor a man from outer space. He was large, powerful, black, and superintendent of the island. I introduced myself, told him my story, and explained what I wanted to do. Mr. Jones, I soon found out, had many attributes besides his physique. He was soft-spoken, a wonderful story-teller, and best of all, he accepted me at face value.

The next two days we spent together, rediscovering the island. Mr. Jones knew his subject well. Each building, each room we entered came alive with his stories. Mr. Jones was a storyteller rather than a statistician, so I had to do some research to find out the following:

Ellis Island is a man-made island. It is twenty-seven and a half acres in size, and the dirt that forms it was ballast from foreign ships entering the harbor. There are thirty-five brick buildings and one greenhouse now on the island—all in very bad condition.

It has had many names: In 1630, Gull Island;

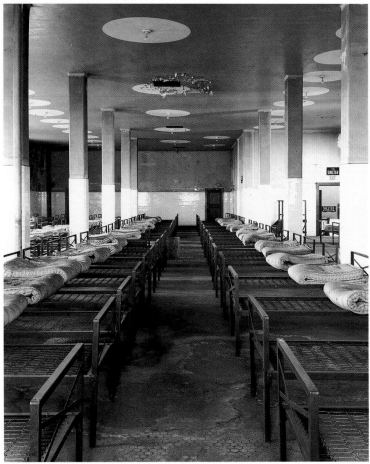

Shirley C. Burden, *Dormitory building, Island 1*, 1956

Shirley C. Burden, *Office, Island 1*, 1956

in 1661, Oyster Island; in 1730, Bucking Island; and in 1765, Gibbet Island. Later, when it was used as an immigration station, the immigrants who were not allowed to enter the United States called it "The Isle of Tears."

Many people have owned it: The Mohegan Indians in 1630, Mynher Paw in 1661, Captain William Dyre in 1674, Thomas Lloyd in 1686, and Samuel Ellis in 1780. More recently, New York State and the federal government have both owned it. It wasn't always used as an immigration station. In 1757 it was a pest house. In 1765 pirates were hanged there. In 1780 it was a tavern, in 1808 a fortress, and in 1892 it became an immigration station. It has also been a prison and a hospital.

For the fourteen million immigrants who passed through Ellis Island, it was truly "The Gateway to America."

The days flew by. Each morning we would meet at a dock next to the Staten Island Ferry slip in Manhattan. The Coast Guard would pick us up, take us to the island, and bring us back each evening. It was far more luxurious than my first trip on the scow.

We met in the powerhouse for lunch. Mr. Jones's Scandinavian assistant had a way with a skillet and a can of Sterno that would make a French chef blush.

During the day I had the island to myself. Sometimes, I would take pictures. Sometimes, I would look at the brick walls and wonder what they could tell me about the people they had seen and heard.

I took many pictures of Ellis Island: some worked, some didn't. I was always looking for that one shot that would say everything. So far, I hadn't found it.

It was late in the afternoon. The rain had been coming down in buckets all day. The light, when there was any, was flat. It just wasn't my day. I started down the fire escape with my equipment. All I could see below was acres of rain-drenched black asphalt roofs. Then a white object caught my eye. It was a dead pigeon. Somehow, it summed up everything I felt about the island—a lonely, desolate, decaying piece of the past.

Not far away, the Statue of Liberty holds her torch high on Bedloes Island, renamed Liberty Island. At her feet they built an immigration museum. Meanwhile, Ellis Island, "The Gateway to America" in 1892, has started to have guided tours. You can get there now on a ferryboat instead of a scow.

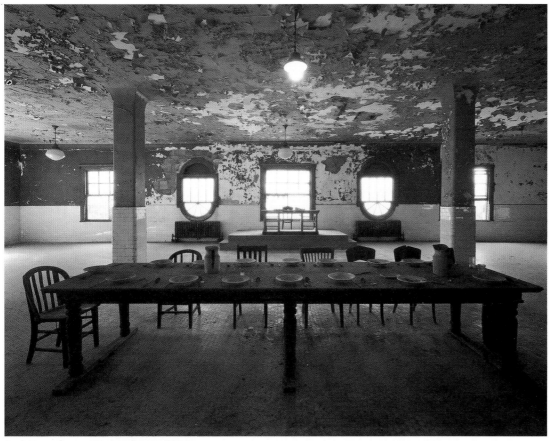

Joel Greenberg, *Dining Room*, 1983

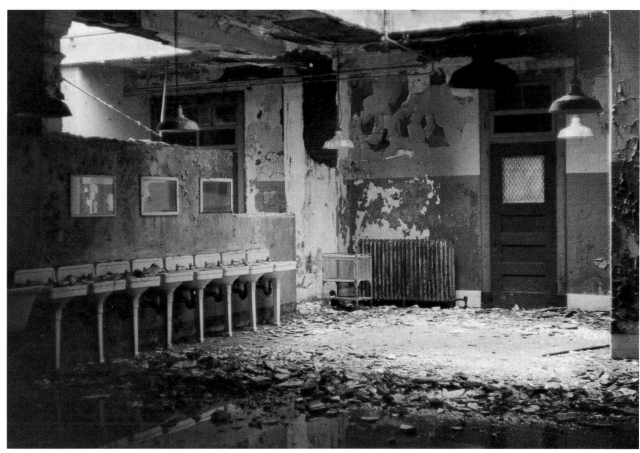

Milo Stewart, *Bathroom, Ellis Island*, 1967

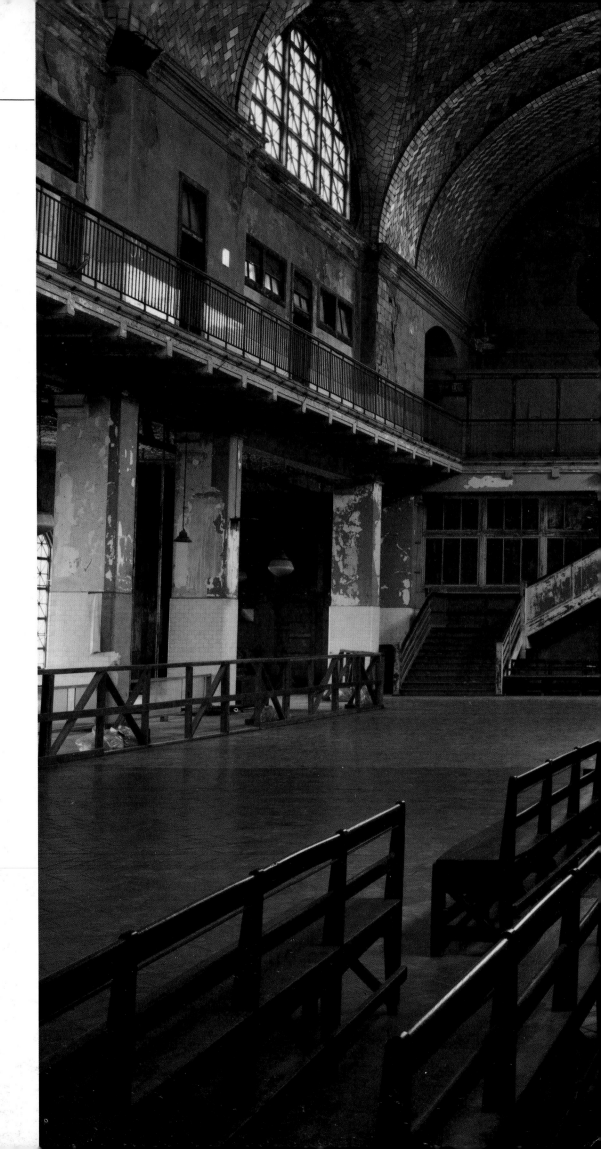

Joel Greenberg,
Registry Room (Great Hall), 1983

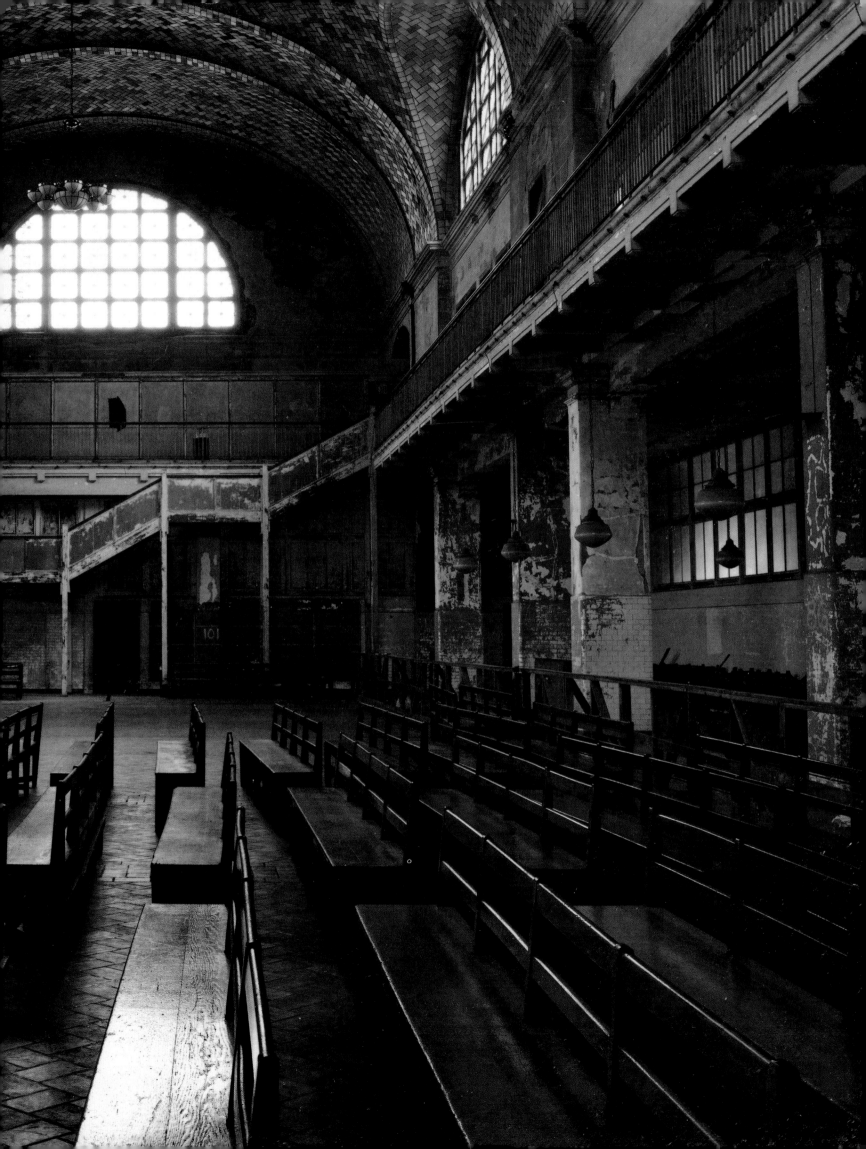

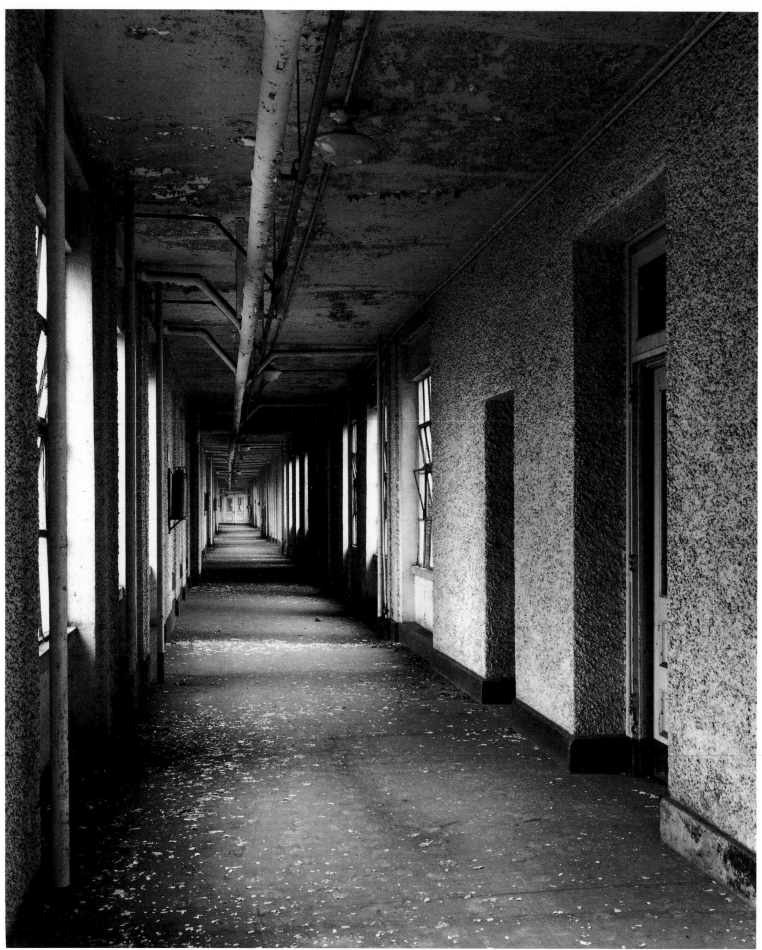

Shirley C. Burden, *Contagious Disease Wards Hallway, Island 3,* 1956

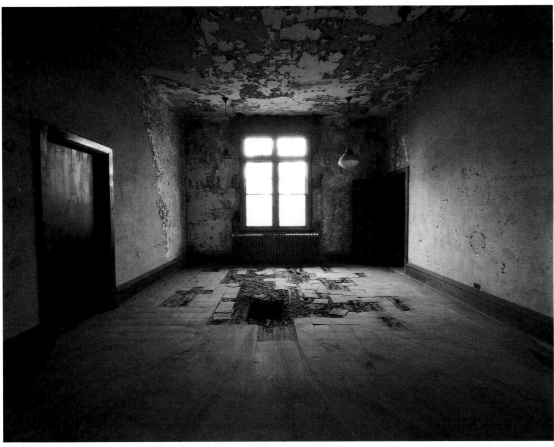

Joel Greenberg, *Room, main building*, 1983

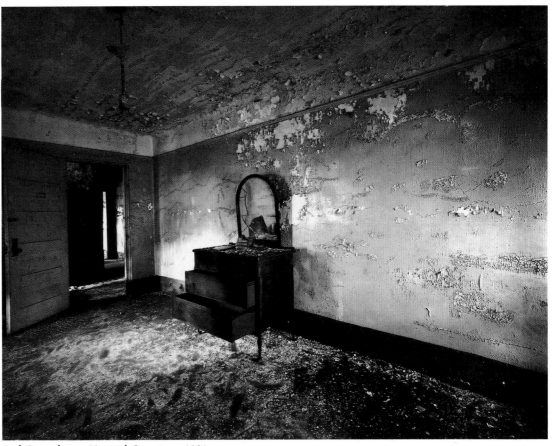

Joel Greenberg, *Nurses' Quarters*, 1983

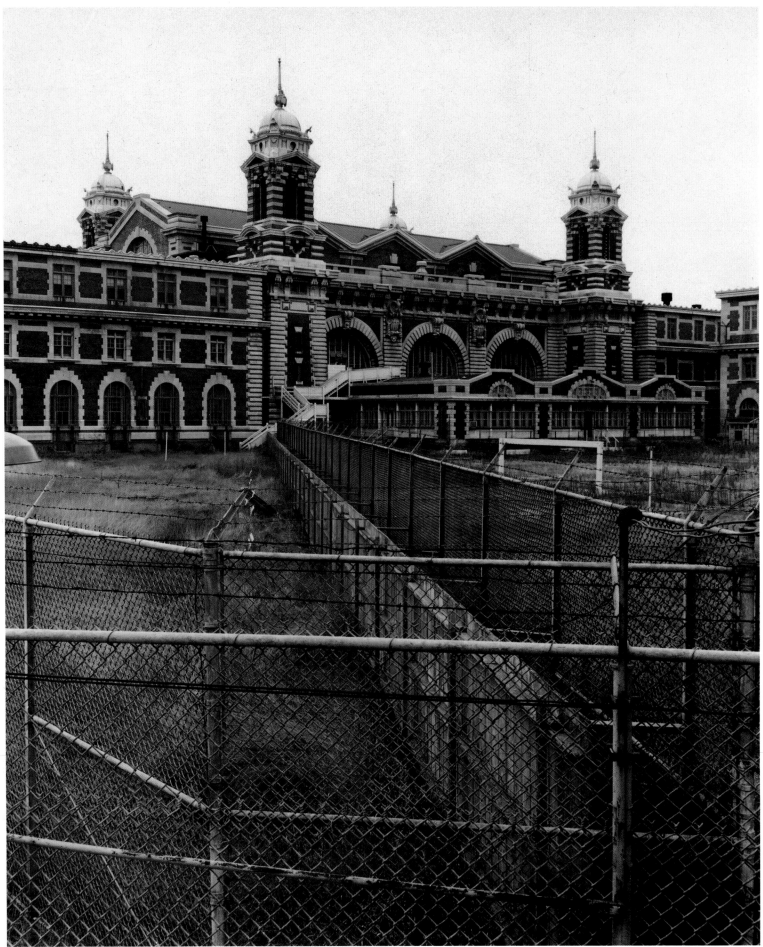

Shirley C. Burden, *Main building*, 1956

Shirley C. Burden, *Guard House, Island 1*, 1956

At the ringing of a bell at seven o'clock every morning, I roll out of a neither comfortable nor notably uncomfortable bed in my dormitory, where there are about fifty beds, all of them usually occupied. I line up for the adjacent bathrooms and showers, dress, gather up my books and papers and a portable typewriter I've borrowed from an American friend—whatever I intend to use during the day—and am downstairs in Passenger Hall before eight o'clock, when the dormitory doors are locked. At eight, another bell rings, and my fellow-passengers and I file down to a cafeteria on the ground floor. Except for lunch (twelve to twelve-thirty) and supper (five-thirty to six), I am in Passenger Hall. At nine P.M., a guard blows a whistle, and I go upstairs to my dormitory, put my belongings under my bed—the only place for them—and usually do my laundry. Lights are snapped out at ten-thirty.

As you are probably aware, the Russians have long made heavy propaganda use of Ellis Island. They call it a concentration camp, which, of course, is outrageous. No one mistreats us here. Our jailers—nearly all of them, anyway—are very kindly people, who go to extraordinary lengths, within the system, for which they don't pretend to be responsible, to make our stay here as little like a nightmare as they can. There is a movie here every Tuesday and Thursday night; the children get milk six times a day and go to school three hours a day. We are kept warm and fed generously—nothing like the Colony, I assure you, but more than enough. And, as people are always pointing out to us, it doesn't cost us anything. But I will tell you, it is hard not to be depressed at the realization that within the American government, which has rightly been honored so long as the guardian of individual freedom and human dignity, there is one small agency that can seize a man and bring him to this place, where every day of his life he can look on the mocking face of the Statue of Liberty and where—almost as if this were that other kind of world, behind the Curtain—he is walled in by silence. He isn't told the particulars of his offense, his accusers are nameless, and the weeks and months pass, as if human beings were no more to be considered than ciphers in a manila folder.

George Voskovec, Czechoslovakian playwright and
actor, detained at Ellis Island in 1951, under the
Internal Security Act of 1950

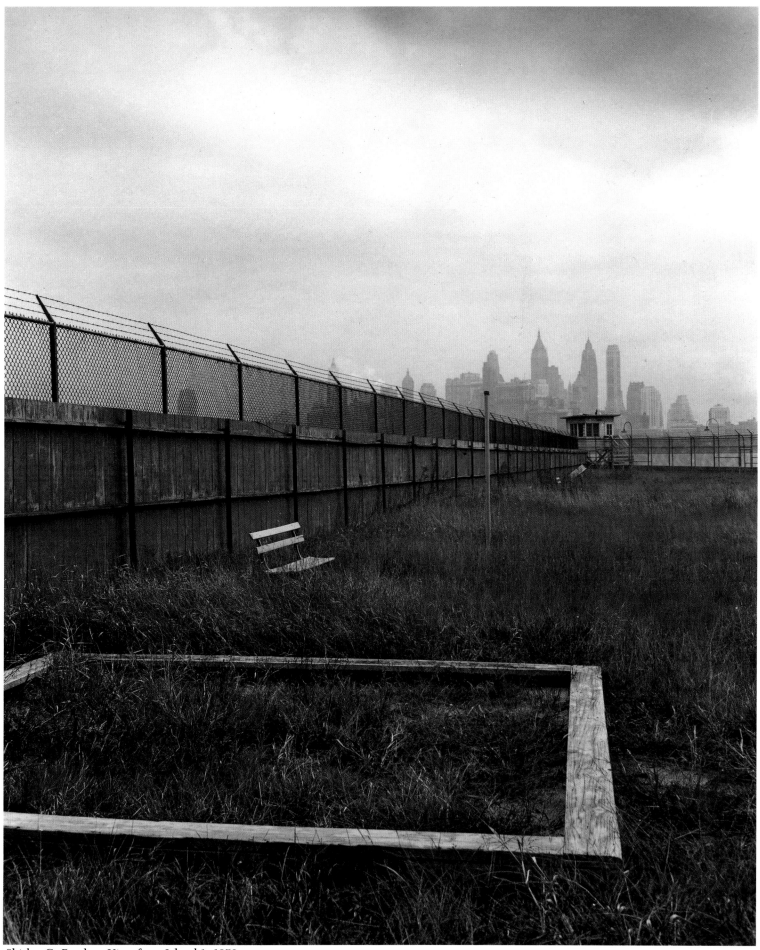

Shirley C. Burden, *View from Island 1*, 1956

Ellis Island: Symbol and Reality

By CHARLES HAGEN

From the first the Statue of Liberty was intended as a monument, a symbol; Ellis Island, separated from it by only a few hundred yards of water, became a symbol only with time. The Statue of Liberty, expressing noble but abstract sentiments through its grand scale and graceful lines, seems perfectly French, reflecting its origins as a gift from France to the young American republic. Ellis Island, on the other hand—coldly efficient, recalling not only the massive railway stations of the turn of the century but also the sprawling factories of the newly industrialized nation—was in its concept and function thoroughly American. Given the varied uses to which Ellis was put, given the ambiguities surrounding the experience of immigration—in which tides of immigrants were often received with suspicion and hostility rather than open arms—the island became a symbol with a variety of contradictory meanings.

It is precisely because it expresses such conflicting meanings that Ellis Island offers photographers so rich an artistic challenge. Photographs seem simply to describe the world, but as most photographers quickly realize, the pictures they make can turn facts into symbols. When the subject of the photograph is itself laden with meaning, this symbolic function is compounded further.

The idea to invite contemporary photographers to depict Ellis Island began simply enough, as an outgrowth of an assignment that Klaus A. Schnitzer devised for his photography class at Montclair State College in New Jersey. Schnitzer, himself an immigrant, has for years taken his students on field trips around the New York area; in 1982 he visited Ellis Island—then overgrown with weeds and deteriorating. Later that year he proposed to the National Park Service that he, his students, and other photographers be given access to the island in exchange for documenting the site. In 1983 Schnitzer and his group assembled an exhibition of photographs of Ellis taken over the summer, which was shown at various sites in New York and New Jersey. That same year, Brian Feeney, one of Schnitzer's graduate students and an original member of the group that photographed the island, joined the National Park Service and was assigned to Ellis,

then in the early stages of restoration. Since then Schnitzer and Feeney have invited many contemporary photographers to photograph the island, with the understanding that their pictures would eventually become part of a collective statement about Ellis Island and its meaning today.

It is not surprising that so many of the photographers involved in this project have chosen not to deal with Ellis Island simply as a physical location, but to address its symbolic dimensions as well. For them, what is important about the island is not whether it should be remembered as a symbol of hope or oppression, but the deeper mysteries of memory and the passage of time. The empty chair draped with a dustcloth, in Jerry Uelsmann's composite print, suggests the importance of memory for the immigrants, who left their homes, their friends, and often their families in coming to the new land. Lorie Novak evokes the experience of arriving at Ellis Island by projecting snapshots of her family onto its decrepit walls, repopulating the halls her grandparents passed through with ghostly images of their descendents. The empty corridors and abandoned, rubble-strewn rooms depicted by Geanna Merola, Sylvia Plachy, and Madoka speak of the effects of time on Ellis itself. Zeke Berman attempts to reconstruct the past literally, by tracing out with rope the missing back of a broken chair. Other photographers consider the human evidence of Ellis Island's past: Mariana Cook portrays people who passed through the island in their youth, while Robert Foster photographs the men working on the restoration of Ellis Island, many of them children or grandchildren of people who came through the island as immigrants.

For these photographers the island is not only a piece of land in the middle of New York harbor, in the shadow of the Statue of Liberty, but also a metaphorical location with a central place in our national ethos. This Ellis is an island of hopes fulfilled and promises denied, of past disappointments and future possibilities. Above all it is a place where the American dream, which attracted so many of the immigrants who passed through the island on their way to the Lower East Side, to Ohio, to Dakota, lives on, continually challenging us to redeem its promise from generation to generation.

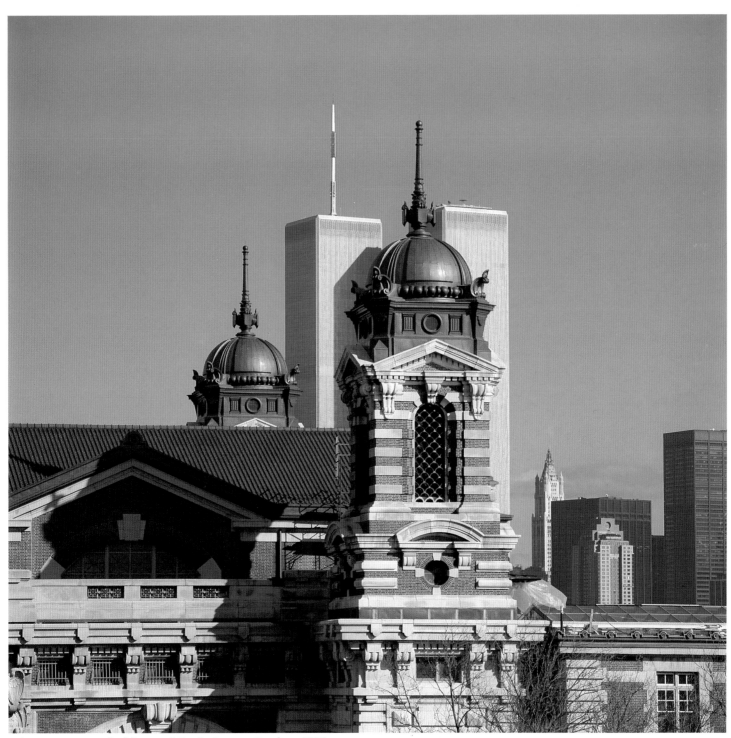

Robert Rose, *Main building and Trade Center*, October, 1987

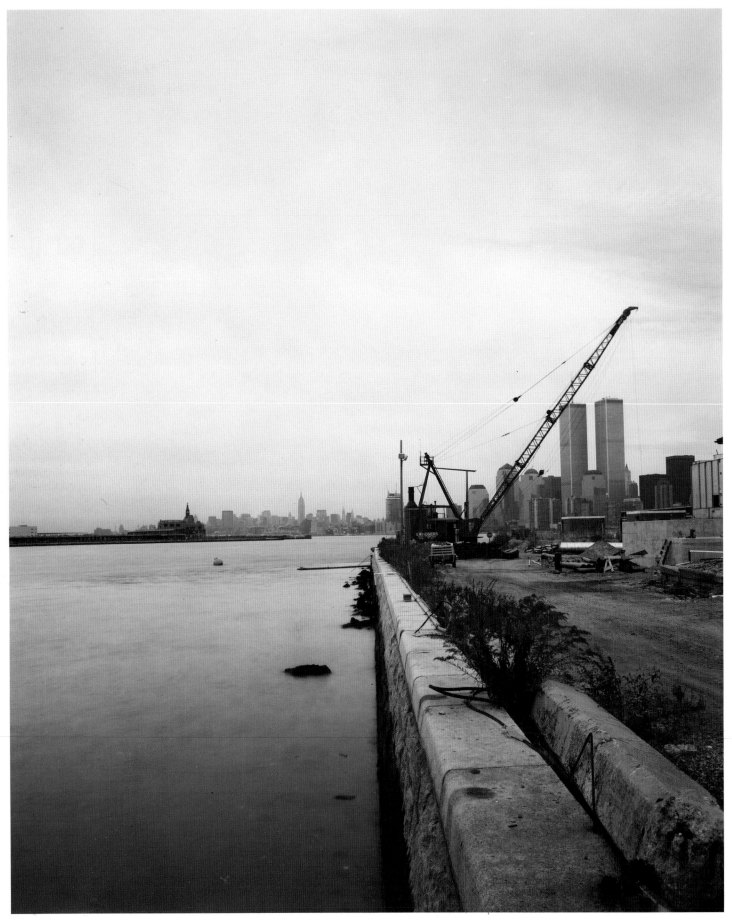

Roger Mertin, *View: Looking Northeast, Ellis Island*, 1988

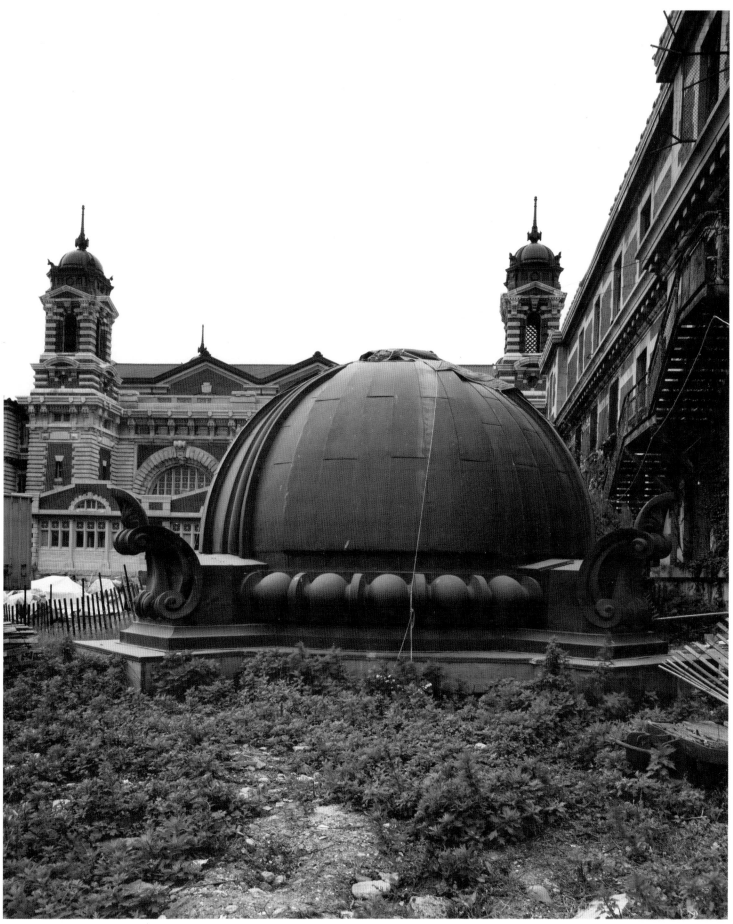

Roger Mertin, *Ellis Island*, 1988

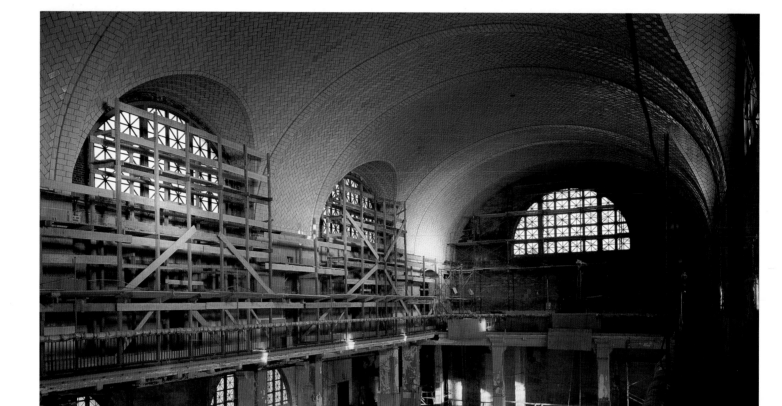

Mark McCarty, *Registry Room under Construction*, 1988

Registry Room, 1915

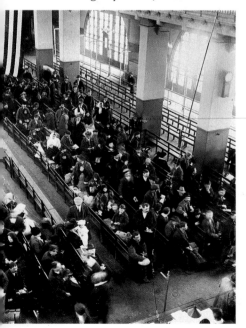

Ellis Island is the nations' gateway to the promised land. In a single day it has handled seven thousand immigrants.

"How much you got?" shouts the inspector at the head of the long file moving up from the quay between iron rails, and, remembering, in the same breath shrieks out, "Quanto monèta?" with a gesture that brings up from the depths of Pietro's pocket a pitiful handful of paper money. Before he has it half out, the interpreter has him by the wrist, and with a quick movement shakes the bills out upon the desk as a dice-thrower "chucks" the ivories.

Ten, twenty, forty lire. He shakes his head. Not much, but—he glances at the ship's manifest—is he going to friends?

"Si, si! signor," says Pietro, eagerly; his brother of the vineyard—oh, a fine vineyard! And he holds up a bundle of grapesticks in evidence. He has brought them all the way from the village at home to set them out in his brother's field.

"Ugh," grunts the inspector as he stuffs the money back in the man's pocket, shoves him on, and yells, "Wie viel geld?" at a hapless German next in line. "They won't grow. They never do. Bring 'em just the same." Jacob A. Riis, 1903

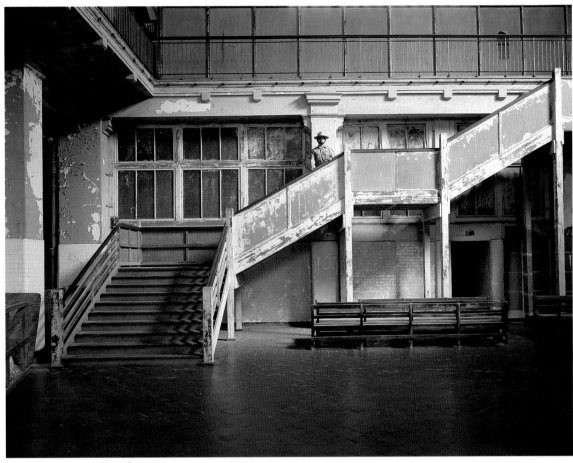

Mark McCarty, *Jeff in the Registry Room*, 1983

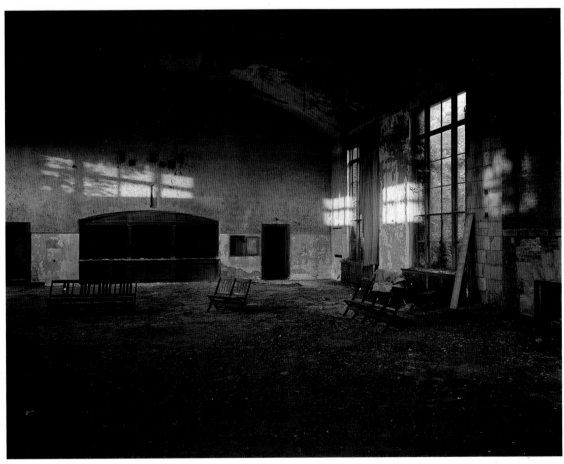

Mark McCarty, *Recreation Hall*, 1983

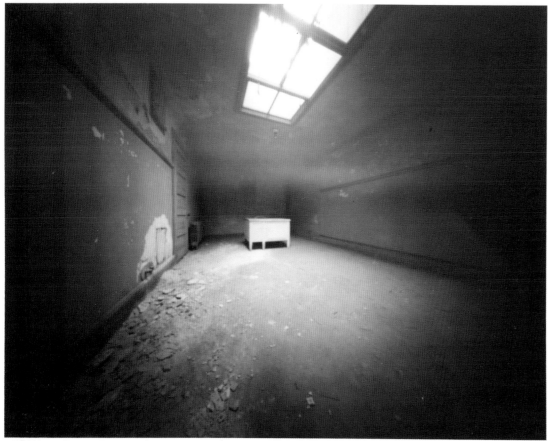

Linda Hackett, *Island 2*, 1988

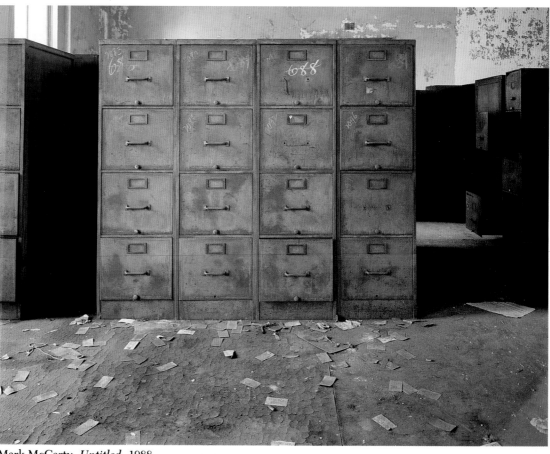

Mark McCarty, *Untitled*, 1988

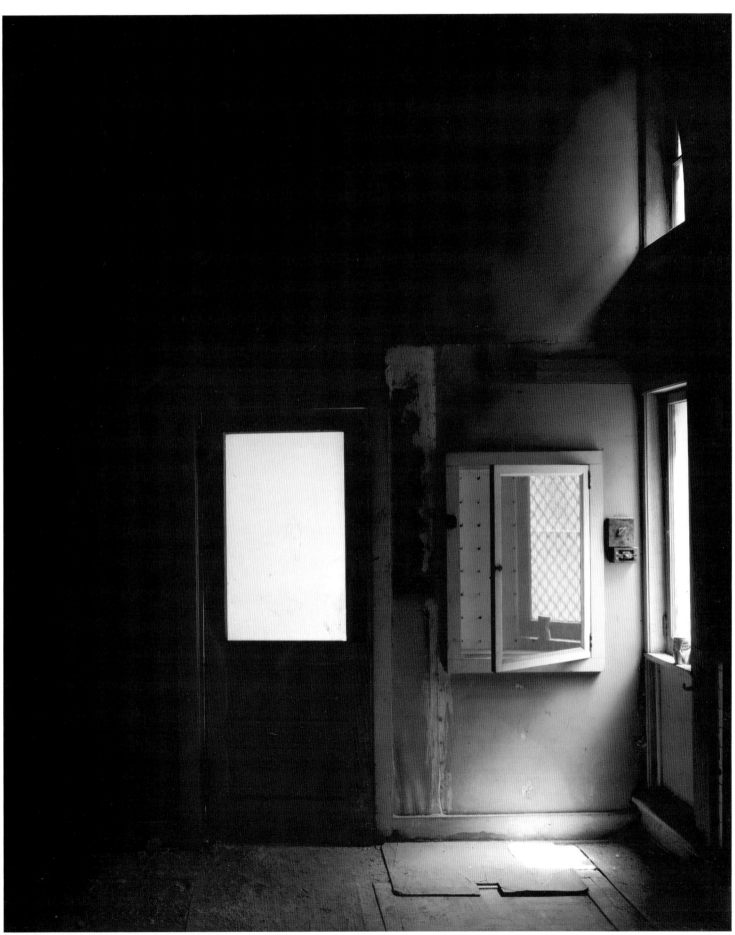

Jon Kline, *Ellis Island Series*, Summer 1988

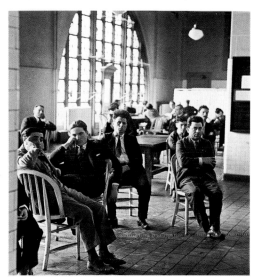

Waiting in the Registry Room,
1932 (Erich Salomon)

*We were on Ellis Island twenty-two days.
They took all us men to one section of the
room, and they stripped us. They took all
our clothes and they only left our papers in
our hands. We went through something like
a cattle booth. At all of these booths there
was a doctor who examined you. If you were
a sick person they told you to wait. If you
were all right you continued with the rest of
the examination. They looked at your whole
body—the eyes, the heart, the teeth. They
brought us into a big hall. All of a sudden
they called your name and your clothes
appeared. All clean and packed and smelling
nice. Because, to tell the truth, I've got to be
honest about it, they deloused us. As I said,
the ship we came over on wasn't a clean ship.
You couldn't clean yourself anyway because
even the water from the fountains was
frozen. In order to drink some water we had
to break the ice with something and melt it.
So how can you keep yourself clean?*
 Rocco Morelli, Italian,
 at Ellis Island in 1907, age 12

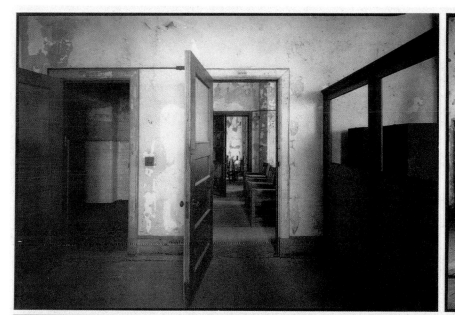

Klaus Schnitzer and Robert Sennhauser, *Aftermath 1,* 1986

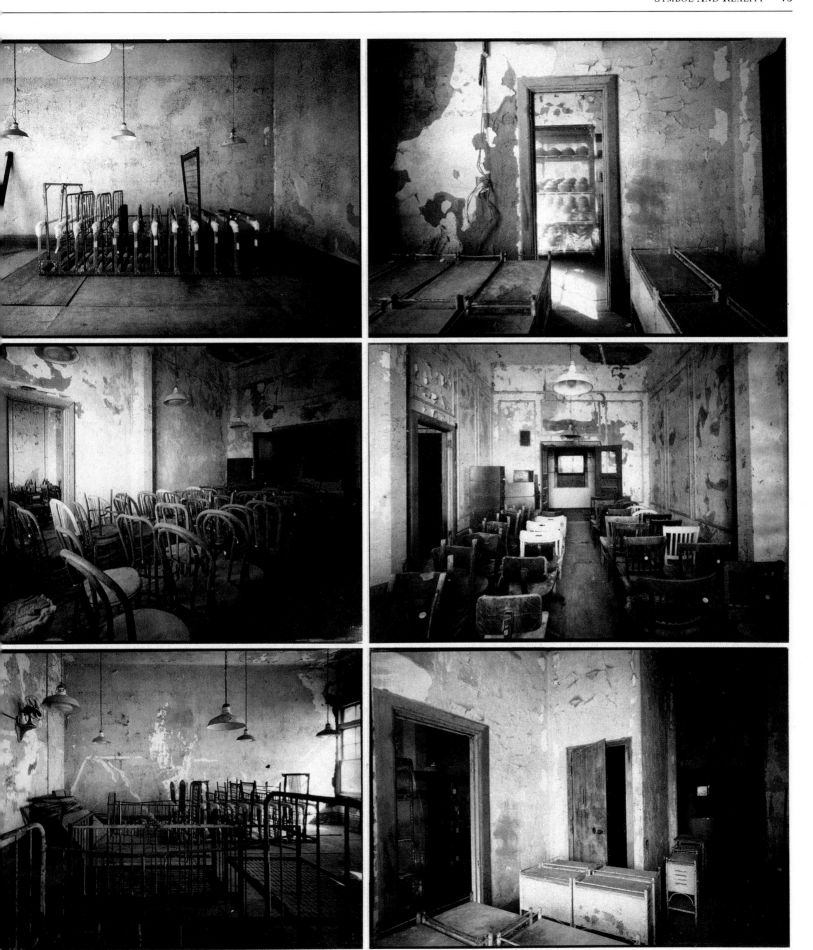

An Appeal from Special Inquiry Board to Commissioner Watchorn, 1905.

A handsome, clear-eyed Russian girl of about twenty years, the daughter of a farmer, comes in and sits down before us. She is clean and intelligent looking. She nervously clasps and unclasps her hands and the tears are welling in her eyes.

"That girl over there," says the commissioner, "is an interesting and puzzling case. Her father is a farmer in moderate circumstances. A young man with whom she grew up, the son of a neighbor, came here two years ago, and last year wrote to her father that if the girl would come over he would marry her. So she came, alone. But the prospective bridegroom didn't show up. I wrote him—he lives somewhere in New Jersey—and last week he appeared and looked her over. Finally he said he wasn't sure whether he wanted to marry her or not. Naturally her pride was somewhat wounded, and she decided that she had doubts herself. So everything is at a standstill. The girl says she doesn't want to go back, to be laughed at; and I can't let her land. You don't know any lady who wants a servant, do you? She could work! Look at her arms. A nice girl, too. No? Well, I don't know what to do. Are you willing to marry Peter if he comes again?"

The girl nods, the tears brimming over.

"Well, I'll write to that fellow again and tell him he's a fool. He'll never have such a chance again."

From Commissioner William Williams Papers, March 1910

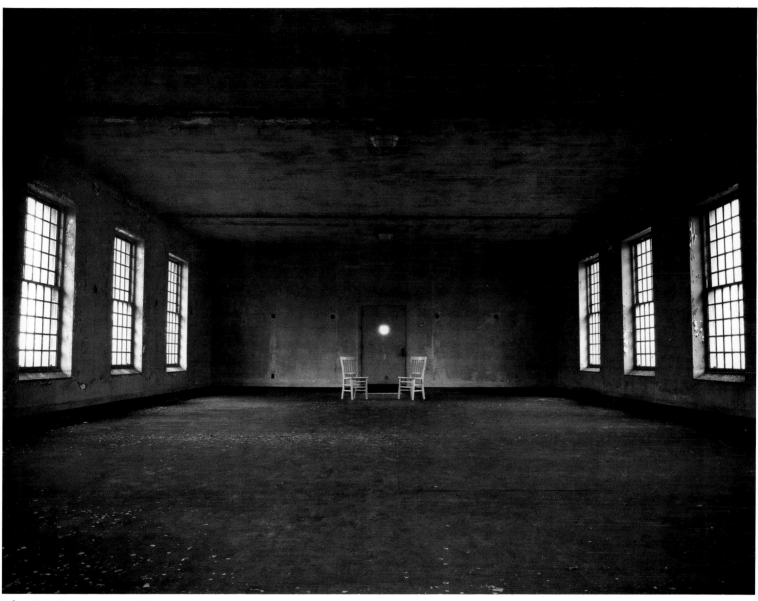

John Fei, *Conversation*, 1988

The hardest quota cases were those that separated families. When part of the family had been born in a country with a quota still open, while the other part had been born in a country whose quota was exhausted, the law let in the first part and deported the other part. Mothers were torn from children, husbands from wives. The law came down like a sword between them.

The Polish wife of a Pennsylvania coal miner—both good Poles, admitted a year before—had gone back suddenly to Poland to visit her old father and mother who had taken sick and might soon die. The visit over, she returned quickly to America. She would be admitted at once, for little visits do not count against quotas. The coal miner was at the island, waiting for her. We told him everything would be all right, but he was unaccountably nervous. Then the ship came in, the Lapland *of the Red Star line, from Antwerp, and we found out why the husband was so nervous. On the day before the ship made port, out on the high seas, a baby Pole had been born to the returning mother. The expected had happened, "mother and child both doing well" in the Ellis Island hospital, everybody delighted, until—the inspector admitted the mother but excluded the baby Pole.*

"Why?" asked the father, trembling.

"Polish quota exhausted," pronounced the helpless inspector. Then they brought the case to me. Deport the baby? I couldn't. And somebody had to be quick, for the mother was not doing well under the idea that her baby would soon be taken from her and "transported far beyond the northern sea."

"The baby was not born in Poland," I ruled, "but on a British ship. She is chargeable to the British quota. The deck of a British ship is British soil, anywhere in the world."

I hummed "Rule Brittania—Brittania rules the waves," hummed I happily, for I knew the British quota was big.

"British quota exhausted yesterday," replied the inspector. There was a blow. But I had another shot in my locker.

"Come to think of it, the Lapland *hails from Antwerp," I remarked. "That's in Belgium. Any ship out of Belgium is merely a peripatetic extension of Belgian soil. The baby is a Belgian. Use the Belgian quota."*

So I directed, quite shamelessly and unabashed.

"Belgian quota ran out a week ago." Thus the inspector. I was stumped.

"Oh, look here," I began again, wildly. "I've got it! How could I have forgotten my law so soon? You see, with children it's the way it is with wills. We follow the intention.

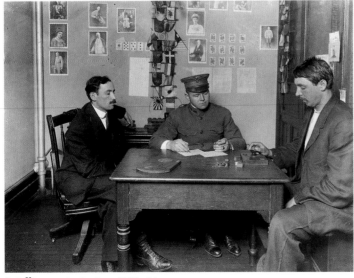

Intelligence test, circa 1921–24

Now it is clear enough that the mother was hurrying back so the baby would be born here and be a native-born American citizen, no immigrant business at all. And the baby had the same intention, only the ship was a day late and that upset everything. But— under the law, mind you, under the law—the baby, by intention, was born in America. It is an American baby—no baby Pole at all—no British, no Belgian—just good American. That's the way I rule—run up the flag!"
Henry Curran, Ellis Island
Commissioner 1922–26, commenting
on First Quota Act, 1921

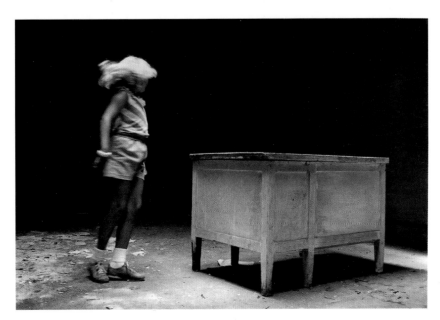

Susan Walkley Topper,
*Ellis Island Series—
Karin*, November 1984

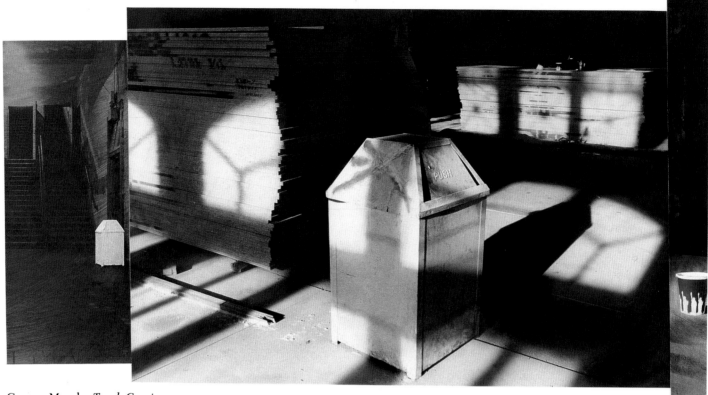

Geanna Merola, *Trash Can in
the Great Hall*, 1988

Vida, *Ellis Island*, 1988

At Ellis Island there was nothing to do. You
just had to sit around. You could walk up and
down among the crowds and wait for the man
to come with chewing gum or an apple, but you
couldn't go any place. . . . Even prisoners go
out into the yard. But we were kept in a place
that was all enclosed. I could walk up and
down, back and forth, and up and down, and
back and forth. That was the extent of my
exercise.

Ettie Glaser, English, at Ellis Island
in 1923, age 18

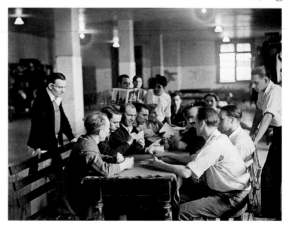

Passing the time playing cards, 1932 (Erich Salomon)

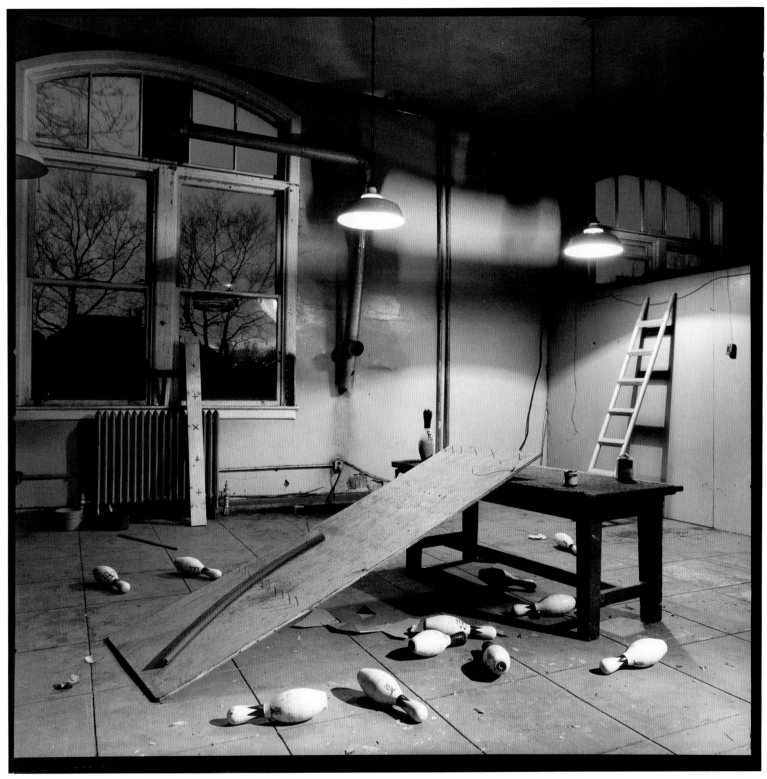

Jan Staller, *Untitled*, 1988

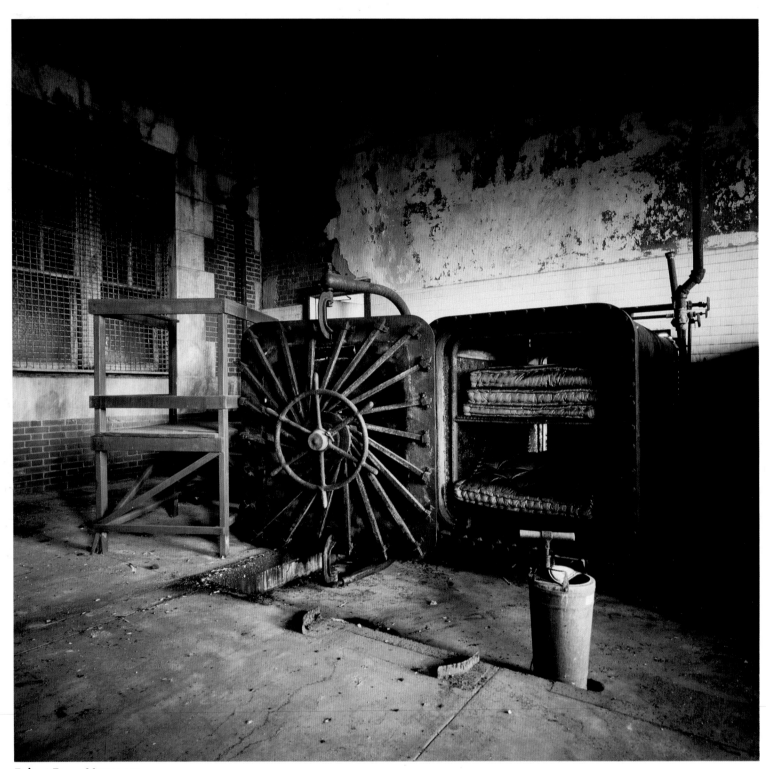

Robert Rose, *Mattresses,*
Island 1, October 1987

Wendy Erickson, *Ellis Island Morgue*, 1987

My middle sister, who shared the room with me, was running a terrible fever. She was so hot I couldn't sleep with her. We tried not to let anyone know she was sick. Finally, she started to break out with measles. We were terribly afraid they would keep us on the island. The day we were to leave the nurse noticed she was running 102 fever, and she took Rosalie, my sister, away from us. This child was absolutely petrified. She thought she was leaving us forever. They took her to the hospital and put her in quarantine. We had to leave without her.

Barbara Barondess, Russian,
at Ellis Island in 1921, age 14

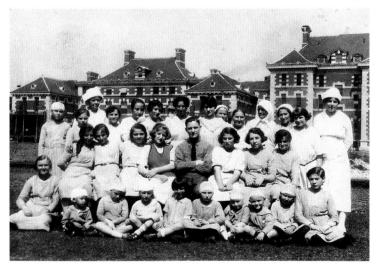

Hospital staff and children, date unknown

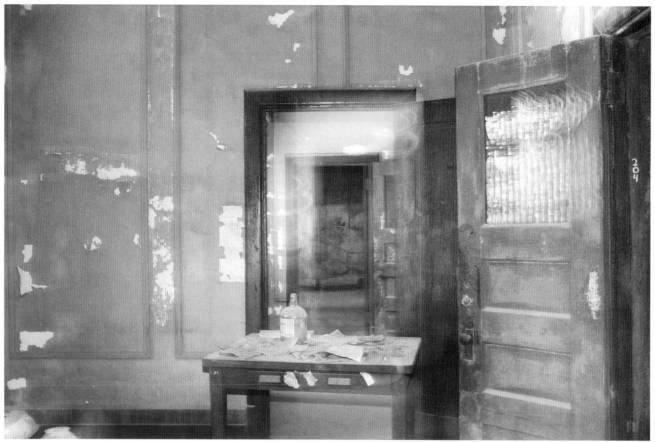

Maryanne Solensky, *Untitled*, August 1983

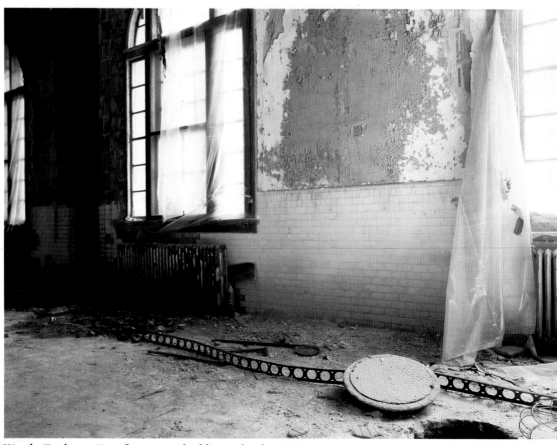

Wendy Erickson, *First floor, main building, Island 1*, 1988

The first night in America I spent, with hundreds of other recently arrived immigrants, in an immense hall with tiers of narrow iron and canvas bunks, four deep. I was assigned a top bunk. Unlike most of the steerage immigrants, I had no bedding with me, and the blanket which someone threw at me was too thin to be effective against the blasts of cold air which rushed in through the open windows; so that I shivered, sleepless, all night, listening to snores and dream monologues in perhaps a dozen different languages.

The bunk immediately beneath mine was occupied by a Turk, who slept with his turban wound around his head. He was tall, thin, dark, bearded, hollow-faced, and hook-nosed. At peace with Allah, he snored all night, producing a thin wheezing sound, which occasionally, for a moment or two, took on a deeper note.

I thought how curious it was that I should be spending a night in such proximity to a Turk, for Turks were traditional enemies of Balkan peoples, including my own nation. For centuries Turks had forayed into Slovenian territory. Now here I was, trying to sleep directly above a Turk, with only a sheet of canvas between us.

Soon after daybreak I heard him suddenly bestir himself. A moment later he began to mutter something in Turkish, and climbed out of his bed in a hurry. He had some difficulty extricating himself, for there was not more than a foot between his and my bunk, and in his violent haste rammed a sharp knee in the small of my back. I almost yelled out in pain.

Safely on the floor, the Mohammedan began to search feverishly in a huge sack which contained his belongings, and presently pulled out a narrow, longish rug and carefully spread it on the floor between two tiers of bunks.

This done, he stretched himself several times, rising on his toes, rubbed his beard, adjusted his turban, which was slightly askew; whereupon, oblivious of my wide-eyed interest, he suddenly crashed to his knees on the floor with a great thud. Next he lifted his long arms ceilingward and began to bow toward the east, touching the carpet with his brow, the while mumbling his sun-up prayer to Allah.

Louis Adamic, Slovenian, at Ellis Island in 1913

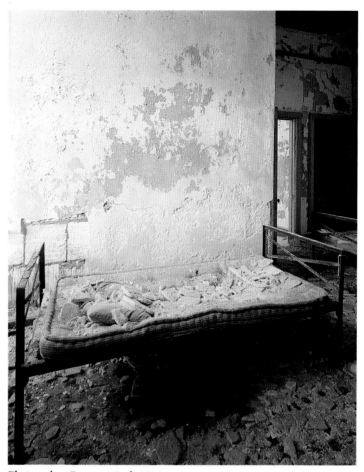

Christopher Barnes, *Bed*, 1988

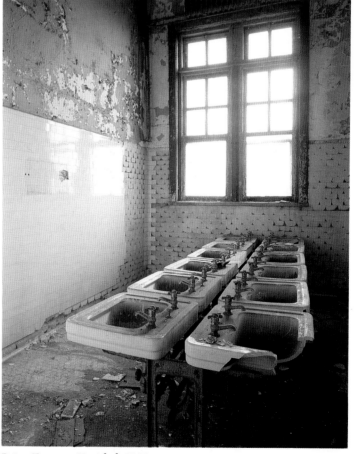

Brian Feeney, *Untitled*, 1988

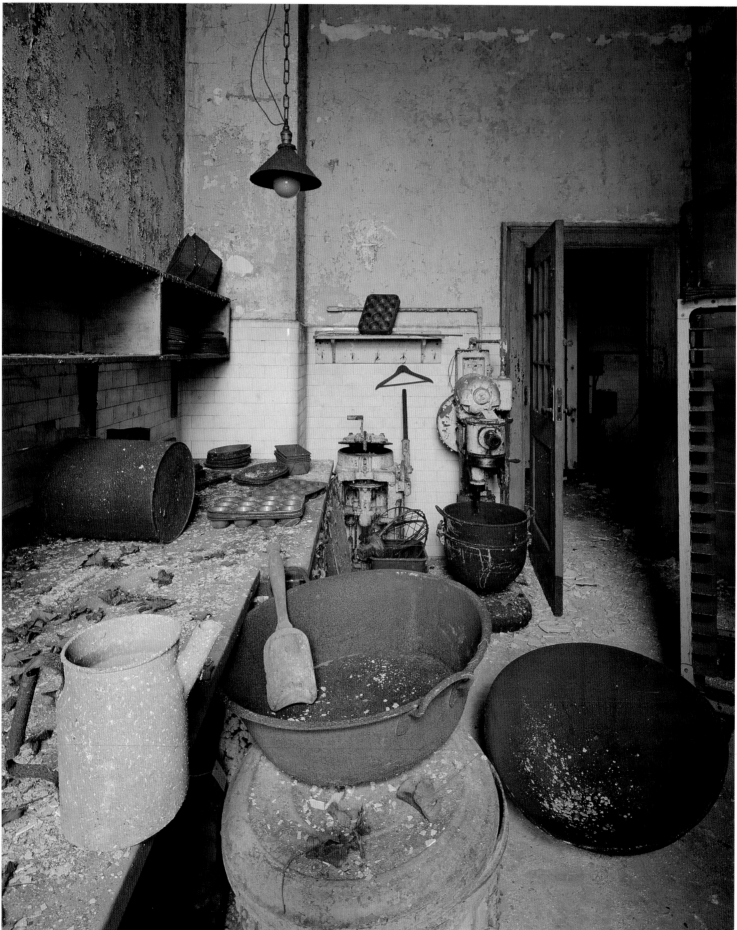

Christopher Barnes, *Ellis Island Kitchen*, 1988

While we were detained on Ellis Island my uncles came to visit us. One of them brought me his pockets full of chocolate. Another one brought us a whole bunch of bananas. Nice and yellow bananas. They picked me up, like you pick up a football. They were big men and I was just a little boy. They told me, "Now, you eat all the bananas because if we come back tomorrow and you didn't eat them, there's going to be trouble." Could I eat a whole bunch of bananas? After they'd gone I said to my grandfather, "Nonno, what do you do with these?" He said, "You eat them, son. They're the American figs." So I grabbed one and I started to put it in my mouth. He said, "No, you've got to take off the skin." "Well," I said, "You said they're like figs. We don't take the skin off figs." He said, "Here, I'll show you." So he peeled one. Right then and there I started to eat bananas. Even today, if I have to eat ten or twelve bananas, I'll eat them, just like that.

Rocco Morelli, Italian, at Ellis Island in 1907, age 12

Sandi Fellman, *Untitled,* 1988

Guadeloupe woman, circa 1911
(Augustus Sherman)

Sandi Fellman, *Untitled,* 1988

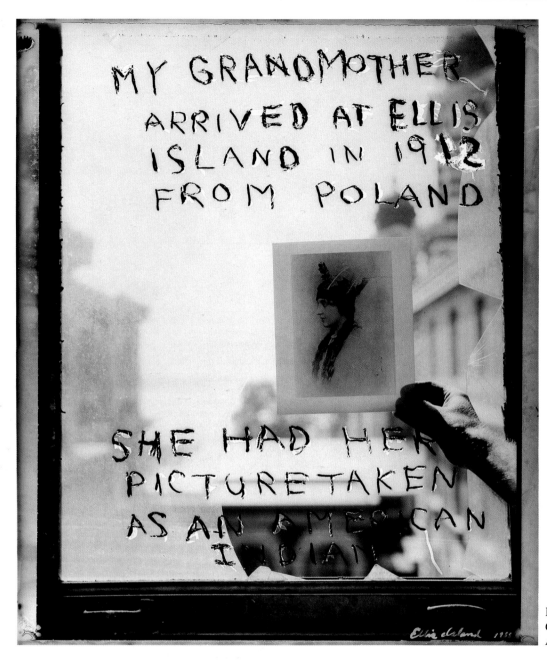

MY GRANDMOTHER ARRIVED AT ELLIS ISLAND IN 1912 FROM POLAND

SHE HAD HER PICTURE TAKEN AS AN AMERICAN INDIAN

Ed Grazda, *I Remember Grandma, Ellis Island,* August 1988

They also questioned people on literacy. My uncle called me aside, when he came to take us off. He said, "Your mother doesn't know how to read."

I said, "That's all right."

For the reading you faced what they called the commissioners, like judges on a bench. I was surrounded by my aunt and uncle and another uncle who's a pharmacist—my mother was in the center. They said she would have to take a test of reading. So one man said, "She can't speak English."

Another man said. "We know that. We will give her a siddur." You know what a siddur is? It's a Jewish book. The night they said this, I knew that she couldn't do that and we would be in trouble.

Well, they opened up a siddur. There was a certain passage they had you read. I looked at it and I saw right away what it was. I quickly studied it—I knew the whole paragraph. Then I got underneath the two of them there—I was very small—and I told her the words in Yiddish very softly. I had memorized the lines and I said them quietly and she said them louder so the commissioner could hear it. She looked at it and it sounded as if she was reading it, but I was doing the talking underneath. I was Charlie McCarthy!

Arnold Weiss, Russian, at Ellis Island in 1921, age 13

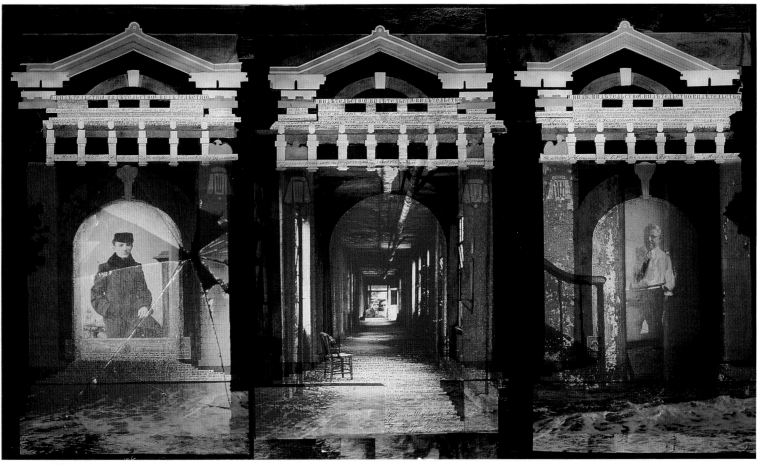

Nancy Goldring, *Ellis Island*, 1988

St. Louis, Mo.

State of Illinois)ss
County of Madison)

 Frank Mack first being duly sworn
on oath deposes and says that he is a citizen of the United
States, resideing in the City of Edwardsville, Madison
County, Illinois. Affiant further states that he is now en-
gaged in theJunk business in Edwardsville, Illinois, and
that his weekly earnings do not exceed Forty Dollars ($40.00)
per week. He further states that his financial worth is
($3000.00) three thousand dollars, and that he is able to
and promises to provide for the following and that persons
until they are in a position to care for themselves.

Chaim Mack-Brother Age 33-------------------
Anzel Mack-Brother Age 32--------------------
Rachel Mack-Sister Age 27--------------------
Dwaira Mack-Mother Age 62--------------------
Hershel Goldring Brother-in-law Age 38------
Tarbe Goldring Sister Age 35------
David Goldring Nephew Age 6------

 Further affiant sayeth nothing-

 Dated at Edwardsville, Illinois this 29th day
of January AL D. 1921.

 Signed Frank Mack

Subscribed and sworn to before me this 29th day of
January A.D. 1921.

 Notary Public.

My commission expires July 28th.1921.

Case 16791

*An affidavit of sponsorship
from a family member.*

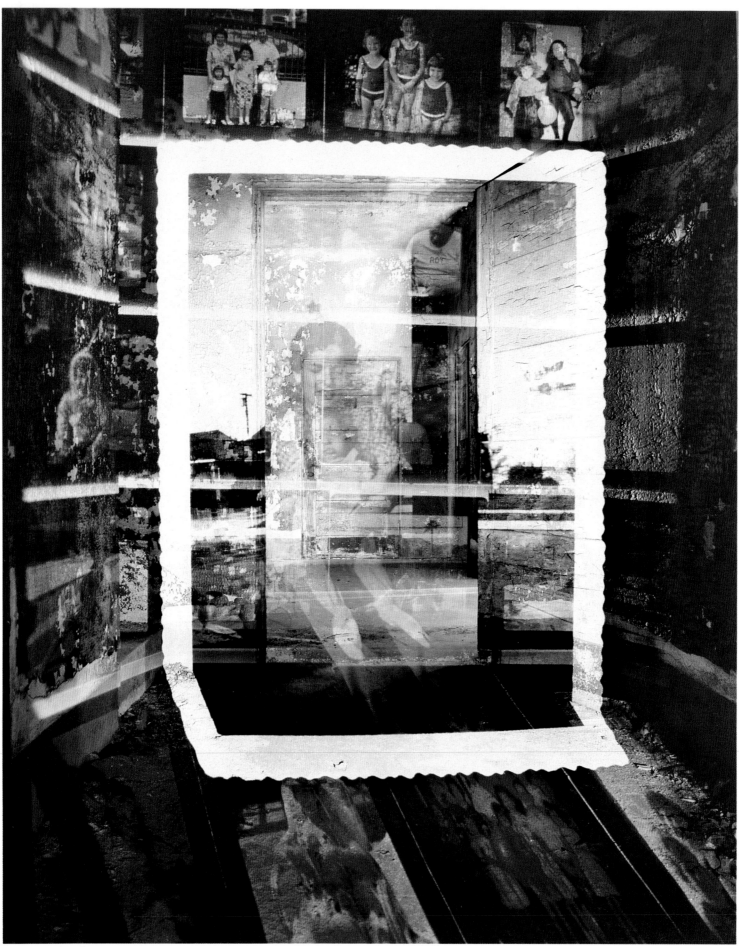

Lorie Novak, *Altar*, 1988

We waited to see when my father would come. And another girl was with me. Her father was a neighbor in the old country. Her father and my father were coming together. So we waited and stayed overnight.

A special woman talked to us in Greek and we felt more secure. She told us, "Don't worry or cry. Your father is going to come—if not tonight, he will be here tomorrow. And when he comes, there will still be many people ahead of you, as we go by numbers and call everybody's name."

What a place that was! Beautiful! Balconies on top, you know, all the way around and people who had to wait a long time could go upstairs and watch the people downstairs. And they had cots where I slept. They had quite a few cots in a big room and a lot of people. You slept with your boots and the way you came was the way you went to bed. There was no place there to get undressed to go to bed. Just lie down and sleep. And get up in the morning ready to travel.

Italian girl, circa 1905

The next day we got up and went downstairs in a line where they called so many names at a time. So when they called my name, I said to my brother, "Come on!" And I took him by the hand.

He said, "Where are we going?"

I said, "They called our name. Let's go. Don't wait!"

So we went into a room, and they had guards there. And there was a woman at the desk who talked Greek. She said, "Where are you going?"

"To my father."

"Do you know your father? Is he here?"

And I looked around. "No, he's not here. But he will be," I said.

She said, "You got money?" To pay for your fares wherever you go?"

We had ten dollars between the two of us, which was a lot of money then. Because they told us you have to have some money for your fares after you finish with Ellis Island, and are on your own. And pretty soon the guard stood in front of me and my brother. I tried to push him away because, you see, I didn't want to miss anything and I was anxious to see my father. So then I saw my father come in. And I started to get up and the guard said, "Sit down." He made me sit down, and the lady said to me, "You better sit down until I am ready, until after you answer the questions I want to ask you."

So I did, I sat down nicely and I was waiting and I said to the lady, "What are you keeping me here for? My father is here. That's my father." And I got up and went to my father and put my arms around him.

Bessie Spylios, Greek, at Ellis Island in 1909, age 11

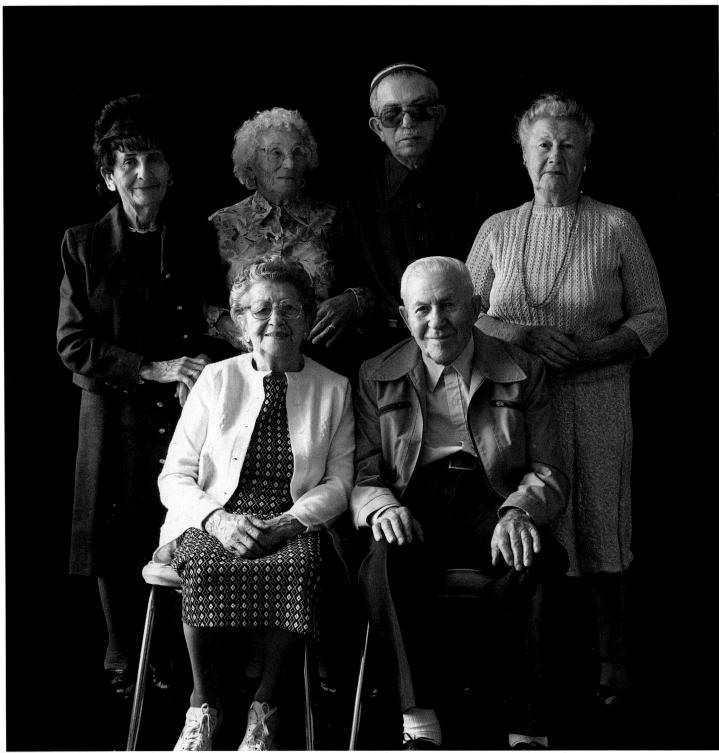

Mariana Cook, *Ellis Island Immigrants*, 1988

We lived through a famine in Russia and almost starved to death. Every day the Board of Health would come to our door and ask if we had any dead. Finally we left Russia for Poland—a frightful experience. We traveled by train. We would get on a train and ride for a few hours until we were thrown off. We used to spend days and nights in the fields, waiting to get on another train. From Poland we came to America. My mother said she wanted to see a loaf of bread on the table and then she was ready to die. So you see, we lived through so much before we came here that Ellis Island was a blessing.

Rose Backman *(back row, left)*, Russian, at Ellis Island in 1923, age 10

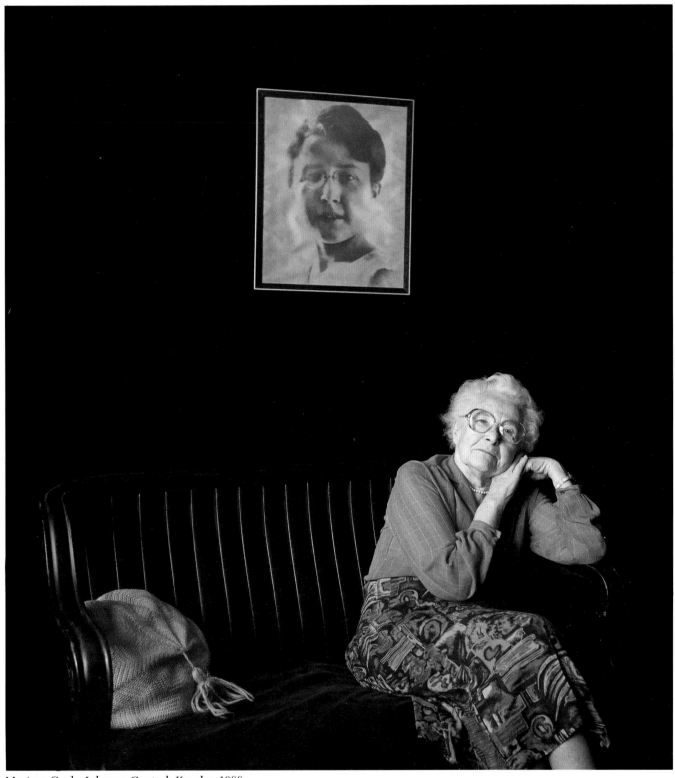

Mariana Cook, *Johanne Gentsch Kusche*, 1988

*I came here with a suitcase and my big trunk. At home you start saving a little
linen and other odds and ends—I embroidered a lot when I was young. So I had all
my linen and I carried it over with me, because everybody said, "You'll get
married right away in America."*

Johanne Gentsch Kusche, German, at Ellis Island

in 1924, age 24

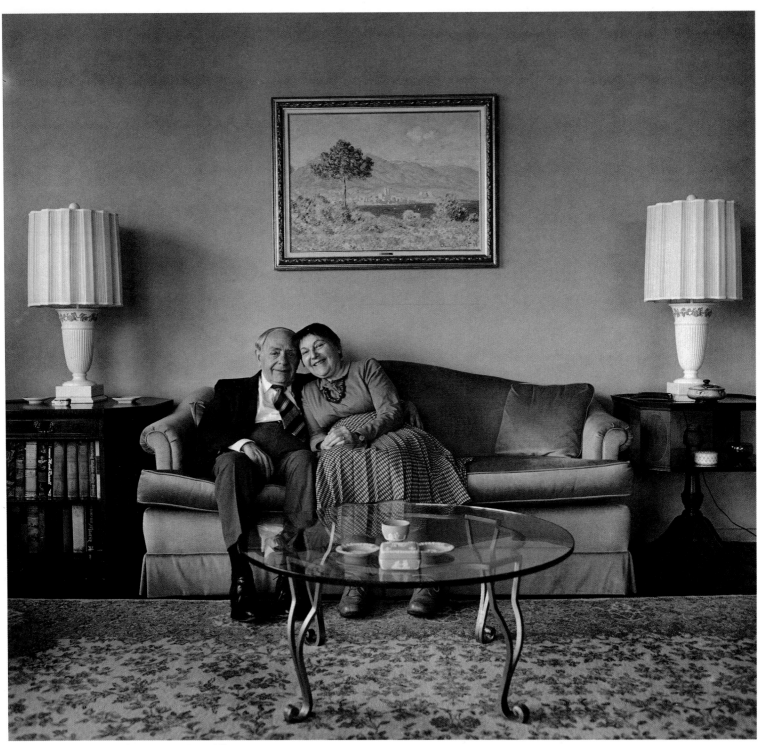

Mariana Cook, *Mr. and Mrs. Joseph Wohlberg*, 1988

We were stuck on Ellis Island over the weekend, when no ferries were running. Around four o'clock on Sunday afternoon they hustled us out into a courtyard where there were chairs set up. They wanted to entertain us with a vaudeville show. We watched magician's tricks, singing, comic acts, most of which we did not understand. When I was a little bored with it all I turned my head to look back and I stayed that way, because behind us was New York Harbor, with all the skyscrapers. It was my first glimpse of Manhattan. I was mesmerized.

Joseph Wohlberg, Hungarian, at Ellis Island in 1921, age 11

At Ellis Island I was allowed to dance with the peasant people who had beautiful costumes, I thought. I was what you call a civilian. I wore little clothes like the children wear now. A tee-shirt and pleated skirt and a little French beret. But I envied the little peasant girls because they had bright shawls and full skirts. But I could do all the dances. I had a marvelous time with them. On the island, there were a number of Ukrainian children, and they had to have their hair taken off. My mother talked fast and furiously and convinced them that I didn't have lice and they let me keep my hair. Cut very short, but not shaved. All these kids with the shaved heads and I played on that island. We went wild. There was one section where there was a boat anchored at the shore and it was full of Chinese people. Men with long pigtails, sinister looking. We dared walk onto the boat and walk around on the deck and down some ladders into a room where the Chinese were sitting on bunks. None of them spoke to us. They just looked at us and we giggled with each other and looked around. We were so bold we weren't frightened. And, of course, what bad things I didn't know they taught me. And what they didn't know I taught them because we were there for five or six weeks.

Mrs. Peggy Dell, Hungarian,
at Ellis Island in 1921, age 10

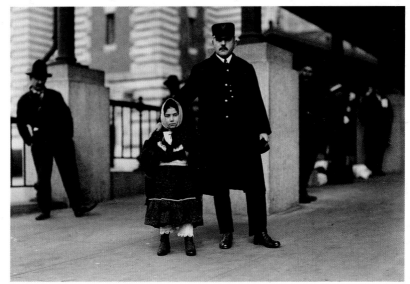

Young girl with Ellis Island official, date unknown

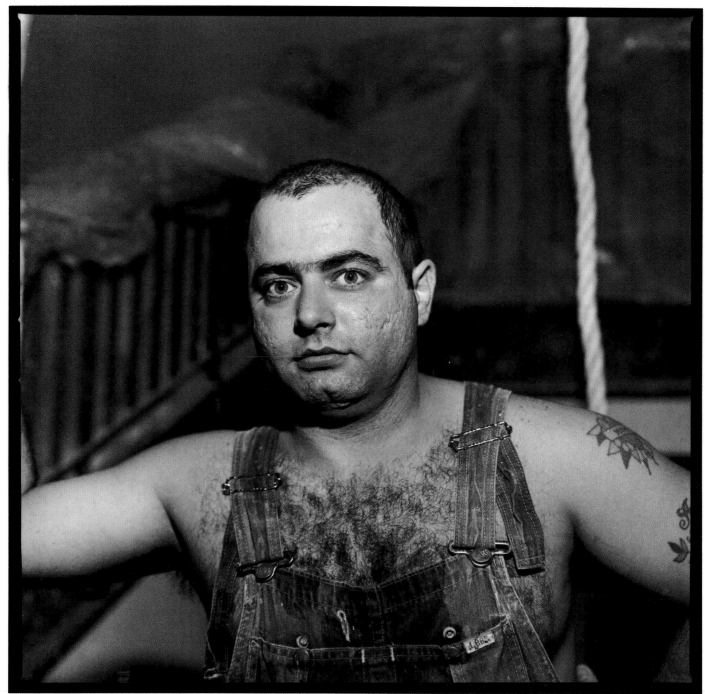

Robert Foster, *Arthur Duclos,* plasterer, 1988

My grandfather came over from Sicily. I don't know if he came with money, but he sure loved this country. He did real well; when he died, he owned three houses. You should call up my mother; she knows all about it. I think he had an ice business.

Arthur Duclos, Plasterer

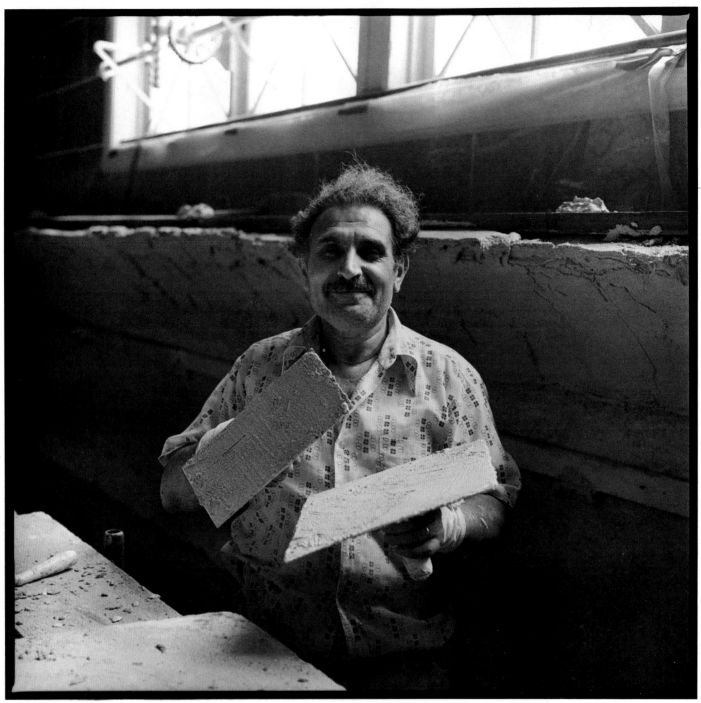

Robert Foster, *Victor Scodes, plasterer*, 1988

*I came to this country in 1938 on an American passport. I came with
my father, who taught me my trade. My father and I are members
of the plasterers' local, and we work on the same jobs.*

Victor Scodes, Plasterer

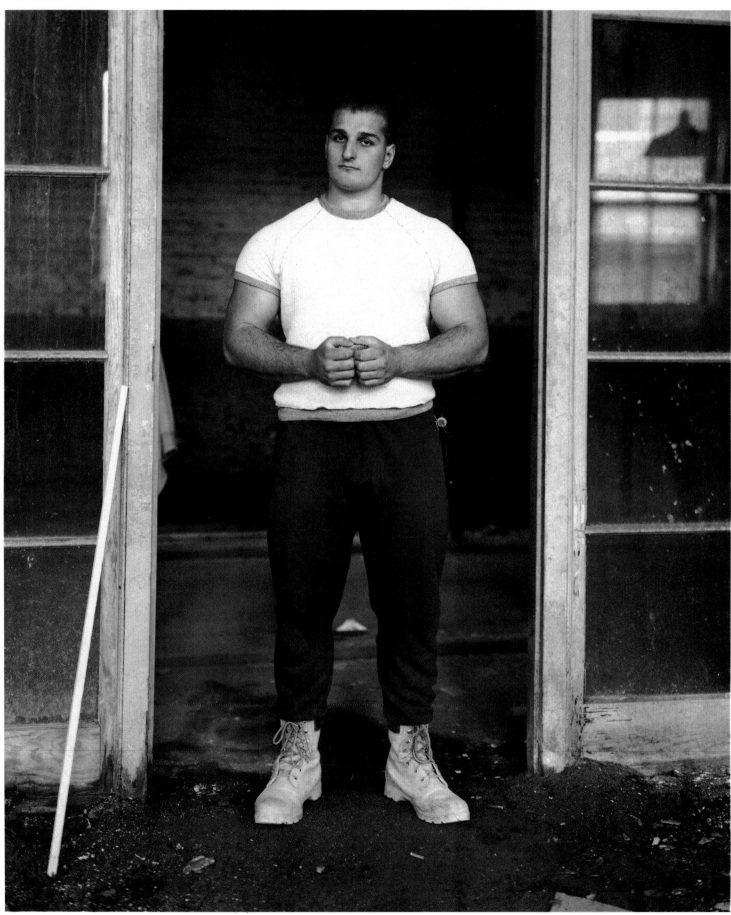

Andrea Modica, *Ellis Island*, 1988

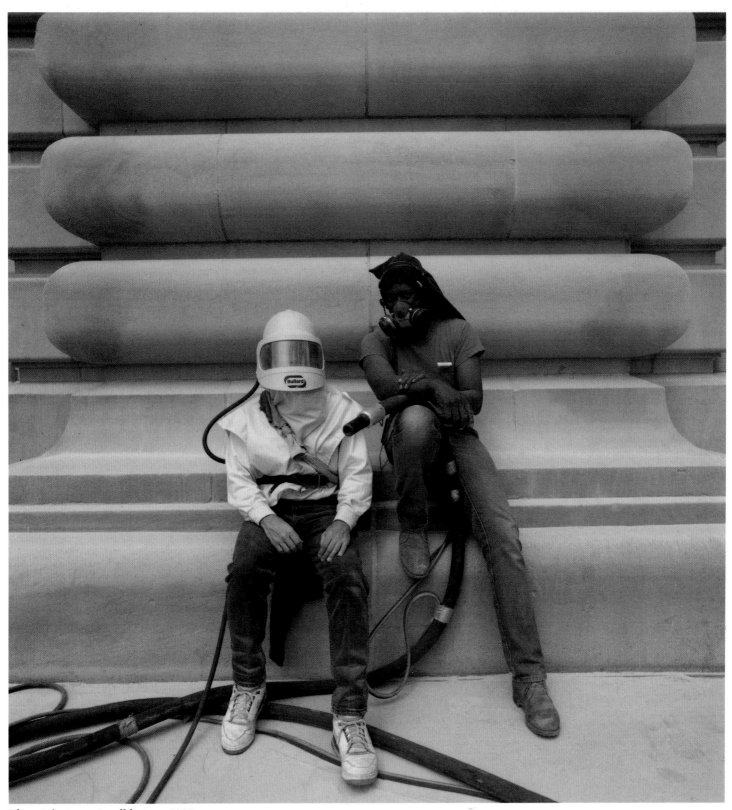

Klaus Schnitzer, *Sandblasters*, 1988

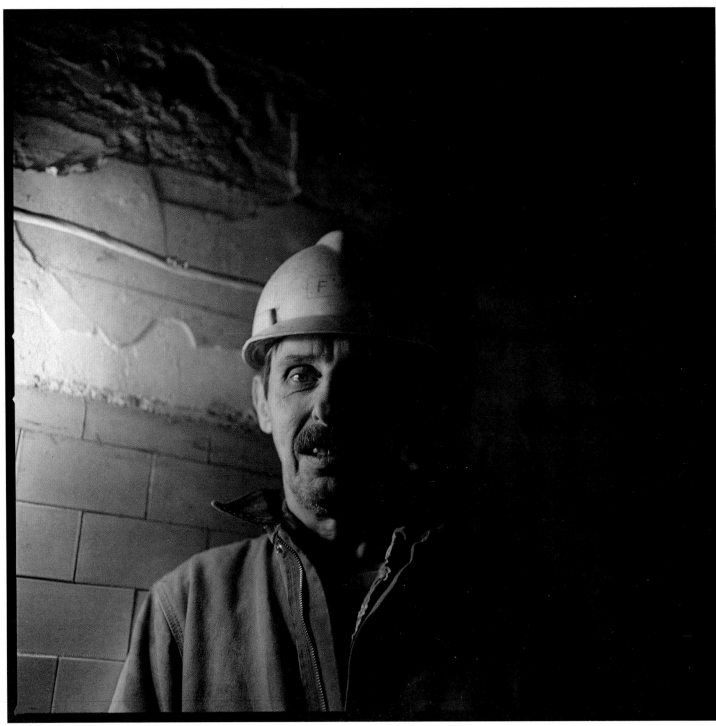

Robert Foster, *Victor Demianycz*, 1988

My mom came over from the Ukraine before World War I. She was the oldest of four sisters, and came to Ellis at the age of sixteen. Nowadays, a sixteen-year-old can't even cross the street, no less travel around the world by herself. At dinnertime, she would talk about her early years in this country, and described how scared she was when she arrived at Ellis and saw all those people in the Great Hall.

The first day I came to work at Ellis, I stood in the Great Hall and wondered what it was like for my mother.

Victor Demianycz, Machinist

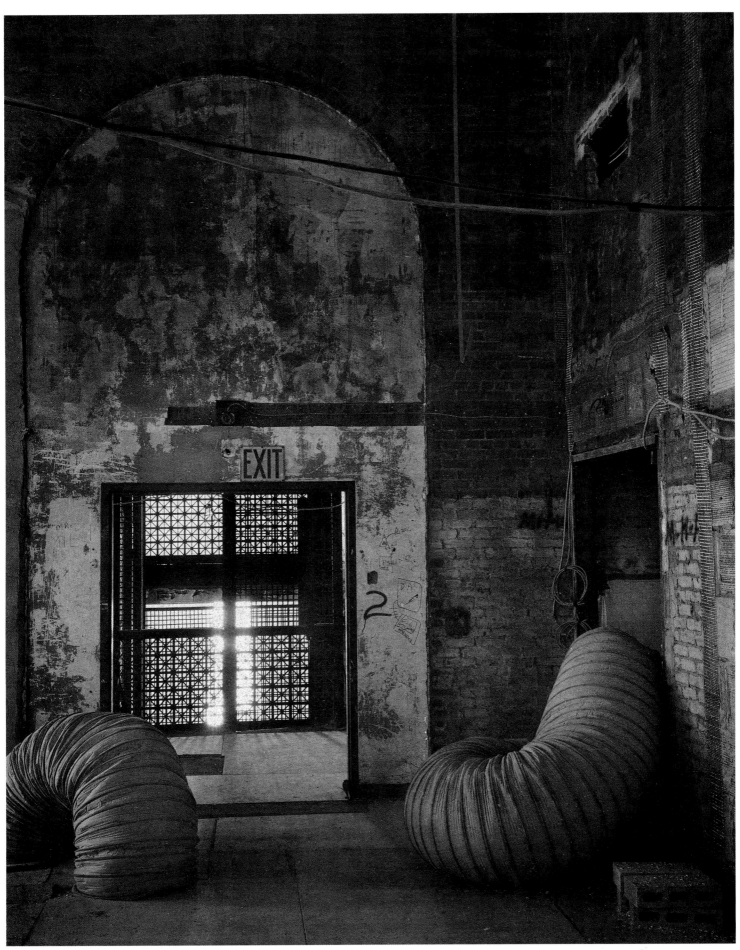

Madoka, untitled, 1988

Niel Frankel, *American Extractor Company*, 1988

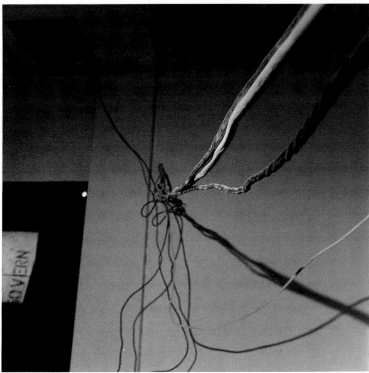

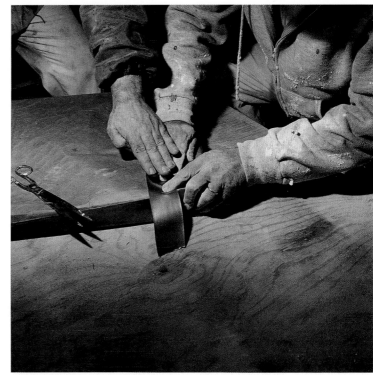

Larry Fink, *Untitled*, 1988

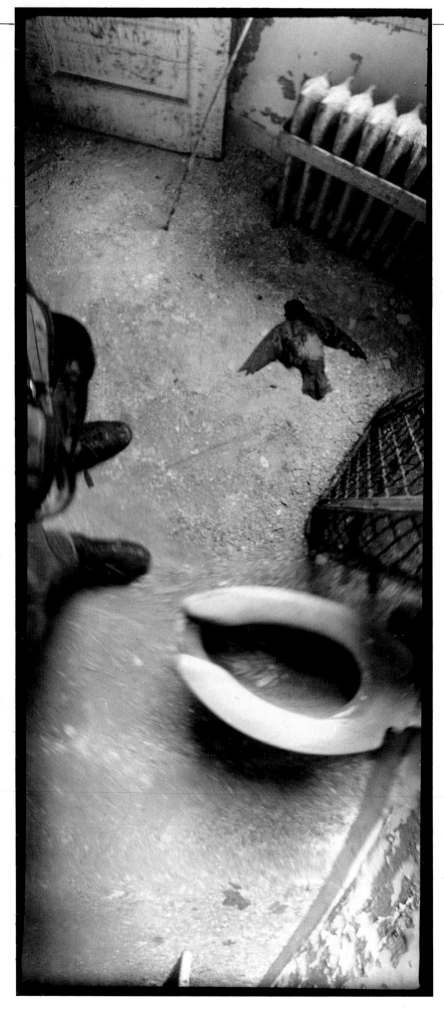

Sylvia Plachy, *Pigeon, Ellis Island*, 1988

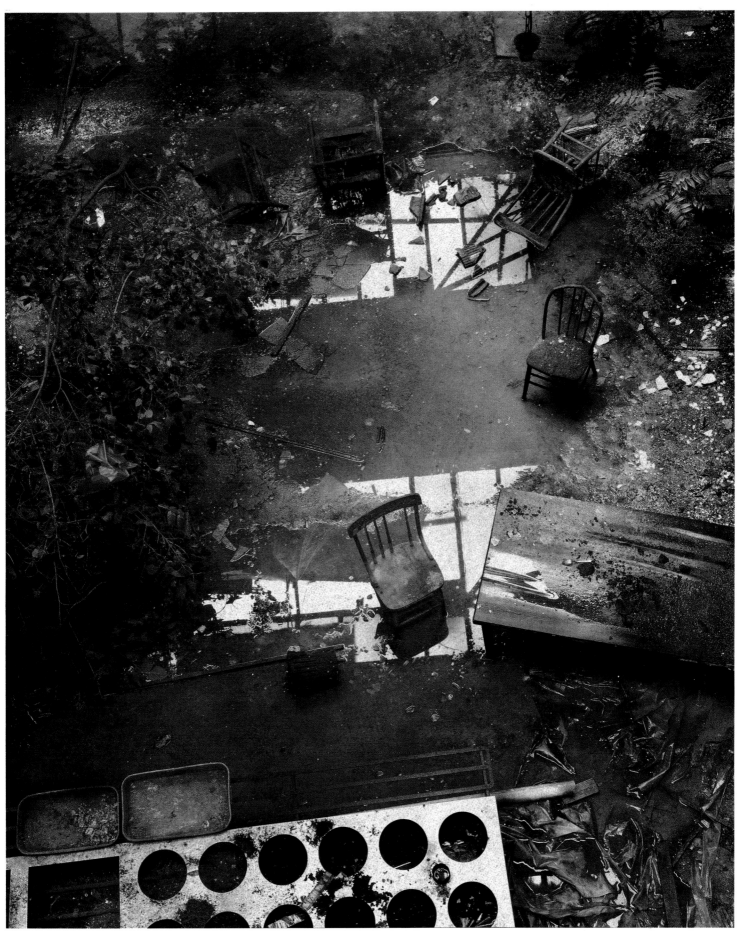

Madoka, *Ellis Island Series, Island 1*, 1988

Maryanne Solensky, *Untitled*, 1983

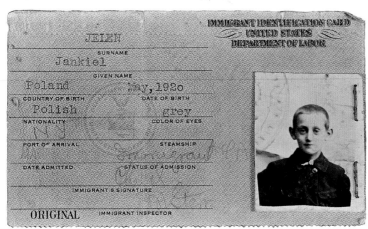

Immigrant Identification Card

Everybody was sad there. There was not a smile on anybody's face. Here they thought maybe they wouldn't go through. There they thought maybe my child won't go through.

Oh, did I cry. Terribly. All my sisters and brothers cried. So I cried. You don't know why you cry. Just so much sadness there that you have to cry. But there's more tears in Ellis Island to ten people than, say, to a hundred people elsewhere. There is all of these tears, everybody has tears.

Fannie Kligerman, Russian, at Ellis Island
in 1905, age 13

Madoka, *Ellis Island Series, Island 3*, 1988

Madoka, *Ellis Island Series, Island 3*, 1988

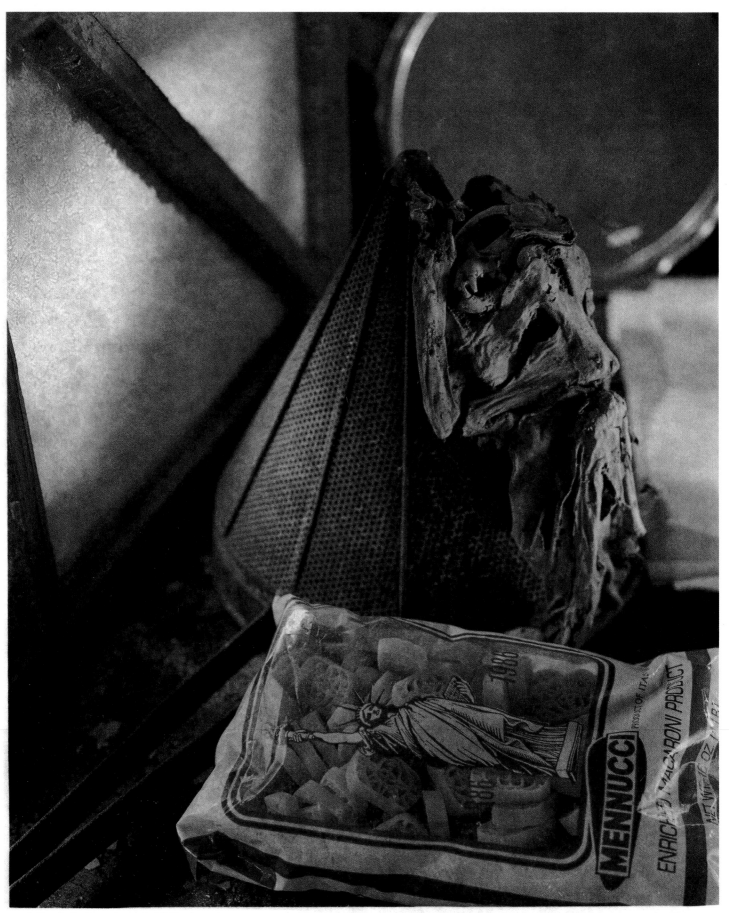

Niel Frankel, *Bicentennial*, 1988

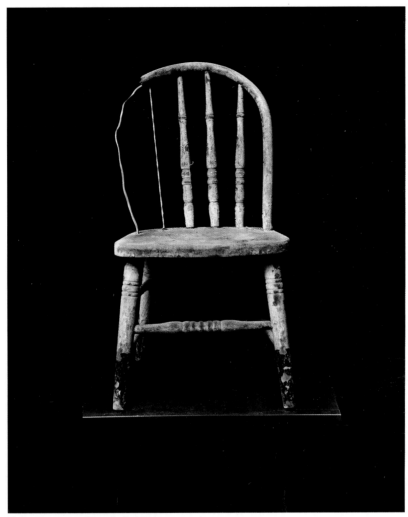

Zeke Berman, *Untitled*, 1988

I walked into a room with hammocks, holding my little basket. A friend of mine had given me a small sailor hat, a going away present when I left home. I put on the hat, attached it with two long hat pins, and walked into the room like a queen. I decided to take a hammock. Then I realized that to lie down, I had to take off my hat. So I remained sitting on the hammock all night because I was afraid that if I moved, it would start to swing. At daylight, I managed to jump down from the hammock still with my hat and my hatpins on. I hadn't slept a wink. When they called us to get in line, I went into another room. Then I saw my sister on the other side of the gate. We knew each other only from pictures because she had left for America before I was born. But here I was, the

greenhorn. I held onto my basket, with my hat pinned on my head. My sister was sure that anyone who would see me would know that I had just got off the boat. She didn't want that. She took everything out of my basket, wrapped it up in paper, put it under my arm and left my basket with my hat there on the dock. I looked back until I couldn't see them anymore. It was my whole treasure.

Celia Adler, Polish/Russian, at
Ellis Island in 1914, age 12

Dutch children, pre-World War I

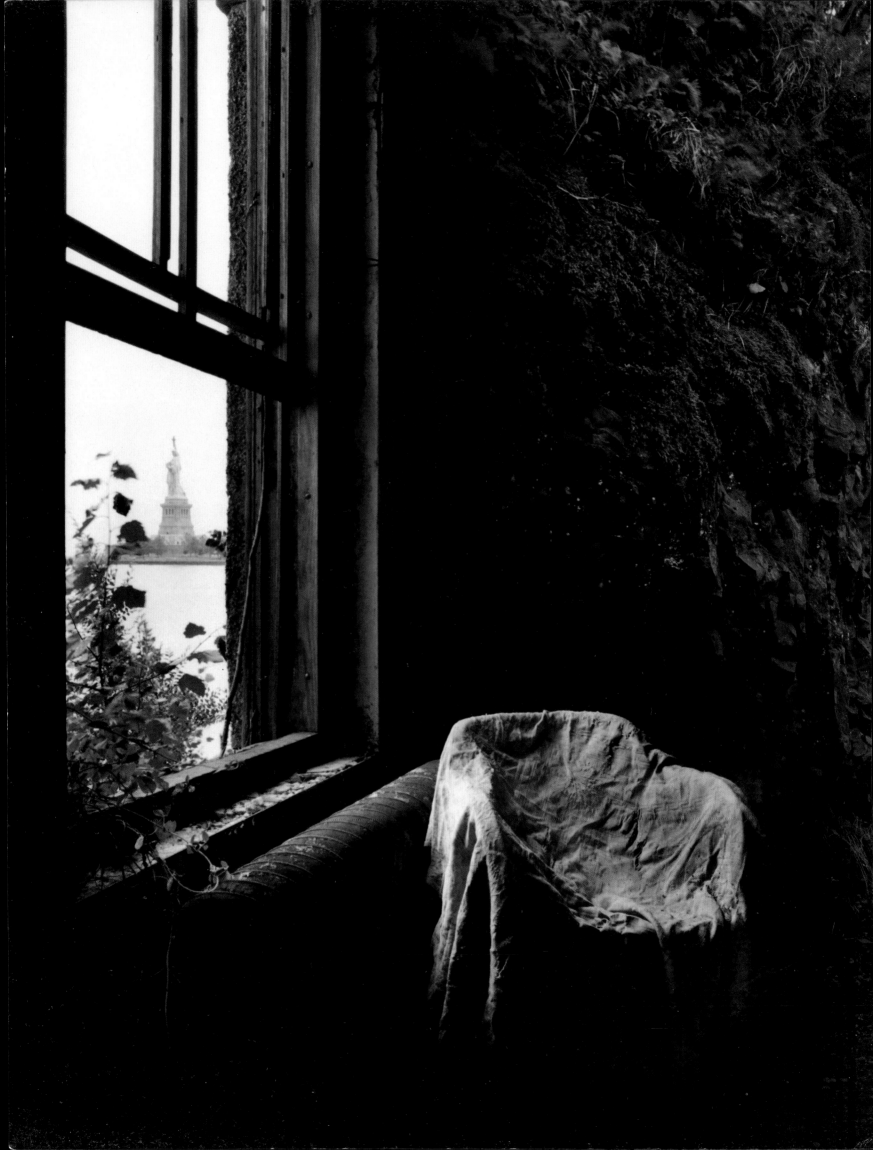

Jerry Uelsmann,
Untitled, 1988

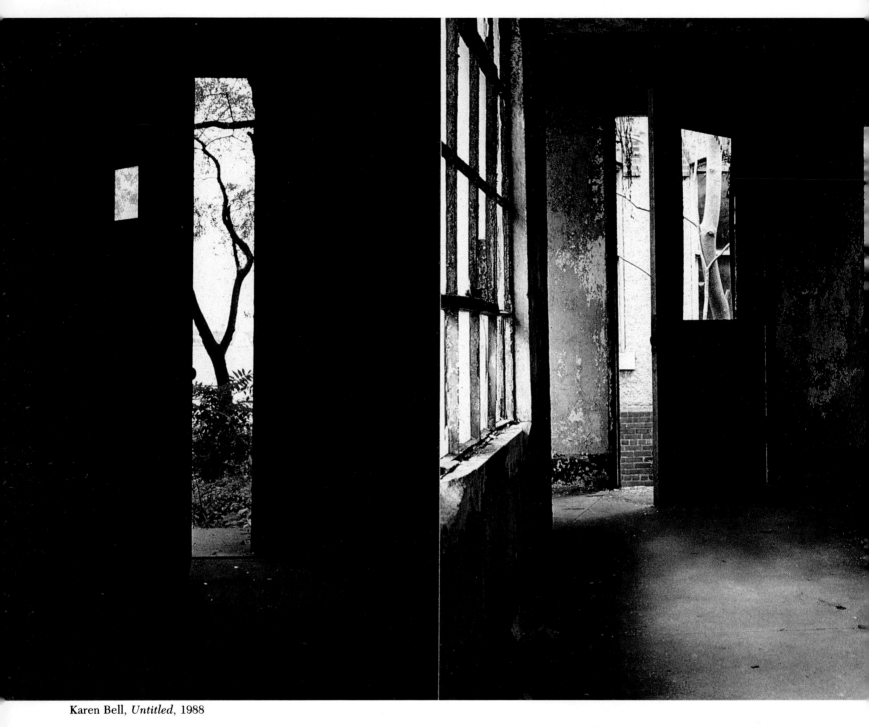

Karen Bell, *Untitled*, 1988

Ellis Island immigrants, date unknown

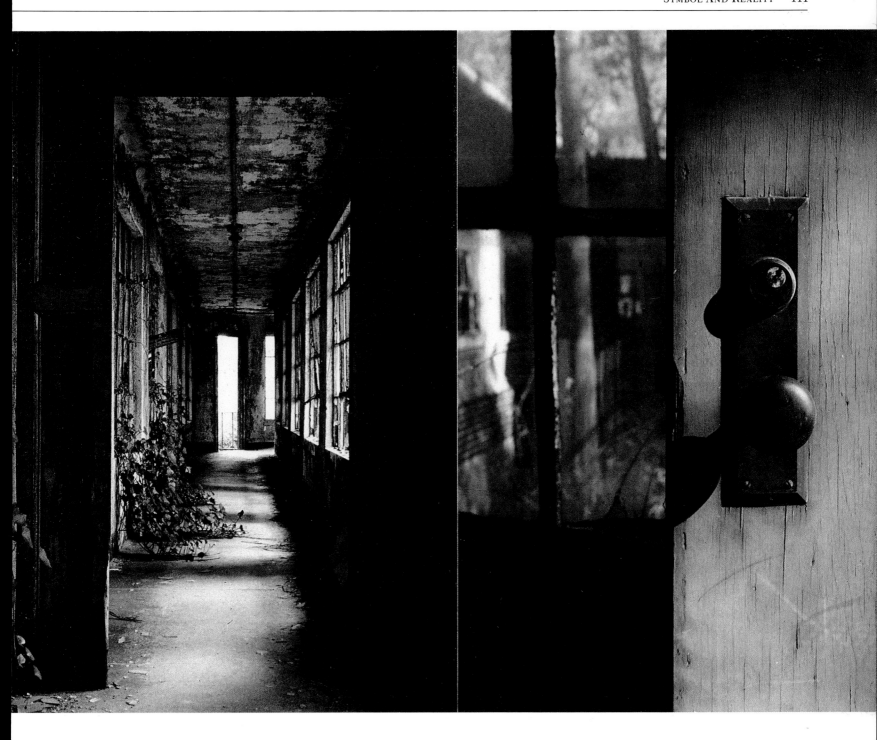

An official-looking lady came toward me and said, "Is somebody waiting for you?" I said, "Oh, yes, my relatives, they're waiting for me." And nobody was waiting for me, nobody. I had nobody. Then I saw the officials approaching another man and they asked him, "Are you Jewish?" He said, "Yes." "Anybody waiting for you?" "No." The official said, "Well, we'll take care of you. We have a Hebrew sheltering organization. Come with us, we'll feed you and take care of you until your relatives pick you up." Then sheepishly I said to the woman who had approached me before, "I lied to you, because of what I've been through in Hungary." She put her hand on my shoulder. She understood. I didn't realize I was free, I wasn't going to be put in prison.

Endre Bohem, Hungarian, at Ellis Island in 1921, age 20

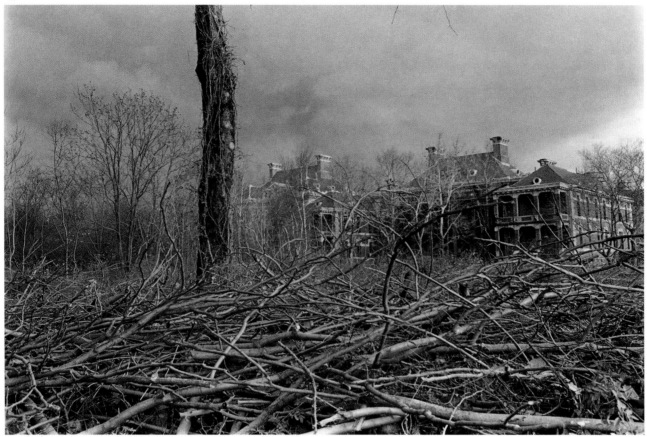

Caroline Kane, *Approaching Storm*, November 1985

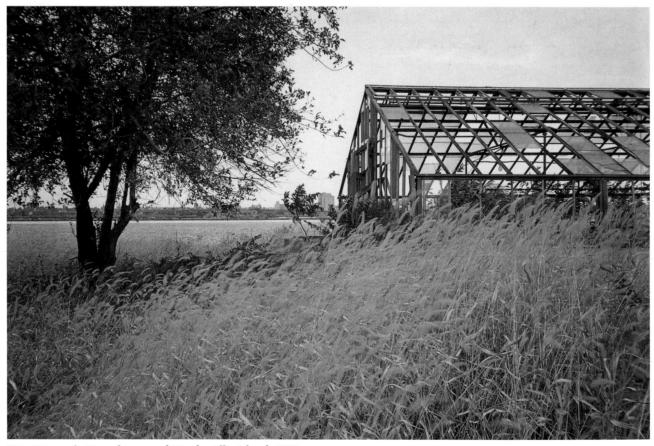

Eric Hummel, *Greenhouse and Weeds, Ellis Island*, 1983

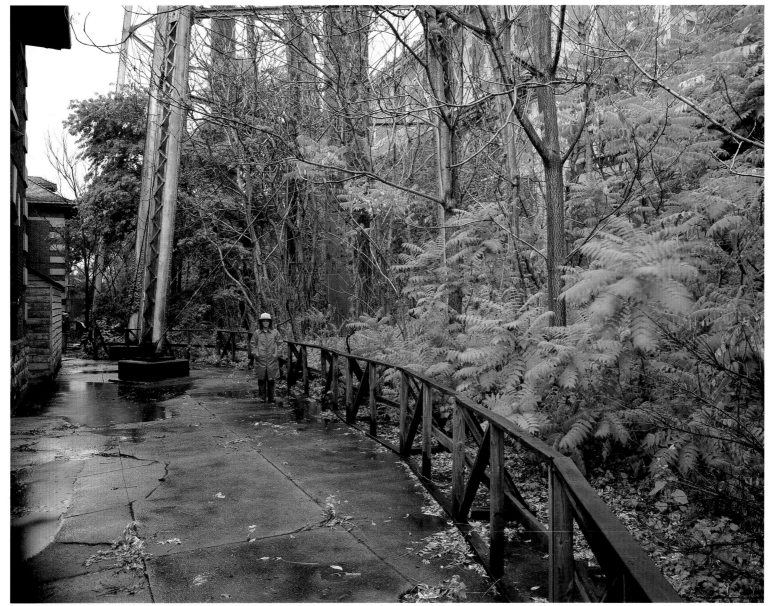

Mark McCarty, *Park Ranger with Water Tower*, 1983

Ellis Island staff on the "roof garden", date unknown

Finally word came that our relatives would furnish the security bond to release us from the island. As soon as we heard that news, they took us away from the waiting room and directed us upstairs, one or two flights up. It was a marvelous change. It was light and there was a fresh air court that was screened in. We were able to go outside and exercise and walk. We had fresh air and a wonderful view of the Statue of Liberty and all the boats going back and forth.

Inge Nastke, German, at Ellis Island in 1922, age 10

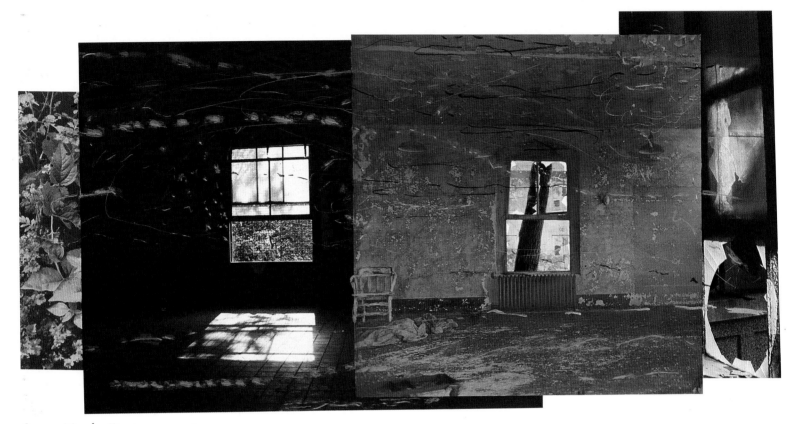

Geanna Merola, *Empty
Rooms, Ellis Island*, 1988

*At nighttime, my mother, being a female, had to be separated from her three children. She
was put with the women. The three boys, and I was the oldest, sixteen, and the youngest,
Joe, about ten, we had to stay with the men. The sleeping quarters were just bunks, one on
top of each other. Naturally, the old residents, who knew exactly what they wanted, would
always pick the lower berths and you had to climb to the very top. They offered you two
grey army blankets. It was Memorial Day, early spring, but we were right on the East River.
It got very cold. Then all of a sudden, here we were, three kids, one close to the other, and
all of a sudden in the middle of the night feeling a jerk and somebody took off your blankets
because whoever was strongest made sure he was warm at the expense of whoever couldn't
protect himself. In the morning we got together with our mother for breakfast and the only
thing we could do, all four of us, was cry.*

Herman Gold, Argentinian, at Ellis Island in 1924

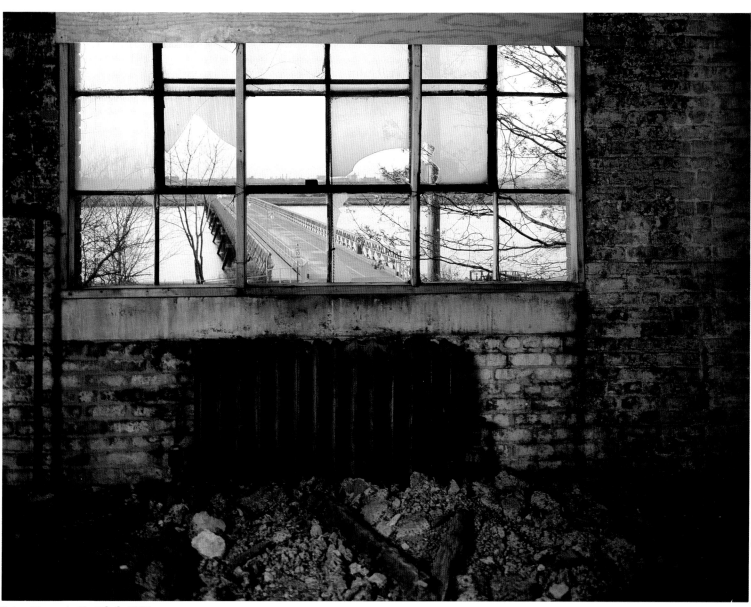

Brian Feeney, *Untitled*, 1988

Nancy Rosing-Saint Paul, *Administration building,*
Contagious Disease Wards, Island 3, 1988

The day after I was put in the hospital they said to my grandfather, "Your case has been cleared and you can leave the island." My grandmother said, "Under no circumstances will I leave the island until my granddaughter has been released." The officials told her, "I'm sorry, Mrs. Schramm, but we have to go by the rules. As soon as your case is cleared you must leave immediately because there are so many people coming in and we must have room for them." My grandmother had a fit but it didn't help. She had to leave the Island of Tears in tears. Fortunately, she had made friends with a German couple who invited her and my grandfather to stay with them until I was released. Five weeks later I was let out. The nurse took me

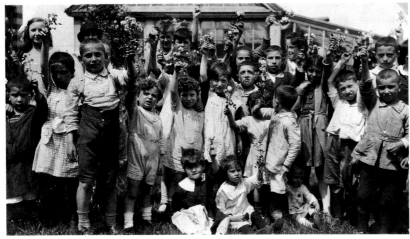

Immigrant children at play, 1920s

to the huge waiting room and I ran to the far side of the area, but no grandmother. And I asked the people who were waiting, "Where is Mrs. Schramm, where is Frau Schramm?" No one had heard of her. No one there was familiar to me and I was a perfect stranger to them. All of a sudden somebody took me by the arm, whirled me around, and said, "Where in the world did you come from?" She was the matron, the overseer. I explained, "I have just been released from the hospital and I thought my grandparents

were here waiting for me." "Oh, your grandparents? I'm sorry, child, but they were released many weeks ago." This struck me so badly that I totally broke down. "Oh," she said, "Don't cry, we're going to fix you up." You see, in their excitement, my grandparents had taken my winter clothes and my coat and my hat. She took me down the hall and she had a huge bunch of keys around her waist. She opened the door with one of the keys and we were in a large room with a huge pile of clothing, brought there by the Salvation Army, Goodwill Industry, and the Red Cross. She said, "Now, you try on a coat." I tried on coat after coat. Either it was for the romper set or too big for me. Finally she pulled out a long green wool coat,

which reached down to my heels. When I looked at myself in the oval mirror I almost started to cry. She said, "I'm sorry we don't have your size, but it's warm, that's the main thing." She took me to the huge vestry hall and I waited there. By and by, someone came in and hung a tag around my neck with all the pertinent information. Then the official said, "Follow me, you will be brought to Manhattan."

Inge Nastke, German, at Ellis Island in 1922, age 10

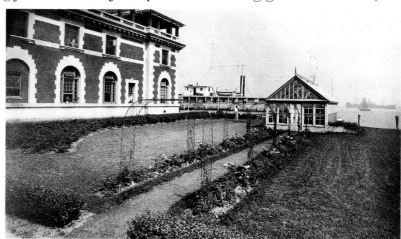

View of garden with greenhouse, circa 1910 (Edward Levick)

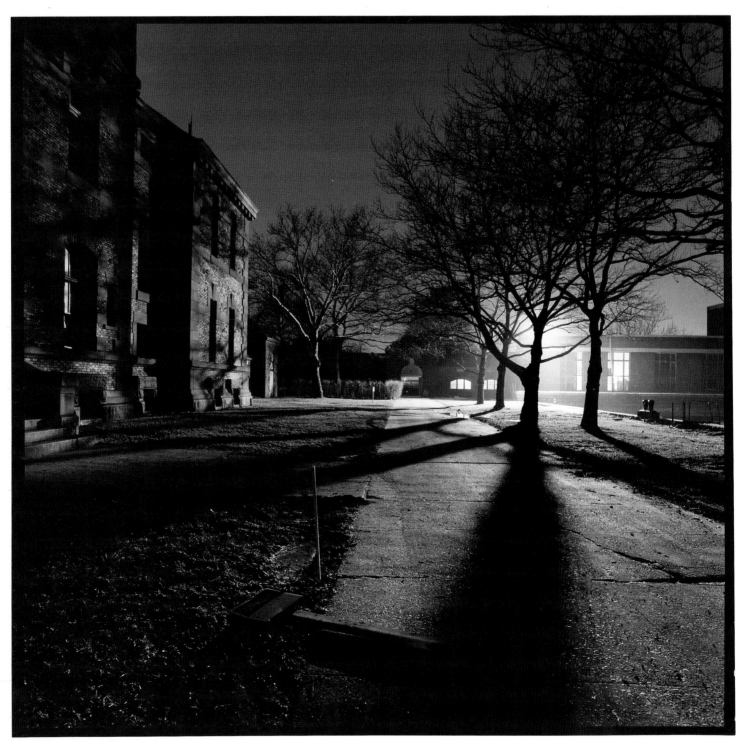

Jan Staller, *Untitled*, 1988

Roger Mertin, *View: Looking Southwest, Ellis Island, Island 3, 1988*

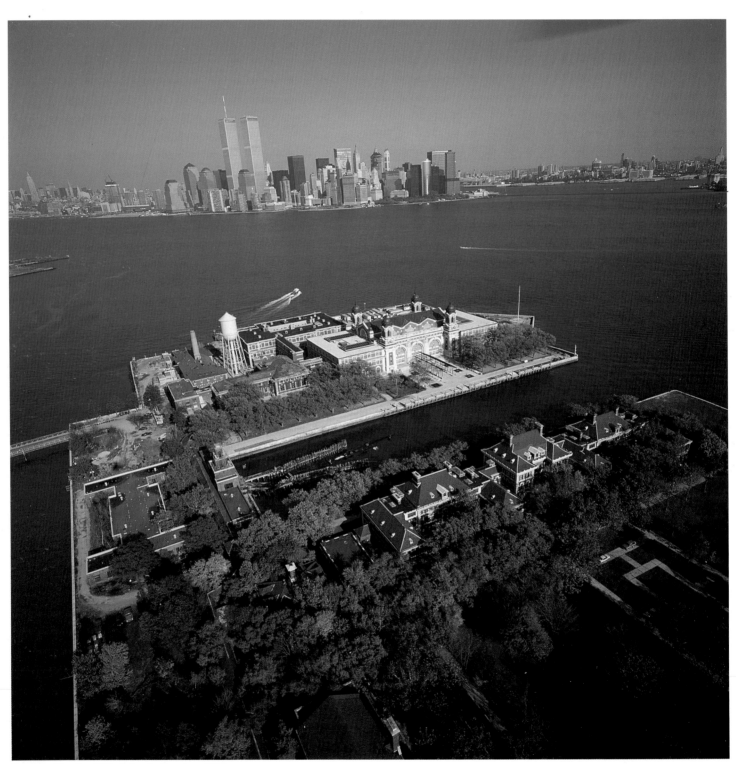

Emmet Gowin, *Ellis Island*, October 1988

The small white steamer, Peter Stuyvesant *that delivered the immigrants from the stench and throb of the steerage to the stench and throb of New York tenements, rolled slightly on the water beside the stone quay in the lee of the weathered barracks and new brick buildings of Ellis Island. Her skipper was waiting for the last of the officials, laborers and guards to embark upon her before he cast off and started for Manhattan. Since this was Saturday afternoon and this was the last trip she would make for the weekend, those left behind might have to stay over till Monday. Her whistle bellowed its hoarse warning. A few figures in overalls sauntered from the high doors of the immigration quarters and down the grey pavement that led to the dock.*

It was May of the year 1907, the year that was destined to bring the greatest number of immigrants to the shores of the United States. All that day, as on all days since spring began, her decks had been thronged by hundreds upon hundreds of foreigners, natives from almost every land in the world, the jowled close-cropped Teuton, the full-bearded Russian, the scraggly-whiskered Jew, and among them Slovack peasants with docile faces, smooth-cheeked and swarthy Armenians, pimply Greeks, Danes with wrinkled eyelids. All day her decks had been colorful, a matrix of the vivid costumes of other lands, the speckled green-and-yellow aprons, the flowered kerchief, embroidered homespun, the silver-braided sheepskin vest, the gaudy scarfs, yellow boots, fur caps, caftans, dull gabardines. All day the gutteral, the high-pitched voices, the astonished cries, the gasps of wonder, reiterations of gladness had risen from her decks in a motley billow of sound. But now her decks were empty, quiet, spreading out under the sunlight almost as if the warm boards were relaxing from the strain and the pressures of the myriads of feet. All those steerage passengers of the ships that had docked that day who were permitted to enter had entered.

Henry Roth,
Call It Sleep, 1934

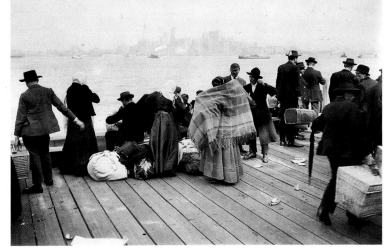

Leaving Ellis Island, 1912

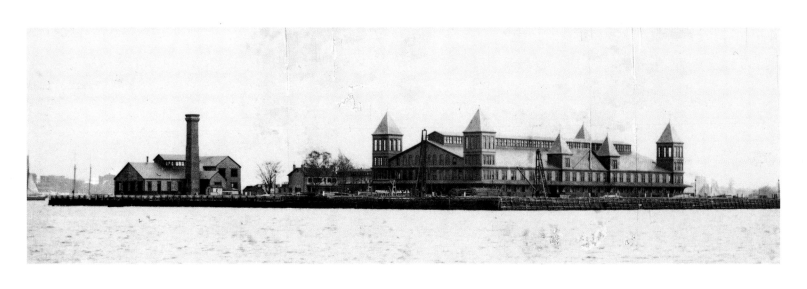

SOUTH ELEVATION
Main Building, Ellis Island

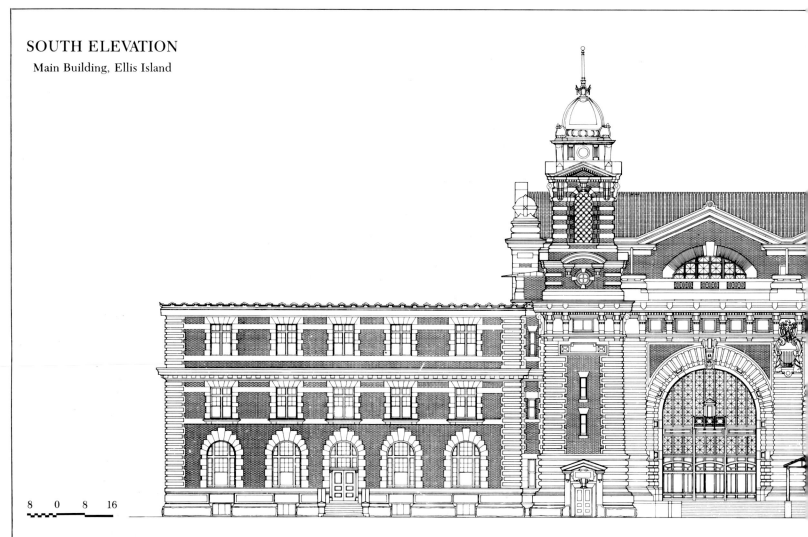

8 0 8 16

Ellis Island: An Architectural History

By ROBERT TWOMBLY

"During the ride across the bay, as I watched the faces of the people milling around me," said former United States Commissioner of Immigration Edward Corsi recalling his own arrival as an alien in New York in 1907, "I realized that Ellis Island could inspire both hope and fear. Some of the passengers were afraid and obviously dreading the events of the next few hours; others were impatient, anxious to get through the inspection and be off to their destinations."[1]

To immigrants, Ellis was both an "Isle of Tears" and an "Island of Hope"—and the two

The original wooden main building at Ellis Island (left) which burned to the ground in 1897, was replaced in 1900 by a classically inspired "French Renaissance" edifice, restored in the 1980s to its original appearance (below).

faces it showed the world were equally real: In one direction it faced the Statue of Liberty, that welcoming beacon for "huddled masses yearning to breathe free"; in the other it looked toward lower Manhattan with its densely packed, ominously gray buildings, as forbidding as it was beckoning.

The two faces of Ellis Island reflected government policy for immigrant processing. Newcomers in first- or second-class cabins were given brief, shipboard examinations without ever setting foot on the island itself. The overwhelming majority, however, passed

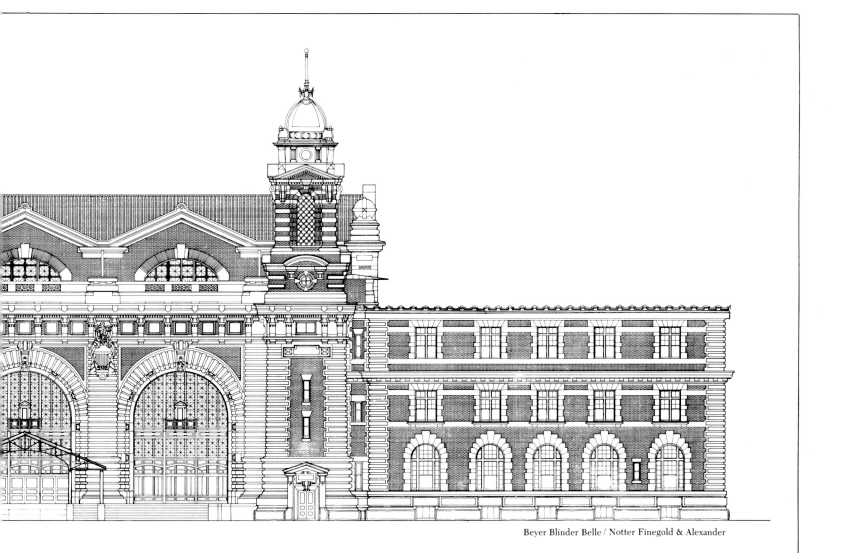

Beyer Blinder Belle / Notter Finegold & Alexander

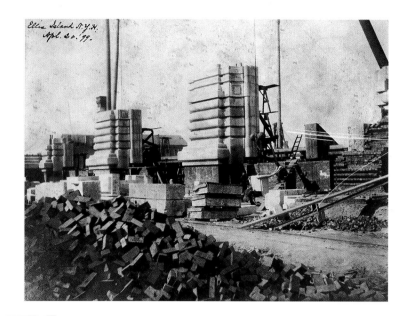 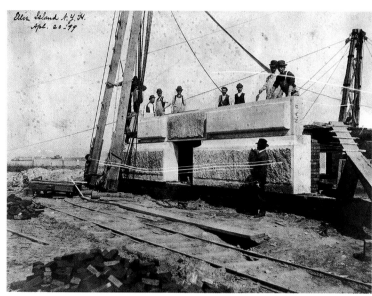

through the still-standing main edifice, opened in 1900. During the next fifty-four years, some twelve million steerage and other passengers were inspected, questioned, and—if among the unlucky five to ten percent suspected of physical, mental, or political aberration—labeled accordingly. On average, ten percent of all arrivals were detained overnight, some for weeks of nights, before boarding a ferry for New York or New Jersey, or being returned home.

Even before the restrictive Immigration Act of 1924, by which time the vast majority of people had passed through, Ellis Island had begun to show its two faces with almost equal frequency. German nationals during World War I and foreign-born "radicals" in the ensuing "Red Scare" were interned there, so that by 1924 it had also become a place of departure for deported aliens and detention for alleged subversives. In 1941 the island was in part turned into a holding center for suspected enemies and in 1950 for those charged with violating the Internal Security Act. In sum, for more than half its history as a federal facility before closing in 1954, Ellis Island was often perceived as an "Isle of Tears."

But even as an "Island of Hope" its architecture had a two-sided quality. "Now that the Government has committed itself to a policy of discouraging immigration," *The New York Times* reporter Charles de Kay wrote in 1898 after inspecting plans for the soon-to-be-built main edifice, "it finds means to prepare such quarters for the reception of the foreigners it does not seem to want as were never seen before on this side of the Atlantic," that is, "a palace far handsomer than many of those . . . in the Old World." Allowing for de Kay's chauvinism and for what might have been a get-tougher-than-usual period at the island, the fact is that the new building was, as he also wrote, "a handsome work

of art."[2] Handsome but Janus-like—two-faced— resembling the orientation of its tiny landmass and the attitudes it represented. Designed to intimidate while it inspired, the immigration station was in fact "a palace," welcoming some newcomers while instilling fear in others.

Immigrants, after all, were simultaneously sought after and spurned in America. Employers, manufacturers, tenement owners, churchmen, urban politicos, and those with something to sell were among the many wanting their labor, their money, their souls, and their votes. But there were others who shunned newcomers for precisely the same reasons or because of darker, more sinister, considerations. After 1900, as the sources of migration shifted even more dramatically to southern and eastern Europe— to non-Protestant, non-English-speaking places —many of those favoring an open-door policy expressed increasing dislike for the people passing through. The architecture at Ellis Island was designed in and was affected by this dichotomous social context: If Uncle Sam extended a hand in greeting, he stood ready to pull it back from people he did not trust.

The most impressive space in Ellis Island's main building was the Registry, or examination room, on the second level, two hundred feet long, one hundred feet wide, and topped by a fifty-six-foot vaulted ceiling. On the floor, in its heyday, twelve narrow aisles channeled the crowd waiting for inspection. Three elaborate electroliers suspended from the ridge line supplemented eight semicircular windows rising from a gallery that ringed the room. The scale, the noise, and brightness must have inspired awe among those who had never experienced artificial light or witnessed such a vast space, except perhaps in church.

And it may have been the cathedral-like

Between 1898 and 1900 the new main building, of fireproof red brick and limestone, was erected at Ellis Island (above and near right). Monumental in style, the structure was similar to other contemporary turn-of-the-century public buildings, among them the New York Public Library (far right) and Pennsylvania Railway Station (below, right).

(Footnotes appear on page 147)

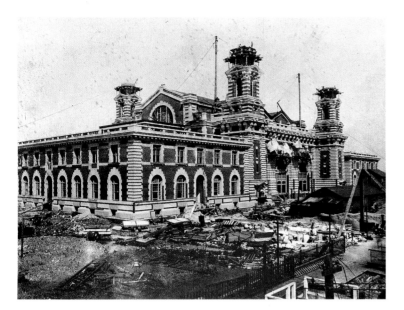

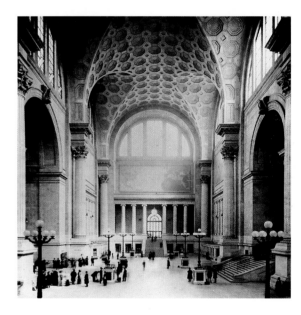

quality of the Registry Room that impressed people most. On the one hand, there was the "hell"—if only imagined—of the fearful inspection that would determine one's future, and on the other, the vaults soaring heavenward. As in church, redemption was available, but at a price. If landing on American shores was like entering the "promised land," then it was reasonable to demand that newcomers reveal their flaws to the guardians of the "golden door."

The great hall was not the first architectural experience for arrivals, however. Disembarking from steamers a few feet from the front entrance, they had already seen the classically inspired "French Renaissance" facade whose four prominent towers loomed larger as they sailed up the harbor. By the time they had passed under the glass and cast-iron canopy, through the high, triple-arched entry pavilion adorned with imposing sculpture, and were taken up the broad stairway to the Registry Room, they had received visual instruction in humility, one of several architectural lessons that had first been taught in a predecessor building, Ellis Island's original processing station.

The 1900 edifice was designed to replace a twelve-unit complex with minor service facilities that had burned down three years previously. Opened on January 1, 1892, in response to the Immigration Act of 1891 whereby the federal government ended dual federal-state control of immigration, the original Ellis Island station became the principal United States installation for the Treasury Department's new Bureau of Immigration. While the new facility was being constructed at an ultimate cost of $739,671, arrivals were processed in the old Barge Office customs house at the Battery.[3]

During its short five-year life span, close to one and a half million people passed through the Port of New York, 445,987 in 1892 alone, of which some eighty percent stopped at Ellis Island, according to a leading authority on immigration. Although newspapers said the main building could handle up to fifteen thousand people a day, it never dealt with anywhere near that number, even though it seemed more than roomy. The ground floor of the two-storey structure, in plan 404 by 154 feet, was entirely devoted to baggage transfer. Above that was the railway ticket office, the inspection room, detention facilities, offices, and lunch counters. The four-storey towers at each corner contained stairwells, but were primarily intended to be ornamental. The only official actually living on the island was the surgeon housed in the former naval gunner's residence, remodeled from the days when Ellis had been a powder storage depot. Other new structures, in addition to several old converted buildings, were three hospitals, a boiler house, and a tank and coal house. At the western end of the island were disinfectant facilities for

When Ellis Island closed in 1954, several architectural schemes were proposed for its development: Philip Johnson suggested a "Wall of the 16 Million" (above, left); an architectural student at Pratt offered a nuclear power plant (above); and Taliesin Associated Architects, successor to Frank Lloyd Wright, proposed a fantasy megastructure called "Dream City" (below, left).

"steaming filthy clothing" and providing hot and cold baths and showers.

The first official arrival, a young girl named Annie Moore of Cork (who received an elaborate ceremony and a ten-dollar gold piece) and her more than one thousand fellow travelers on opening day, confronted an "enormous building" that was said to be of "no particular style of architecture." Describing it shortly before completion, one observer deemed it "temporary in character" because of its wood construction— from some four million board feet of lumber— which he said was typical of government niggardliness when it came to public structures. Niggardly with materials, perhaps, but not with New York soil. In the process of leveling the old naval magazine and adding an L-shaped sea wall to make a slip large enough for two substantial vessels, the Treasury Department expanded the original three-acre, vaguely egg-shaped island to a rectangle of fourteen acres (using, many people claim, dirt from subway excavations).

The main building, "temporary" only because it was so unexpectedly short-lived, offered several architectural themes taken up by its 1900 replacement. Aside from its large scale and imposing towers, shiploads of immigrants confronted a facade made to look the more impressive by its "bands of galvanized iron to a height of five feet. From that point above the sides will be [and were] slate. The roof will be composed of the same material."[4] After entering the south side of the building, arrivals were shown to the main stairs taking them to one of ten aisles in the vast hall staffed by registry clerks. Those detained were held in a wire-screen pen; those admitted were placed in similar enclosures according to whether the next leg of their journey went east or west.

Inspection, classification, and labeling were not the only objectives to be established by a coincidence of architecture and policy. "A gallery which extends completely around this [second] floor will allow an inspection of the immigrants by the immigration authorities or others interested," *The New York Times* reported, "without the necessity of actual contact with them." Contact was certainly to be avoided, and was entirely unnecessary, if from their elevated perch officials could successfully detect those "immigrants who are opposed to bathing on

general principles" and who would henceforth "either have to stay at home or overcome their prejudices when they land . . . for a bath will be compulsory for those whose appearance indicates that they need it."[5] It was never officially acknowledged that filthy steerage did not ordinarily provide adequate bathing facilities. If some passengers arrived dirty, the assumption was that they did so on "principle," that they were "prejudiced" against cleanliness; in other words, that they were either recalcitrant or barbaric. Bathing was therefore more than simple grime removal. It was a symbolic act of moral instruction and of establishing power relations. Observed from on high, grilled via interpreters and herded into pens, newcomers quickly perceived something about the way things worked in their adopted homeland.

Although it is difficult to know the extent to which new Americans were affected by their first architectural contact with the United States, others grumbled about the building from day one. Railway clerks complained it was too big, forcing them to run about assembling passengers for New Jersey ferries. Perhaps their complaint was not to be taken seriously, but within weeks after opening, more troublesome problems surfaced. Convinced that the huge edifice was in danger of imminent collapse, the chairman of a joint House-Senate investigating committee, refusing to accept a federal inspector's report that it was structurally sound, hired his own architects to examine the work and materials at the Ellis Island complex. Robert Nielson and John Parker reported in May 1892 that the "main building was badly constructed, the materials very bad, the foundation insecure, particularly that portion resting on wood piles, and the roof leaky, weak, and too flat." The section on piles "could not possibly last more than ten years, and probably not more than five." Heavy wind or snow loads could cause roof collapse. Specification standards had been blithely ignored, furthermore: doors calling for three brass hinges were hung with two; flooring was omitted in the basement; boiler plate and speaking tubes, though paid for by the government, were nowhere to be found. It would take $150,000, the architects concluded, to put things right.

Accusations flew back and forth for the rest of the building's short life. Although a House

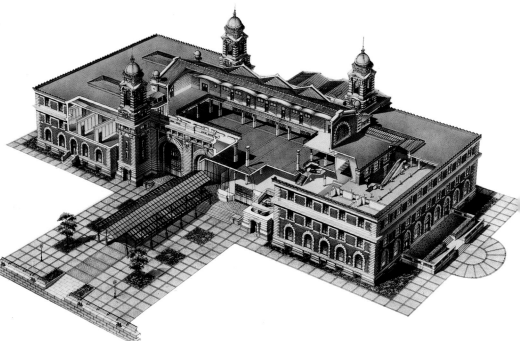

committee concluded in July 1892 that the Superintendent of Construction had been woefully inexperienced, that Treasury Department and Immigration Bureau officials had evidenced "recklessness in the handling of public money," and that the whole facility was shoddily built except for the hospitals, nothing happened other than a few resignations. In May 1895 the Supervising Architect's office in Washington sent John J. Clark, a Massachusetts architect, to investigate the island yet again. When he reported that the roof was in good shape, island employees asked why they were always getting rained on. Rumors of faulty construction and financial chicanery persisted. No instance of fraud was ever conclusively proven at law, but the original Ellis Island buildings remained an albatross on the ship of state.[6]

As if potentially dangerous conditions were not bad enough, the detainee capacity was also seriously overburdened. Federal Superintendent of Immigration Herman Stump, formerly the Maryland Representative leading the House investigations, reported in April 1896 that congestion had reached epic proportions. Recently, eight hundred people had been held overnight in a dormitory built for 250 because the usual detainee rate of one to two percent had suddenly shot to ten percent as a result of "more rigid" inspection: "So many of the recent arrivals are of an undesirable class," he explained. "This is especially true of the Italians, who are flocking to our shores to escape service in the Italian armies in Abyssinia. . . . With the exception of the Italians, the immigrants now coming here seem to be of a superior class." Stump announced that contracts were about to be let for adding a 250-bed dormitory storey to the detention house with a connecting bridge to the main building. Washington architect J. Crawford Nelson had drawn the plans.[7]

Before those plans could be realized, however, fire broke out in the restaurant and kitchen shortly before midnight on June 15, 1897. The main building of spruce, Georgia pine, and galvanized iron collapsed within the hour, and with it everything else on the island except the surgeon's quarters, engine house, and electric light and steam plant. Perhaps this was a blessing in disguise, burying in ashes forever proof of prior malfeasance. If the architectural report of

1892 had been accurate in predicting the building's collapse in five years, then its time had come anyway.

Although there were 191 detainees being held at Ellis overnight, no one was hurt. Within a few weeks, Inspector of Public Buildings John L. Smithmeyer announced that three replacement buildings—this time in brick, stone, and steel—would cost an estimated $600,000. Newspapers reported in August 1897 that all would be ready for occupancy in 1898, but only the plans were completed by then. Construction would take another two years.

According to the Tarsney Act of 1893, commissions for federal buildings would only be awarded after design competitions, held among at least five architects. The winner would oversee construction, although final authority would remain in the hands of the Supervising Architect in the Treasury Department. The winner of the Ellis Island competition, the New York firm of Boring & Tilton, produced its plan in 1898 and saw its building open on December 17, 1900. Not only did their concept extend traditions established in the previous structure, but it also drew on themes quite familiar in American public architecture.

The "main and central feature" of Boring & Tilton's Ellis Island registry building, according to *Architectural Record* in December 1902, "is the same as that of a railroad station, the requirement of 'landing,' collecting and distributing great and sudden crowds with a minimum of confusion or delay." The comparison was a good one, for crowd control and circulation was indeed "the primary problem, like that of the railway station only even more urgent." Boring

In 1984 the architectural firms of Beyer Blinder Belle and Notter Finegold & Alexander, working with the National Park Service, proposed restoring the Registry Room to the 1918–1924 period, seen in the center of the cutaway rendering above.

In January 1987 an opening was cut for a new stairway to link the ground-floor baggage room and the vaulted Registry Room (right). (Photographs on pp. 129–136 by Christopher Barnes)

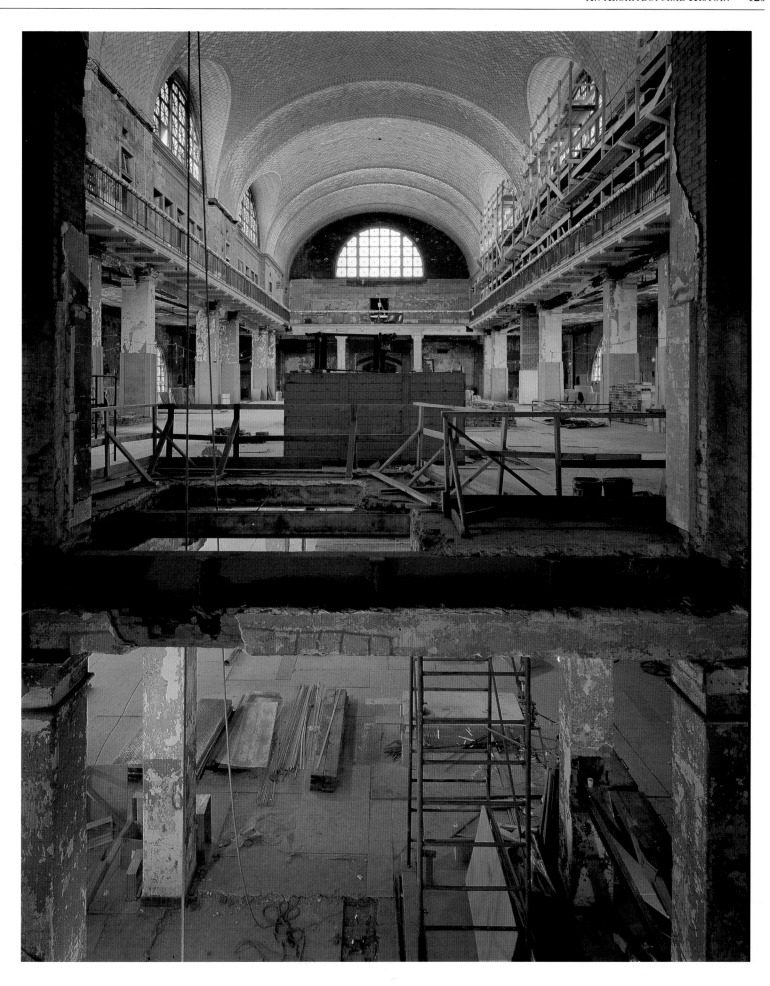

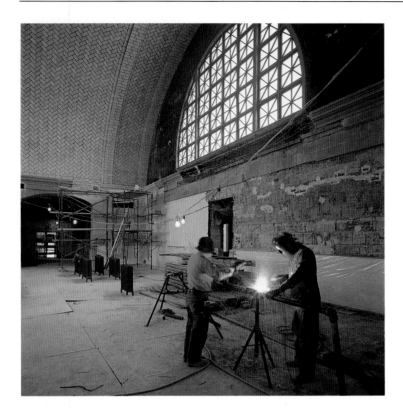

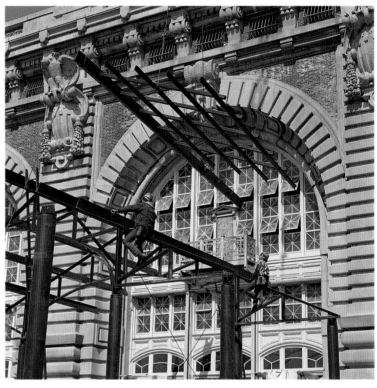

& Tilton's admirable solution in the great hall and its appendages provided, in the *Record*'s words, "for a continuous human flow, distributed according to the respective destinations of its constituent drops, but not subject anywhere to stoppage or congestion." The proof was that one memorable day "6,500 immigrants, each one of whom received some individual attention, entered, passed, and 'cleared' in nine hours."[8]

The railway station comparison might be taken further, however. One of the great engineering feats of the nineteenth century was the vaulted, glass and metal train shed. In London, St. Pancras Station (1863–65) was among the most glorious, with its self-supporting arch, 690 feet long, 243 feet high, and 100 feet wide. If the arch did not spring up overnight, so to speak, having evolved from myriad columned and trussed antecedents, the station itself as an architectural type also evolved slowly but most notably on the Continent and in England. In Paris, the Gare de l'Est (1847–52) and the second Gare du Nord (1861–65) epitomomized the monumental, palacelike facade, while in London's Euston Station the "Grand Hall" (1846–49) with its Ionic columns, majestic staircase, elaborate bracketing, and richly coffered ceiling (that Louis Sullivan said was "so solid, so oppressively heavy, he was glad to escape to the street") set a standard for luxurious interiors. Shed, facade, and interior merged into a type of urban portal so ostentatious that by 1890, according to one authority, "megalomania" had set in: "The old interest in sheds had yielded to a mania for

grandiose head-buildings," no less in America than in Europe.[9]

The turn-of-the-century American railroad station was a celebration of the urban and the bourgeois self, verifying metropolitan standing for the one, cultural credentials for the other. Designed to welcome respectable and affluent classes only (workers could not ordinarily afford such transport, especially over long distances), stations were determinedly splendid, signaling the importance, power, and artistic intelligence of their cities and of the entrepreneurs who built and owned them. At a time when heads of state, old wealth and new all traveled by train, the station was their first architectural glimpse of the city. More than monumentality was at work in the United States as New Yorkers and Chicagoans strove to match the cultural maturity of the European aristocrats they mimicked. By erecting a Grand Central or a Union Station, railroad promoters told themselves and others that as cultivated gentlemen they were also arbiters of correct opinion. Clearly well versed in the arts, they were no doubt to be heeded on other matters as well.

Proclamations of state and owning-class hegemony were not, of course, new at the turn of the twentieth century, nor were they limited to railroad stations. But there was an unprecedented blatancy about them in the United States roughly from the Civil War to World War I, as the nation became more avowedly imperialist, as a reckless and unschooled industrial elite emerged, and as the

Steamfitters weld pipe to be used in the installation of 192 reconditioned radiators dating from the original building (above, left). Ironworkers lower into place a section of the new interpretative canopy at the entrance to the main building (above).

A copper finial is lowered by helicopter into place atop one of the main building's four copper-capped domes in March 1987 (above, right).

A detail of the ornamental sandstone U.S. eagle with shield on the facade of the main building, from Boring & Tilton's working drawings (below, right).

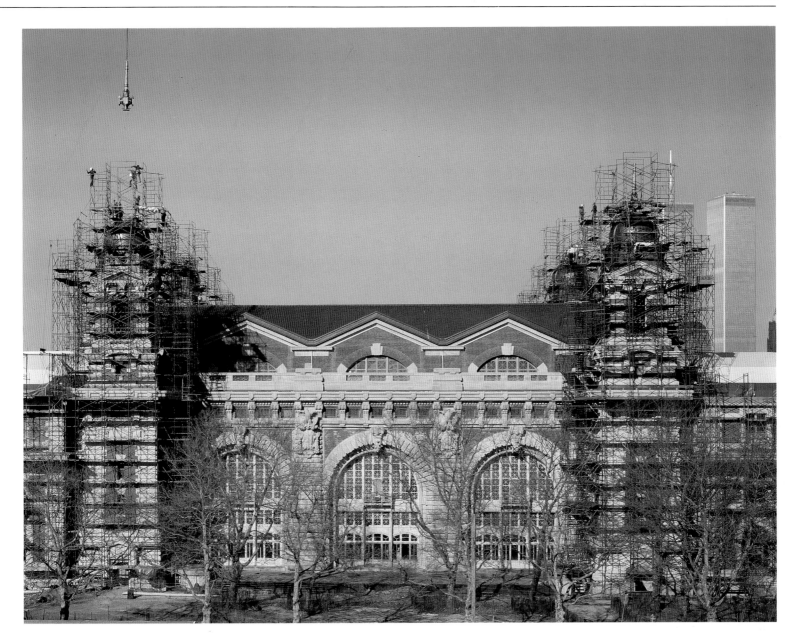

foreign-born became so numerous. Working-class political and non-Anglo-Saxon cultural assertions prompted owners to justify their privileges and governments to assert their inviolability through, among other things, the purchase of certain kinds of architecture.

Is it coincidental that, as the United States assumed "the white man's burden" overseas and battled organizing labor at home, neo-classical and neo-Renaissance styles came into vogue? As overt opposition to official policies mounted, Roman-inspired courthouses, state capitols, embassies, and city halls mushroomed, in urban centers as well as in the new colonies. It was almost as if government at all levels were fatefully drawn to Rome—seat of the most enduring western empire, in fact and in memory—suggesting thereby that any intellectual or physical assault stood slight chance of weakening a state which, like Rome, intended to be eternal.

Public edifices privately endowed by the owning class conveyed similar messages, as if the new industrial elite, recalling the glories of the quattrocento aristocracy, hoped to make their own reputations as enduring, by design. The late-nineteenth-century burgeoning of museums, libraries, historical societies, university buildings, opera houses, and concert halls—collectively institutions of "cultural philanthropy," ordinarily in the vogue styles of the times—had clear non-programmatic objectives that were not so much sinister as class-determined: deciding which art and knowledge was legitimate and which not, limiting access to it to approved individuals, and declaring who would define and guard the cultural heritage. Therefore, Chicago symphony and opera companies, for example, refused for years to perform German music; buildings were closed after working hours and on weekends to exclude the working class; and entrance spaces were purposefully monumental and overwhelming to intimidate the unwanted.

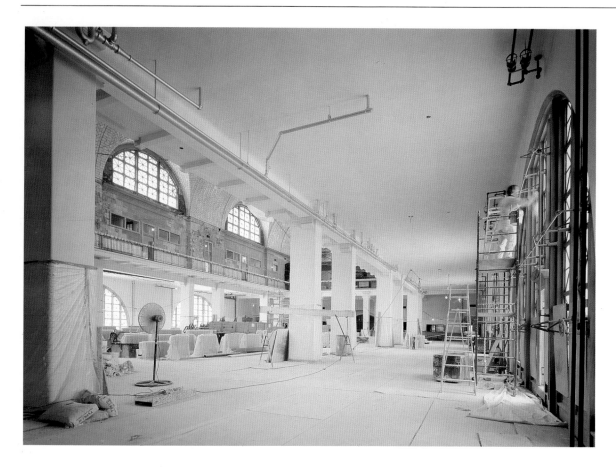

The imposing facade and vast, palacelike interiors of the New York Public Library, for instance, were intended to demonstrate the expertise of those responsible for building it, either as professionals or as patrons, while at the same time making the uncultivated uncomfortable.

The neo-"French Renaissance" architecture of Boring & Tilton's Ellis Island main building can be interpreted in this design context. Like the railroad station it was a portal—the entrance to wonders beyond its doors—in this case to an entire nation. It was meant to establish the power, importance, and unquestioned authority of the government that built it. It did this by the bold contrast in color and scale between the red-brick walls and the larger-than-normal gray-stone quoining and by the oversized eagles and shields (the nation's symbols) dividing the three monumental entry arches. It did it by the prominence of the four corner towers—capped by brilliant copper domes—that thickened as they descended, and by the powerful balustrade placed in front of the semicircular windows on the upper storey. And it did it with the crisp, copper-faced gables playing against the huge, sloping roof. All of these and other design elements combined to make the acts of approach and entry, through the massive central pavilion, a memorable event, which was continued in time and space by the procession up the grand staircase into the center of the awe-inspiring Registry Room flooded with light and sound.

Confused and overwhelmed long before they reached the examination stations, newcomers were unmistakably told by the architecture that in an intimidating situation within and beyond the portal they were well advised to cooperate with the superior power and wisdom that had created this magnificent edifice. A building "of so much architectural pretension," the *Architectural Record* correctly observed, could hardly fail to attract the "attention . . . and the bovine stare of the dazed immigrant."[10]

Contemporaries praised the building's siting as often as they applauded its successful circulation system, suggesting that its iconographic function was as important as any other. Like the Court of Honor at the recent Chicago World's Fair, or a well placed statue, it could be viewed from many angles, giving it "as imposing an appearance to the tourists coming down the Hudson . . . as to foreigners arriving . . . from the ocean." "The combination of large architectural masses and decorative towers and central facades" plus the red, gray, green, and copper color combination, had "solved the problem well."

The "problem" was less visibility than memorability, however: the memorability not simply of impressive architectural images but more importantly of the messages those images were intended to convey. Charles de Kay caught something of this when he "supposed" that a cripple, a criminal, someone without a sponsor or "the lawful number of dollars" was sent

A painter primes the Registry Room before applying ornamental sand paint simulating stone in February 1989.

A new skylight in the main building's oral history room (above, near right) looks out on a restored copper dome.

The tiled ceiling of the Registry Room (above, right), developed by Raphael Guastavino and his son and installed in 1918, proved so durable that during restoration only seventeen tiles out of more than 28,000 needed to be replaced.

A detail of the ornamental keystone on the main building's facade, from the original 1898 working drawings of Boring & Tilton (right).

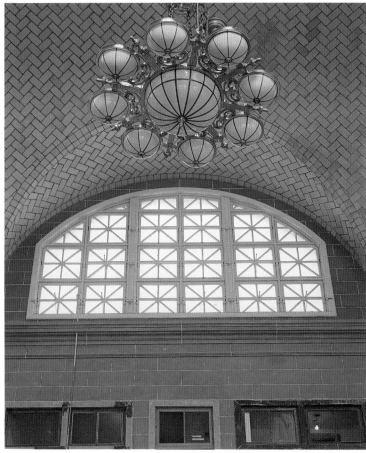

packing, having set foot only on Ellis Island. While sailing away from the main building in hopes of one day returning, "he can indulge in the inexpensive pleasure of imagining that in his role [as] a future American monarch the Republic has placed at his disposal a palace" as fine as many in Europe. If its symbolic meaning could be so visually potent as to displace intense disappointment among the banished, then its didactic role for those who stayed could have been even more profound.[11]

There can be significant discordance, however, between policy objectives and public reaction to them. That the government and its architects used the iconography of Ellis Island's main building to instruct does not mean that immigrants absorbed the lessons. Some may have been too dazed, exhausted, excited, or distracted. Approaching the end of a long, burdensome journey, their experience at the island may have been only the last of many indignities to which they had become inured. On the other hand, the island was certainly interpreted by many as a welcoming place, a portal to the land of freedom and opportunity. With the Statue of Liberty nearby, their few hours there were seen at the time and remembered later as a joyous and liberating event. Humanity's ability to circumvent assertions of authority is one of its greatest

strengths. The substance of Ellis Island's architecture and of immigrant determination did not necessarily mesh.

But the island's iconographic message was also directed at "native" Americans, at "tourists coming down the Hudson," in *Architectural Record*'s words. It was meant to tell them that many fine things had been accomplished in the arts by this relatively young land, that its architecture could be as good as Europe's best, that the United States had reached a certain maturity. It was a symbol to its residents of how far the country had come, much like the Chicago World's Fair a few years before. It was a statement of the nation's pride in itself.

However it is assessed, as a metaphor or as a practical solution, Boring & Tilton's immigrant station was a success. But this did not prevent its being altered over time. According to plan, the seawall enclosing the boat basin became in 1899 the northern edge of Ellis Island Number 2 containing hospital facilities. Despite this enlargement, services were still seriously overtaxed. Estimates for improvements in 1904 came to more than one million dollars, over half of it for extending the main building and erecting two more hospitals .With a record 11,747 people passing through in one day in 1907—a year in which 1,004,756 were processed in the Port of New York and 195,540 of them detained—by

1911 the complex had of necessity again grown. A second slip now bordered the new Island Number 3 for contagious diseases, and a third storey was placed atop the west wing of the main building, followed two years later by a third storey on the east wing.

The island was now more than twenty acres, but regular filling that in the 1920s eliminated the second boat basin, and during the next decade expanded the original island yet again, brought the whole to its present 27.5 acre size and configuration. Between 1934 and 1937 the last major additions were made with Works Progress Administration funds: new facilities for offices and recreation, and a ferry building at the head of the remaining slip. Several other structures were altered or tacked on to make a total of more than thirty. After 1954 construction included rehabilitation measures and crowd-control devices following the National Park Service's inauguration of a visitor program in 1975.

In response to the Government's request, suggestions for what to do with the island after the Immigration Service left in 1954 were ceaseless, some involving major architectural intervention. In 1958 Bruce Graham, today titular head of Skidmore, Owings, and Merrill, but then its young employee, collaborated with two other architects on "Pleasure Island" for developer Sol. G. Atlas. Atlas was known for several Manhattan apartment houses, but most especially for shopping malls: the Cross County Center in Yonkers, the North Shore Mart in Great Neck, Long Island, and Miracle Mile in Manhasset. The fifty-five million-dollar resort and culture center would have included a six hundred-room hotel linked by canals, arcades, and paths to a four thousand-seat convention center, a music shell dedicated to Arturo Toscanini, a "Museum of New Americans," a language school for immigrants, sports facilities, a helipad, and a sail-in movie. All historic buildings were to be replaced by a disparate assortment of undistinguished current styles. In the end, the federal government rejected Atlas's $201,000 bid to purchase the island after considerable public outcry against its falling into private hands.[12]

The National Institute for Architectural Education sponsored a design competition for the island's disposition in 1960. Students at Cooper Union and Pratt Institute in New York offered a range of fanciful alternatives, from a gigantic nuclear power plant and atomic research facility to a nautical museum, a nondenominational cathedral, and a world center for trade and cultural exchange. Their imaginative ideas were amateurish and over-blown in plan, but had the virtue of assuming public ownership and service, albeit in conventionally monumental modes of expression.[13]

The most startling proposal came in 1962 from Taliesin Associated Architects, successor firm to the late Frank Lloyd Wright. Allegedly based on a Wright sketch for the New York Damon Doudt Corporation created by two low-level but eager National Broadcasting Company employees, "'The Key'—so named because for 20,000,000 [sic] immigrants it was the key to a land of freedom and opportunity—" was a billion-dollar fantasy megastructure dubbed "Dream City." An official Taliesin statement called it "an imaginative and creative solution to decentralization"—a lifelong Wright objective— "whereby workers in nearby Manhattan can live in a residential—city." Since no vehicles were to be allowed, these workers could luxuriate in moving sidewalks and be ferried from Manhattan to a central slip where elevators and escalators led to eight glassy apartment towers. "Decorative cables" from pylon tops rising through the towers held a vast, landscaped, semicircular terrace superimposed over the actual island's rectangle. Ringing this gigantic platform was a periphery of domes for sports, schools, a theater and galleries, a planetarium, and a medical center. Although nothing was said about shopping and other everyday services, Taliesin maintained it had provided for "all facets of residential needs and luxuries." The proposal was one of Taliesin's many grandiose concoctions tangentially based, if at all, on Frank Lloyd Wright's last, equally grandiose ideas. It had even less to do with the historic significance of the place than did Graham's "Pleasure Island".[14]

Although standing small chance of realization, "The Key" was unceremoniously put to death on May 11, 1965, when President Lyndon Johnson, on recommendation of the National Park Service, declared Ellis Island part of the Statue of Liberty

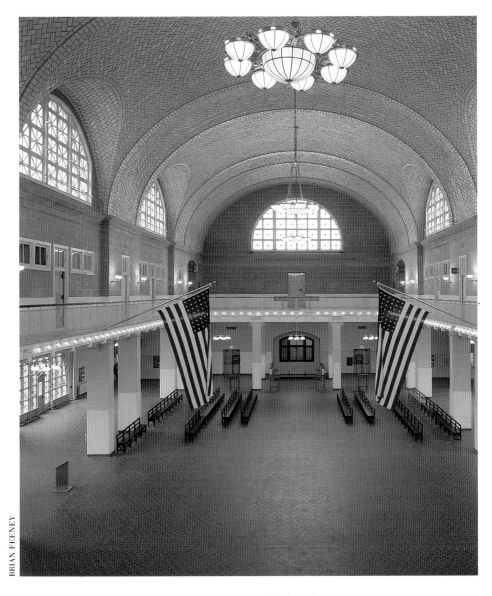

BRIAN FEENEY

Fully restored by September 1990, the Registry Room boasts a newly cleaned tiled balcony and ceiling, newly painted walls and many of the original benches.

National Monument. The Park Service would take over operations from the General Services Administration, which had maintained it since 1954 at an annual cost of more than $140,000. On June 7, 1965, Stewart Udall, who as Secretary of the Interior supervised the Park Service, announced that the well-known architect Philip Johnson would redesign the island as a National Immigration Museum and Park. Plans called for razing everything except "the four-towered, somber, polychrome Victorian main building," once considered the most handsome of palaces.

When Johnson's scheme was published in February 1966, reactions were mixed. Closely resembling a 1925 Frank Lloyd Wright plan for an automobile drive and planetarium atop Sugar Loaf Mountain, Maryland, it consisted of a three hundred-foot diameter, vertically ribbed, truncated concrete cone wrapped with a spiral ramp. "If you look hard enough, and if you're lucky," Johnson said, you could find specific names of people who had passed through among the millions inscribed on the wall. "The point is

to let the spectator himself re-create the feeling of those hard times." If Johnson was somewhat casual about relatives trying to find their ancestors' names, he was equally insensitive about historical remains. Contending that turn-of-the-century architecture was not worth preserving, he urged that everything be demolished except the main edifice and hospital which he would turn into "romantic, vine-covered ruins. Pedestrian walkways will wind through the gutted buildings." Johnson's intention to "stabilize the ruins, preserve the nostalgia" was applauded by *The New York Times* architecture critic Ada Louise Huxtable as "a creative, imaginative response to the problem of making a national landmark and shrine out of 27.5 weedy acres." The day after her column appeared, however, her editorial bosses took an opposing position. Walls, as in Berlin, were made to exclude, and "would seem to be the least appropriate symbol" for an emotion-laden place that had once been a "gateway." And this particular wall, resembling "a rheostat cast in concrete," was especially inappropriate. Rheostat or not, Johnson's proposal was a reasonable reflection of mid-1960s attitudes toward historic preservation which gave low priority to adaptive re-use. Reflecting his own narrow perception—romanticized nostalgia—of an often difficult collective experience, it had at least the singular merit, unlike previous schemes, of saving part of the original complex.[15]

Susana Torre's 1981 proposal, easily the most thoughtful and respectful of Ellis Island's history, came out of public hearings in response to the Park Service's 1979 General Management Plan which called for the redevelopment of the island through a public-private sector partnership. It would have retained the immigration station and hospital buildings intact, though empty: "a mute, silent space," she explained, a home for ghosts of the past. Walkways and walls would re-establish the island's outline at particular historical moments, with special emphasis on 1900 to 1914, the peak years of immigration. But the scheme went beyond recreating the past. It also looked to the present by providing a computerized "Center for the Study of American Ancestry" wherein visitors could trace their origins. And it offered a sample of historic landscape designs— Thomas Jefferson's University of

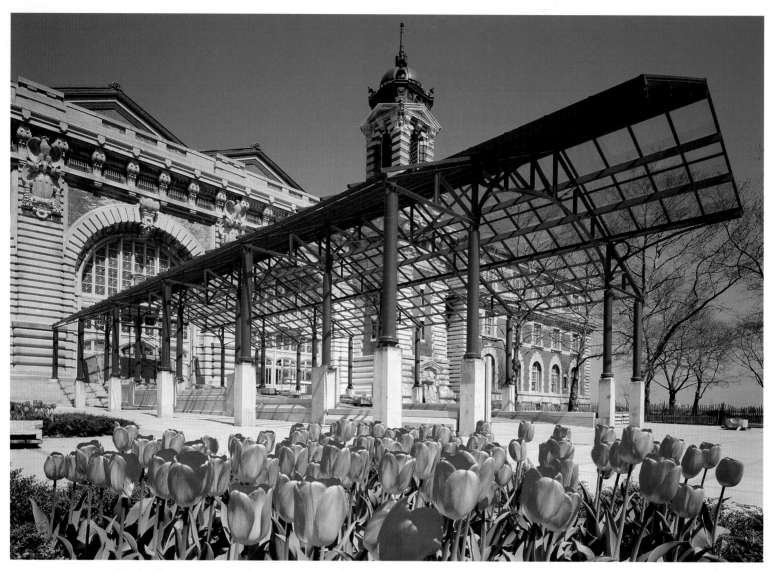

Virginia, New England village greens, and formal European gardens—from which to view Manhattan and to enjoy the contemporary expressions of ethnic variety Torre envisioned taking place on the grounds. Her guiding idea was that the "then" and the "now" should interact physically, literally, and symbolically in a kind of permanent "theater." Torre's vision incorporated, but went well beyond, adaptive re-use to make Ellis Island a living part of today's national experience.[16]

By the time Torre published her plan in 1981, interest in rehabilitating the island was mounting more rapidly than ever. A campaign led by Chrysler Corporation chairman Lee Iacocca raised both dollars—ultimately $250,000,000—and public awareness. Since the 1979 General Management Plan, National Park Service policy had been that the southern half (that is, the previously consolidated islands numbers 2 and 3) should be preserved by the private sector—present plans call for a conference center—while the northern half would be restored as the Ellis Island Immigration Museum. In 1982 the firms of Beyer Blinder Belle and Notter Finegold &

Alexander (BBB/NFA), noted for restoration work, were hired by the Park Service to prepare design and construction drawings for Boring & Tilton's main building, centerpiece of the renewal project.

The thorniest problem confronted at the outset was selecting the most significant date to which to return the structure. The solution was not obvious. Should it be restored to its condition on opening day in 1900, on closing day in 1954, to the peak year of 1907, or to another date that seemed important? The architects' first step was to compile a comprehensive "Historic Structure Report: The Main Building" in 1983, incorporating the results of prior investigations into its condition, including studies undertaken in 1978 and 1980 by Building Conservation Technology / The Ehrenkrantz Group and Syska & Hennessy. Based on this research, BBB/NFA agreed with the Park Service to return the edifice to the 1918–24 period, that is, to the end of the heaviest immigration years following the most arresting architectural changes. The building had been altered many times between 1900 and 1954, but in 1910–11 the central stairs were

The glass, steel, and granite canopy at the entrance to the main building is a modern interpretation of the original, which was removed in a deteriorated state in the 1930s.

A detail of one of four stairtowers in the main building, from Boring & Tilton's original working drawings (right).

(overleaf)
Carolyn Anne Clark, *Great Lawn, Ellis Island*, 1983

eliminated and, even more noteworthy, in 1918 the Registry Room was redone following an explosion set off in 1916 by German saboteurs at Black Tom Wharf in New Jersey that caused extensive damage. Together, these and other modifications left major portions of the building quite different in 1918 from the way they were in 1900. The decision to return to the 1918–24 period recognized both the architectural and the historical importance of that era.

In 1918, the original asphaltic flooring in the Registry Room—which by consensus is the outstanding space in the building—was replaced by red Ludowici quarry tile in a herringbone pattern. Above that, from the top of a tile dado to the spring point of the balcony arches, artificial "caen," or limestone, was installed. But the most impressive change—increasing even the original grandeur—was the terra-cotta vaulting system for balcony and ceiling developed by Raphael Guastavino and his son of the same name who had migrated from Barcelona in the 1880s. Its deployment in this room (and in other major New York structures, including the Oyster Bar at Grand Central Station) involved laying up three courses of buff-glazed tile at right angles to each other, the outer two bedded in thickly applied Portland cement to almost fifty percent of the total volume. "The resulting vault," as found by the restoration architects, "acted as a continuous, thin shell which, through the slight curvature of the tiles, was nearly self-supporting."[17] Not only was the Guastavino system comparatively inexpensive, easy to construct and maintain, but it was also handsome and durable, proof being that when its cleaning began in 1986, the architects discovered that after sixty-eight years of hard use only seventeen tiles of more than twenty-eight thousand needed replacing.

With the restoration completed in 1990, the Ellis Island Immigration Museum features, in addition to its renewed self, exhibits, theaters, library and research facilities, and an oral history recording studio. Visitors are offered three central themes: 1) the processing story, whereby they are encouraged to follow the path taken by immigrants through the main entrance into the ground-floor baggage room, up the stairway to the Registry, and then to various ancillary points; 2) a history of American immigration between 1892 and 1954 in the second-floor gallery, east

wing; and 3) an exhibit on the peopling of America located in the former railway ticket office at ground floor rear.

The Park Service and BBB/NFA agreed on four criteria for determining which spaces would be restored and which modernized: existing condition, architectural significance, historic use, and changes over time. Analysis based on these considerations led to the conclusion that 1) exteriors be rehabilitated to the chosen 1918–24 period; 2) interior spaces most closely associated with the immigrant experience be preserved and interpreted, among them the baggage, Registry, a legal inquiry, and a detention/dormitory room, plus the ticket office; and 3) the remaining spaces be devoted to administration, research, curation, visitor needs, and to private use under lease or contract, for example, food service.

The most visually conspicuous new elements—although very much compatible with Boring & Tilton's design vocabulary—are the entrance canopy (a contemporary interpretation of the original) and an outdoor dining terrace attached to the east wing. Under the Park Service's supervision, BBB/NFA also restored the power house necessary to serve the main building. The $140,000,000 in privately donated funds expended on the two renewed structures was done in the anticipation that other facilities on the northern portion of the island—the kitchen and laundry, bakery and carpentry, and baggage and dormitory buildings—will also be rehabilitated.

The BBB/NFA strategy of combining adaptive re-use with historic restoration is very much in keeping with current inclinations. It is an intelligent compromise between preservation purism, which advocates exact reconstruction to a given archaeological period, and architectural recycling, in which past functions are obliterated. Depending on circumstances, either mutually exclusive philosophy can be appropriate. But not in this case, because Ellis Island is today required to live in the past while being of the present, in effect resuming an historic two-sidedness, although in new, very different ways.

After decades in ruin, Ellis Island lives again as a monument to human struggle and endurance, entering perhaps the happiest phase of its long, often tortured, evolution.

CHRONOLOGY
By PAUL KINNEY

1600 The early Mohegan Indians called it Gull Island. Only two to three acres in what is now Upper New York Bay, it would nearly disappear from sight at high tide.

1628 Dutch settlers, discovering rich oyster beds in the waters between the island and the nearby New Jersey coast, rename it Oyster Island.

1765 After a pirate named Anderson is hanged on the island, it becomes known as Gibbet Island.

1785 On January 20, Samuel Ellis, who had come into ownership of the island, advertises its sale in *Loudon's New-York Packet*.

1808 After purchasing the island from descendants of Samuel Ellis, New York sells it to the federal government for ten thousand dollars.

1812–1814 The United States Army improves fortifications on Ellis Island and renames it Fort Gibson.

1861 The federal government dismantles the fort, which reverts to its earlier name, Ellis Island.

1876 The United States Navy stores on the island munitions reported to be in excess of 260,000 pounds of powder, causing New Jersey residents to voice alarm.

1890 Removing munitions from the island, the federal government chooses Ellis as its first immigration station. Size of the island is increased to 3.3 acres by landfill. Ferry slip is built.

1890–1892 The island is enlarged to fourteen acres to accommodate immigration depot and support buildings.

1891 Congress passes new immigration law formally creating the Bureau of Immigration under the Treasury Department. More restrictive law excludes as "undesirables" idiots, insane persons, persons likely to become a public charge, people convicted of crimes involving "moral turpitude," polygamists, and all those with "loathesome or contagious" diseases.

1892 On January 1, Annie Moore, a young Irish girl from County Cork, becomes the first immigrant to pass through the new immigration station. 444,000 immigrants are admitted through the Port of New York. During the years Ellis Island is receiving immigrants, it can be estimated that about eighty percent of those entering the Port of New York are processed at Ellis Island.

1897 Fire completely destroys wooden station in less than three hours. Though approximately 200 immigrants are on the island at the time, there are no casualties.

1898 The island is expanded to seventeen acres as additional landfill is used to create Island 2.

1900 New fireproof station of red brick with limestone trim, designed by the New York architectural firm, Boring & Tilton, officially opens on December 17, and 2,251 people are processed on opening day.

1901 Kitchen, bathhouse, laundry, and power house are erected beside main building on Island 1.

1902 President Theodore Roosevelt appoints William Williams as Commissioner of Immigration, with the specific task of ending corruption and mistreatment of immigrants at Ellis Island. Hospital building and laundry are built on Island 2.

1904 Administration of station is transferred from Treasury Department to Commerce and

Presenting Pen to Frederick Alfred Wallis, U.S. Immigration Commissioner, 1920

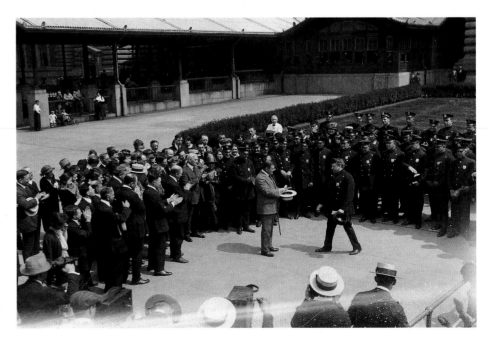

Barbara Ann Bell, *Hand on Heart*, 1988

Labor Department. Railroad ticket office is added to main building to accommodate immigrants departing for New York, New Jersey, and destinations beyond.

1905–1906 Island 3, five acres in size, is created with landfill, with a wooden bridge connecting it to Island 2.

1907 Immigration peaks: 1,004,756 people pass through the Port of New York by year's end; 11,747 through Ellis Island in a single day.

1909 Contagious Disease Wards, including measles, isolation and psychiatric units, mortuary, and staff house, are completed on Island 3.

1913–1915 Bakery, greenhouse, and carpentry shop are built on Island 1.

1915 World War 1 causes dramatic decline in immigrants; 178,416 are admitted for the year.

1916 On New Jersey's Black Tom Wharf, German saboteurs ignite munitions destined for Russia, then at war with Germany. Tremendous explosions damage Ellis Island, though no one is harmed.

1917 In addition to processing immigrants, the island becomes a detention center for enemy aliens, a way station for Navy personnel, and a hospital for the Army. The federal government introduces a literacy test, stipulating exclusion of anyone over sixteen unable to read thirty to forty words in his or her own language.

1918 Wounded and shell-shocked soldiers arriving from war-torn Europe are hospitalized in main building's Registry Room.

1919 26,731 immigrants pass through the Port of New York. Many Socialists are deported during "Red Scare."

1920 Immigration returns to pre-war levels, as 225,206 people pass through New York.

1921 560,971 pass through New York. The Johnson Act, the first quota law, goes into effect. Act imposes annual ceiling of 358,000 and states that the United States will not admit more than the equivalent of three percent of immigrants whose countrymen had been living in the United States in 1910. Quota system is in effect until 1965.

1924 Mass immigration decreases dramatically as more restrictive quotas are enforced. Immigrants are now required to obtain visas from United States consulates overseas.

1933 127,660 aliens voluntarily return to Europe, greatly outnumbering the 23,068 new immigrants arriving in the United States.

1934 The area of the island is increased to its present size of 27.5 acres. 4,488 immigrants pass through station.

1934–1941 Restrictionists resist efforts in Congress to open door to refugees from European fascism.

1939 Coast Guard begins to use the island as a training facility.

1940 Immigration and Naturalization Service

is transferred from Department of Labor to Department of Justice, reflecting prevalent view of immigrants as potential threat to national security. Ellis Island is used primarily as a detention center for enemy aliens and their families, some of whom are held for the duration of World War II.

1943–1944 All Ellis Island immigration records from 1897 to 1943 are microfilmed and shipped to National Archives in Washington, D.C.

1945 War Brides Act permits 120,000 wives of American servicemen, exempted from quota, to enter the United States.

1948 Displaced Persons Act allows up to 205,000 refugees from Allied detention camps to enter the United States. Number is eventually increased to 400,000.

1950 McCarran Act, designed to exclude subversives, is so loosely drawn that many potential immigrants are denied admission. 1,500 suspected enemy aliens are rounded up and examined at Ellis Island during new "Red Scare."

1952 McCarran-Walter Act, passed over President Harry Truman's veto, extends quota system.

1954 The ferry boat *Ellis Island* makes its final run between the Battery and Ellis Island. The island is officially closed and declared surplus property by the General Services Administration.

1956–1960 Over fifty bids for purchase and/or reuse of the island are rejected by the General Services Administration as too low or unsuitable. Proposals include transforming the island into a hospital, a Bible college, a luxury hotel and convention center, a drug rehabilitation center, and a gambling casino.

1965 President Lyndon Johnson designates the island a part of the Statue of Liberty National Monument, under the administration of the National Park Service. Six million dollars is allocated to preserve and restore the island. Due to cuts in federal spending, money is never appropriated and deterioration of Ellis Island continues.

Barbara Ann Bell, *Ear Tug*, 1988

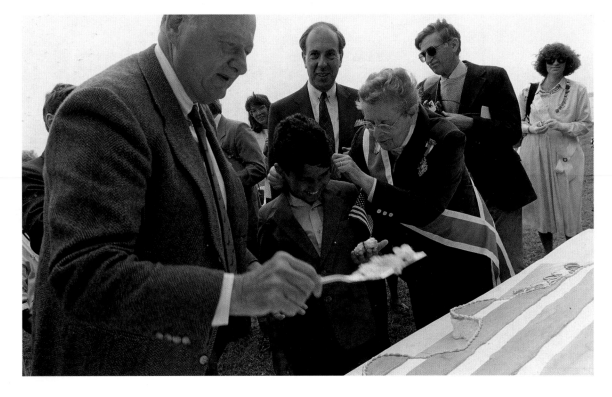

1970 Two minority attempts to take over the island fail: Indians from several tribes, citing the "disease, alcohol, poverty, and cultural desecration" inflicted on Indians by white men, are unable to land on the island when their outboard motor breaks down; forty blacks squatting on the island start a drug rehabilitation operation, which they later abandon.

1974 The Restore Ellis Island Committee is formed, which lobbies for restoration and reopening of the island as a tourist site.

1976 President Gerald Ford approves Congressional appropriation of one million dollars for the island's restoration and a $500,000 annual operating budget. The island is opened to the public for limited guided tours. Regular ferry service is reinstated.

1979–1982 The National Park Service planning team develops a General Management Plan, identifying the need for 50 million dollars to restore the northern half of Ellis Island and suggesting the possibility of leasing the southern half to the private sector.

1982 Interior Secretary James Watt establishes the Statue of Liberty–Ellis Island Centennial Commission with Lee Iacocca as Chairman. The Statue of Liberty–Ellis Island Foundation is set up as fundraising arm. National Park Service hires architectural firms Beyer Blinder Belle of New York and Notter Finegold & Alexander of Boston to start restoration.

1983 Restoration of main building and adjacent structures begins, with a construction budget of 62 million dollars.

1984–1989 Construction continues, including major restoration of Registry Room and creation of museum, library, oral history studio, two movie theaters, and restaurant in main building's east and west wings. Overall project budget increases to 140 million dollars.

1987–1989 Proposal is considered to develop a conference center in southern portion of the island. Details of leasing agreement are under discussion.

Barbara Ann Bell, *New American Woman*, 1988

BIBLIOGRAPHY

Abbott, Edith. *Immigration: Select Documents and Case Records.* Chicago: University of Chicago Press, 1924.

Adamic, Louis. *Laughing in the Jungle.* New York: Harper and Brothers, 1932.

Bell, James, and Richard Abrams. *In Search of Liberty.* Garden City, NY: Doubleday and Co., Inc., 1984.

Benton, Barbara. *Ellis Island—A Pictorial History.* New York: Facts on File, 1985.

Brandenburg, Broughton. *Imported Americans—The Story of the Experiences of a Distinguished American and His Wife.* New York: FA Stokes Co., 1904.

Brownstone, David, Irene Franck, and Douglass Brownstone. *Island of Hope, Island of Tears.* New York: Rawson, Wade Publishers, 1979.

Corsi, Edward. *In the Shadow of Liberty: The Chronicle of Ellis Island.* New York: The Macmillan Co., 1935.

Curran, Henry C. *Pillar to Post.* New York: Charles Scribner's Sons, 1941.

Fisher, Leonard Everett. *Ellis Island: Gateway to the New World.* New York: Holiday House, 1986.

Graham, Stephen. *With Poor Immigrants to America.* New York: The Macmillan Co., 1914.

Heaps, Willard A. *The Story of Ellis Island.* New York: The Seabury Press, 1967.

Howe, Frederic, C. *The Confessions of a Reformer.* New York: Charles Scribner's Sons, 1925.

Howe, Irving, and Kenneth Libo. *How We Lived: A Documentary History of Immigrant Jews in America.* New York: Richard Marek Publishers, 1979.

Howe, Irving. *World of Our Fathers.* New York: Harcourt Brace Jovanovich, 1976.

Jones, Maldwyn A. *Destination America.* London: Weidenfeld and Nicolson, 1976.

Knaplund, Paul. *Moorings Old and New: Entries in an Immigrant's Log.* Madison: The State Historical Society of Wisconsin, 1963.

La Guardia, Fiorello. *The Making of an Insurgent: An Autobiography, 1882–1919.* Philadelphia: J. B. Lippincott Co., 1948.

Novotny, Ann. *Strangers at the Door.* Riverside, Conn.: The Chatham Press, Inc., 1971.

Pitkin, Thomas Monroe. *Keepers of the Gate.* New York: New York University Press, 1975.

"Going thru Ellis Island," *Popular Science Monthly* (January 1913).

Riis, Jacob. "In the Gateway of Nations," *The Century Magazine* (March 1903).

Roth, Henry. *Call it Sleep.* Patterson, N.J.: Pageant Books, 1960.

Schoener, Allon, ed. *Portal to America: The Lower East Side 1870–1925.* New York: Holt, Rinehart & Winston, 1967.

Shapiro, Mary J. *Gateway to Liberty: The Story of the Statue of Liberty and Ellis Island.* New York: Vintage Books, 1986.

Steiner, Edward. *On the Trail of the Immigrant.* New York: Fleming H. Revell Co., 1906.

Taylor, Philip. *The Distant Magnet: European Emigration to the USA.* New York: Harper and Row, 1971.

Unrau, Harlan D. *Historic Resource Study/Ellis Island/Statue of Liberty National Monument.* U.S. Department of the Interior/National Park Service, 1984.

Wells, H.G. *The Future in America.* New York: Harper and Brothers, 1906.

CONTRIBUTORS

SHIRLEY C. BURDEN was photographer and author of *I Wonder Why . . ., God is My Life, Chairs, Presence, Behold Thy Mother,* and *The Many Faces of Mary.* For thirty-five years he devoted himself to fine art photography, exhibiting at The Museum of Modern Art, the Tokyo Museum, and other galleries and museums throughout the world. Mr. Burden also taught photography at the Art Center College in Pasadena, California, from 1978 to 1987.

CHARLES HAGEN is a writer and critic. Formerly editor of *Afterimage* and reviews editor of *Artforum,* he is now editor of *Aperture* magazine. He has written about contemporary art and photography for many publications, including *Artforum, Art News, Camera Arts,* and *The Village Voice.*

PAUL KINNEY was Museum Curator at the Statue of Liberty National Monument from 1980 to 1986. He is currently Director of Development for the Staten Island Historical Society at the Richmondtown Restoration, Staten Island, New York.

NORMAN KOTKER is the author of three novels: *Learning About God* (1988), *Miss Rhode Island* (1978), and *Herzl the King* (1972). He is also the author of numerous histories, among them *New England Past* (1980), *Massachusetts: A Pictorial History* (1976), and *The Earthly Jerusalem* (1969). From 1960 to 1969 he edited Horizon Books for the American Heritage Publishing Company.

ROBERT TWOMBLY teaches architectural history at The City College of New York and is the author of *Frank Lloyd Wright: His Life and His Architecture* (1979), *Louis Sullivan: His Life and Work* (1986), and *Louis Sullivan: The Public Papers* (1988). In 1987–88 he was Fulbright Lecturer at the University of Leiden, The Netherlands, where he held the Walt Whitman Chair in American Civilization. Professor Twombly is currently writing a biography of Henry Hobson Richardson.

ACKNOWLEDGMENTS

We are indebted to Klaus Schnitzer, Associate Professor of Fine Arts at Montclair State College, and to Brian Feeney of the National Park Service for their help in shaping *Ellis Island* and in expediting our numerous, often difficult requests.

Various members of the National Park Service gave us invaluable advice in text and picture research. Kevin C. Buckley, Superintendent, Statue of Liberty National Monument; Diana Pardue, Chief of Museum Services Division; Felice Kudman, Curator of Collections; Marcy Cohen, Curator of Exhibits; and Michael Adlerstein, Chief Historical Architect, were especially generous with their time and expertise. We also wish to thank Joel Bauman, Sidney Onikul, Jeff Dosik, Barry Moreno, Frank DePalo, Ken Glasgow, Christine Hoepfner, and Jesse Jack of the National Park Service.

The architectural firms of Beyer Blinder Belle (BBB) and Notter Finegold & Alexander (NFA) gave us access to their research files and picture archives. We wish to thank Bruce Heyl, Project Manager/Architect; John Belle, Partner in Charge, BBB; George Notter, Partner in Charge, NFA; Pat Sherman Morse, Principal, NFA; Maxinne Leighton, Marketing Manager, BBB; and the members of the architectural project team for their assistance in preparing the architecture section of the book.

The Ellis Island Project has been supported by the Governor's Challenge Grant for Excellence in the arts, awarded to Montclair State College School of Fine and Performing Arts. Individual photographers have been supported by the New Jersey State Council on the Arts, Polaroid artist support grants, and the National Endowment for the Arts. We thank these grantors for their assistance. We also thank Marie Bosetti, who helped curators Klaus Schnitzer and Brian Feeney in many aspects of the project.

Wendy Byrne designed *Ellis Island* with skill and unfailing patience; we owe her our gratitude.

Finally, we thank the photographers, whose commitment to the Ellis Island Project has made this book possible.

PHOTOGRAPH CREDITS

Officials on barge, Ellis Island, date unknown

TEXT CREDITS

NOTES

Notes to *Ellis Island: An Architectural History* by Robert Twombly, page 123.

1. Quoted in Peter C. Marzio (ed.), *A Nation of Nations: The People Who Came to America* . . . (New York: Harper & Row, 1976), 137.

Much of the historical material regarding Ellis Island and the architectural information on its main building was assembled in "Historic Structure Report: Main Building" (1983), a copy of which was kindly provided by Beyer Blinder Belle/Notter Finegold & Alexander Inc., New York, the restoration architects in charge of the project. I am indebted to them for their valuable assistance.

2. *The New York Times Magazine*, (August 7, 1898: 6).

3. Information on the original Ellis Island immigration station was found in *The New York Times* of July 28, 1891, January 2, 1892, and July 29, 1892.

4. Ibid., July 28, 1891.

5. Ibid.

6. *The New York Times*, May 22, 1892; June 30, 1892; July 6, 1892; May 17, 1895; January 31, 1897.

7. On overcrowding and the fire see *The New York Times* of April 5, 1896 and June 15, 16, 26, 1897.

8. "The New York Immigrant Station," *Architectural Record* 12 (December 1902); 726–33.

9. Louis H. Sullivan, *The Autobiography of an Idea* (1924; New York: Dover Publications, 1956 ed.), 216; Carroll L.V. Meeks, *The Railroad Station: An Architectural History* (New Haven, Conn.: Yale University Press, 1956), 125.

10. *Architectural Record* (1902); 726.

11. Ibid., and *The New York Times* (August 7, 1898). For other lengthy contemporary evaluations see *The New York Times* of December 3, 1900, March 31, 1901, and July 12, 1903.

12. Ibid. (February 15, 1958), including renderings.

13. Ibid. (April 24, 1960), including renderings.

14. Ibid. (May 11, 1962); and Patricia Coyle Nicholson (ed.), *Architecture, Man in Possession of His Earth: Frank Lloyd Wright* (New York: Doubleday & Company, 1962), 124–25, for Taliesin's statement and rendering.

15. *The New York Times* (June 8, 1965; February 25 and 26, 1966); *Time* magazine (March 4, 1966), with rendering.

16. Kevin Wolfe, "Island of Dreams: Castle-Building on Ellis Island," *Metropolis* (January/February 1985); 40 (rendering, 28).

17. See Beyer Blinder Belle/Notter Finegold & Alexander, "Historic Structure Report: Main Building" (1983), 152, for this quotation, as well as pages 289–96 for a statement of renewal intentions and strategy.

INDEX

Jeffrey A. Newman, *Untitled*, August 1984

(overleaf)
Carolyn Ann Clark, *Ellis Island*, 1983

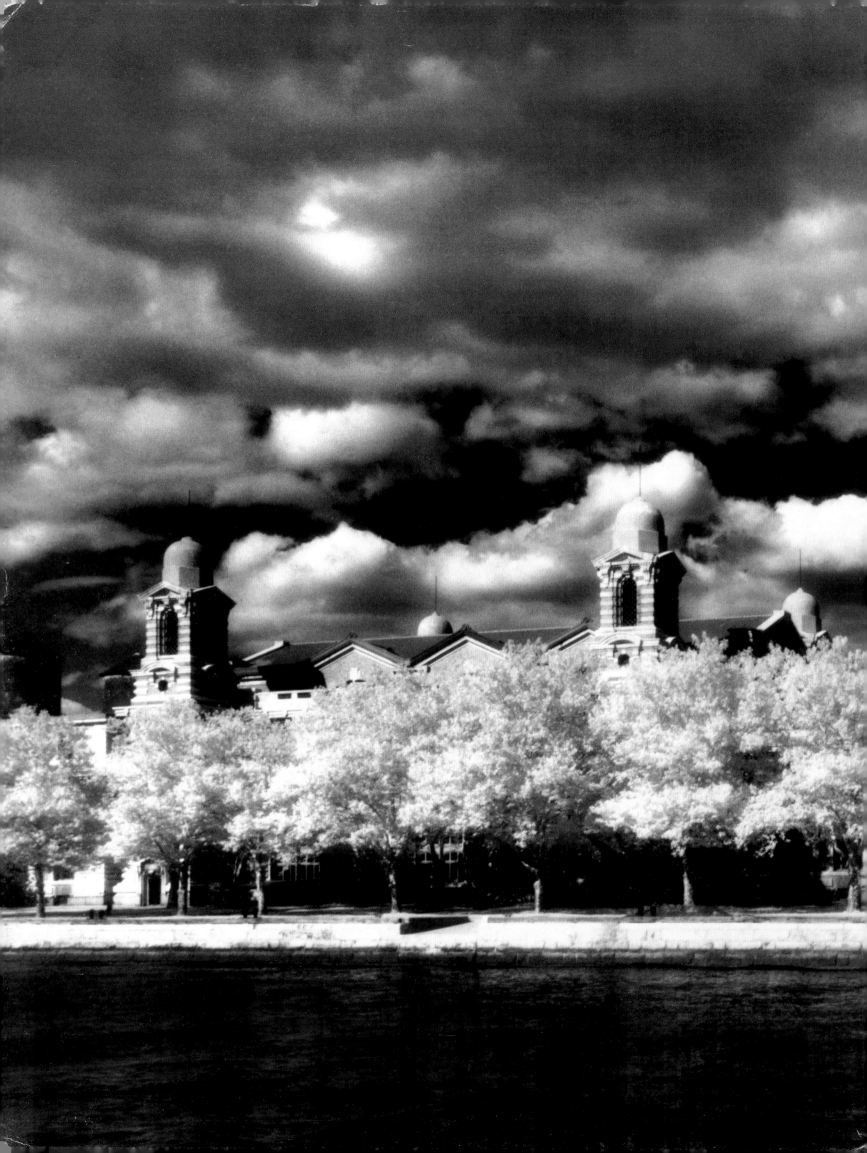

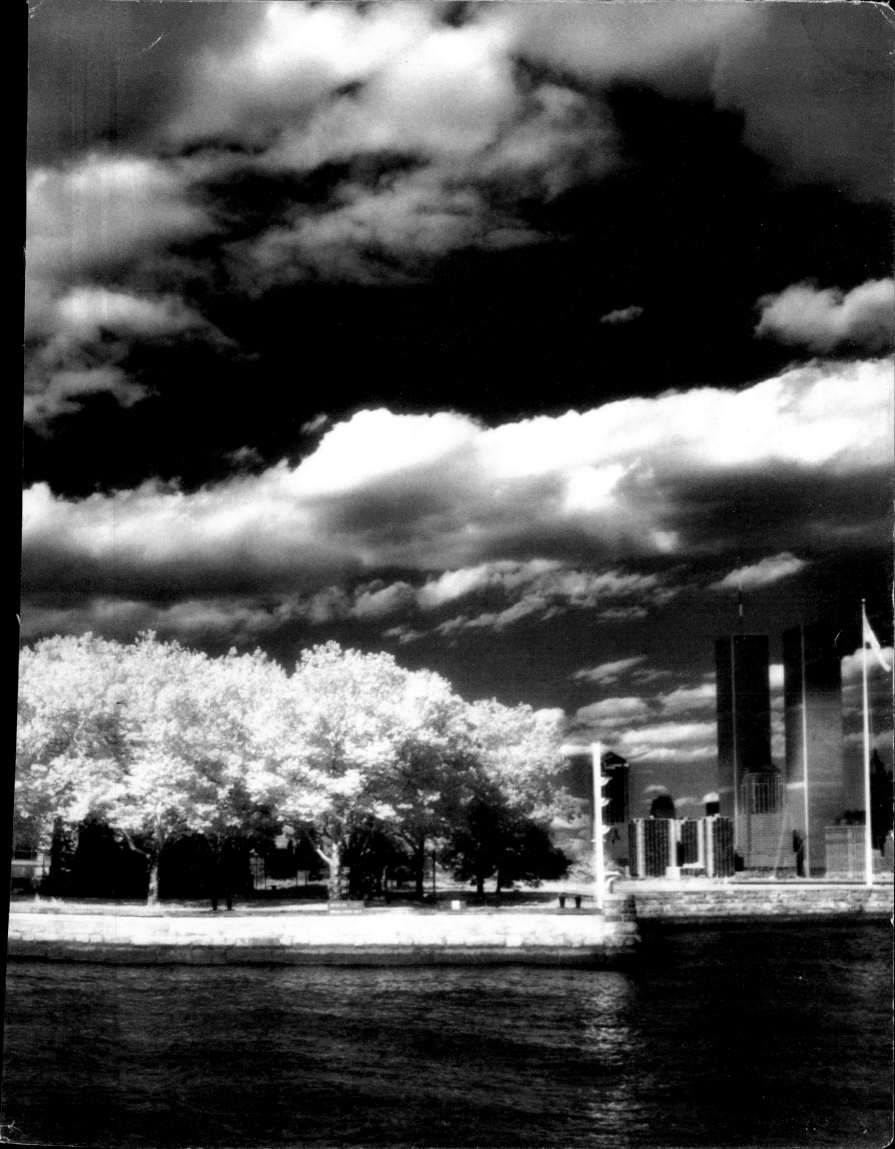

Library of Congress Card Catalog Number: 89-084901
Hard Cover ISBN: 0-89381-396-6
Paperbound ISBN: 0-89381-397-4

Composition by EyeType, 611 Broadway, New York, New York. Printed by Everbest Printing Co., Ltd., Hong Kong. Second Printing.

Aperture Foundation publishes books, portfolios and a periodical of fine photography to communicate with serious photographers and creative people everywhere. A complete catalog is available upon request from Aperture, 20 East 23rd Street, New York, New York 10010.

Ellis Island: Echoes from a Nation's Past accompanies a major photographic exhibition organized by Montclair State College and the National Park Service, U.S. Department of the Interior. The exhibition was conceived by Klaus A. Schnitzer and was presented at the Ellis Island Museum in honor of the opening to the public in 1990.

Staff for *Ellis Island: Echoes from a Nation's Past*: Executive Director, Michael E. Hoffman; Vice President, Editorial—Books, Steve Dietz; Project Editor, Susan Jonas; Managing Editor, Lisa Rosset; Production Director, Stevan Baron; Editorial Work-Scholar, Laura Allen; Copy Editor, Lydia Edwards. Book design by Wendy Byrne.

National Park Service: Superintendent, Statue of Liberty National Monument, Kevin C. Buckley; Chief of Museum Services Division, Diana Pardue; Curator of Collections, Felice Kudman; Museum Photographer, Brian Feeney.

Montclair State College: President, Irvin A. Reid; Dean of the School of Fine and Performing Arts, Geoffrey Newman; Associate Professor of Fine Arts, Klaus A. Schnitzer.

Front end paper: *Leaving Ellis Island, 1910*
Back end paper: Marilyn Bridges, *Overview, Ellis Island*, 1987